# THE COLUMBUS OHIO
## Coloring and Activity Book

### PART II

ILLUSTRATED AND CREATED
BY
KATIE BARRON

The Columbus Ohio
Coloring and Activity Book
Part II

All content
©Katie Barron LLC 2015

All Rights Reserved

www.KatieBarron.com

ISBN: 978-1-63337-077-7

Published by Proving Press

Special thanks
to
*Steve Botts*

Dedicated to
*Lily & Ulli*

For best results, use

colored pencils

or

*markers may bleed through pages*

# Table of Contents

Italian Village .................................... 1

Olde Towne East ................................ 25

University District ................................ 51

Victorian Village ................................. 73

Answers .......................................... 93

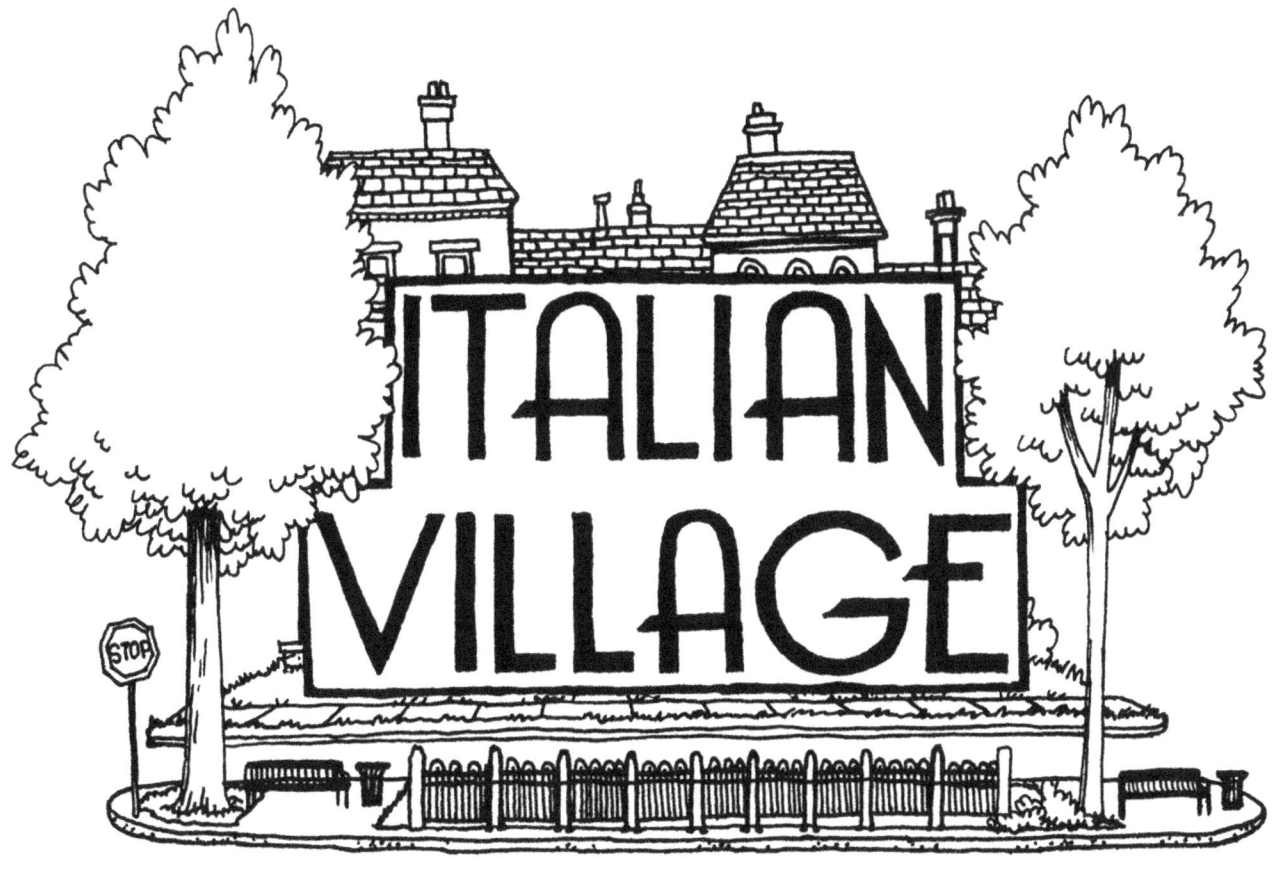

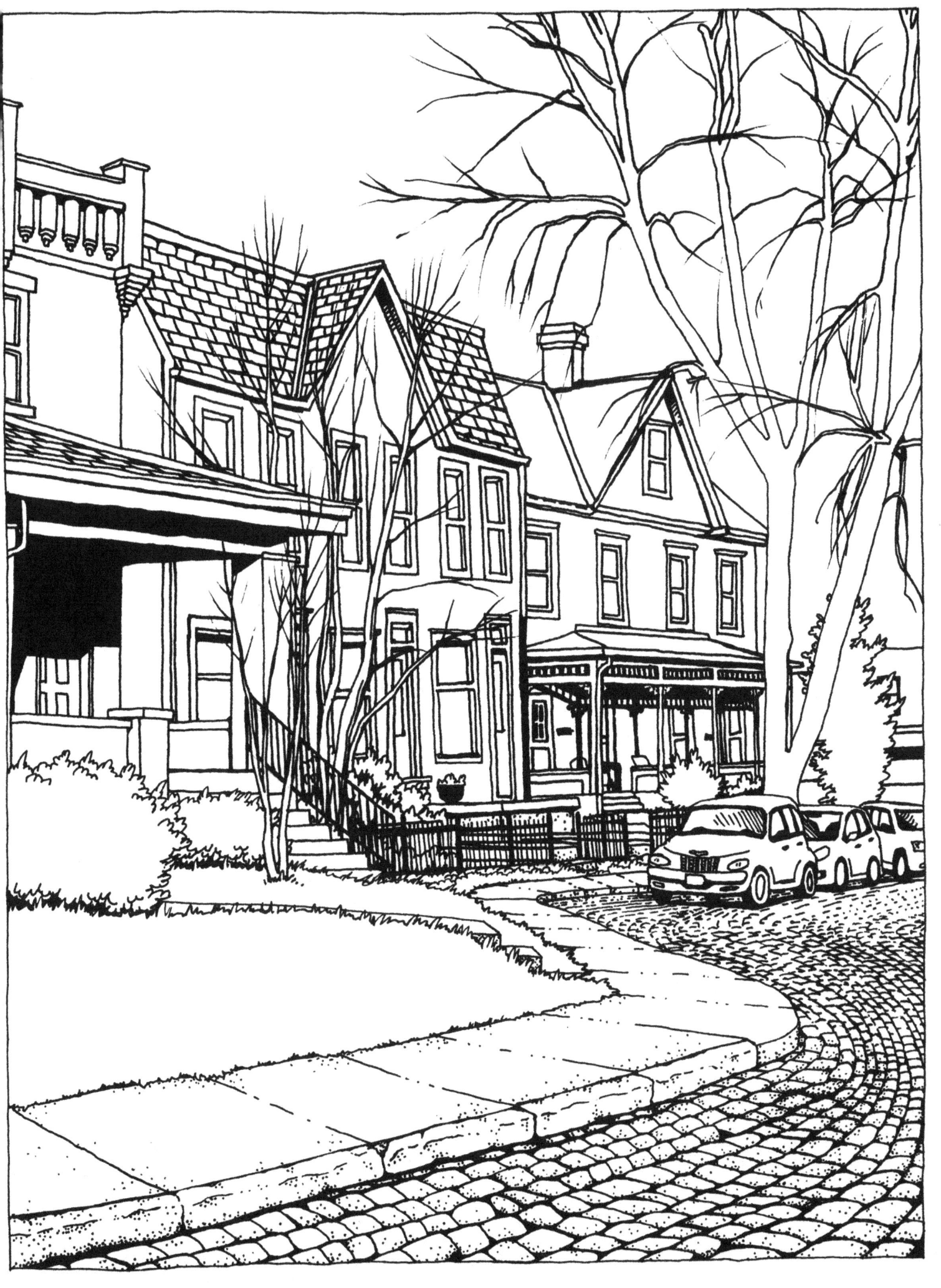

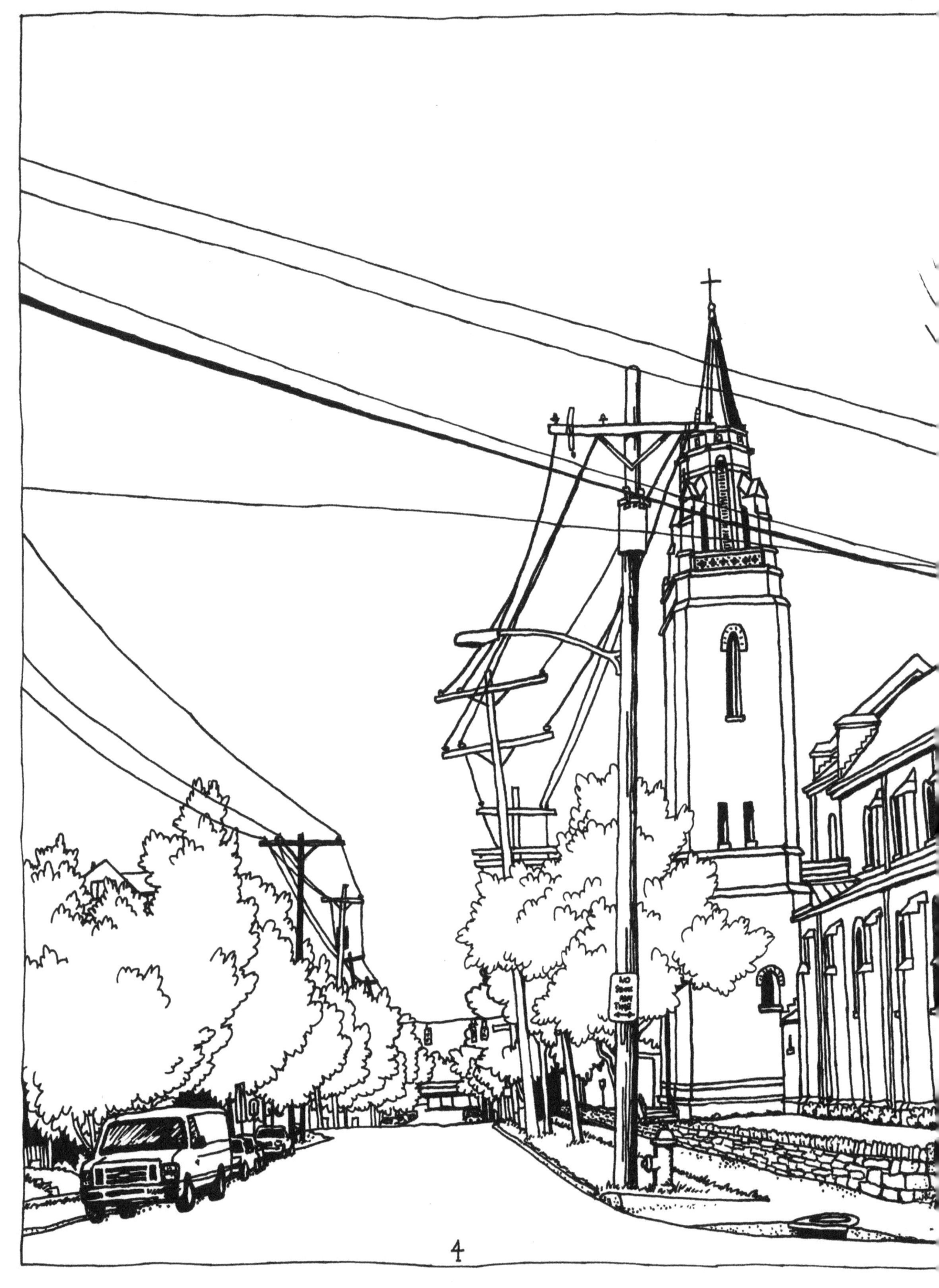

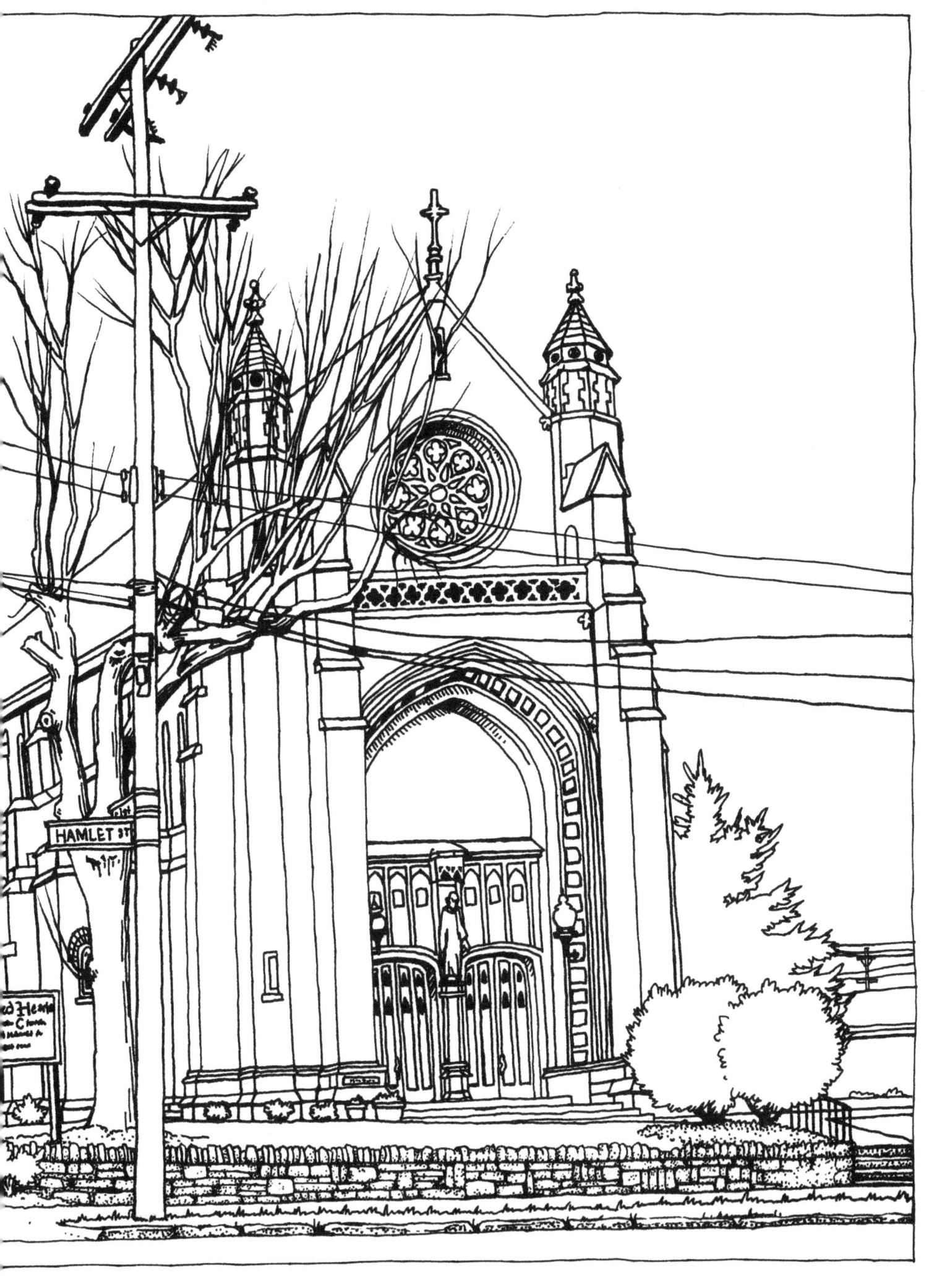

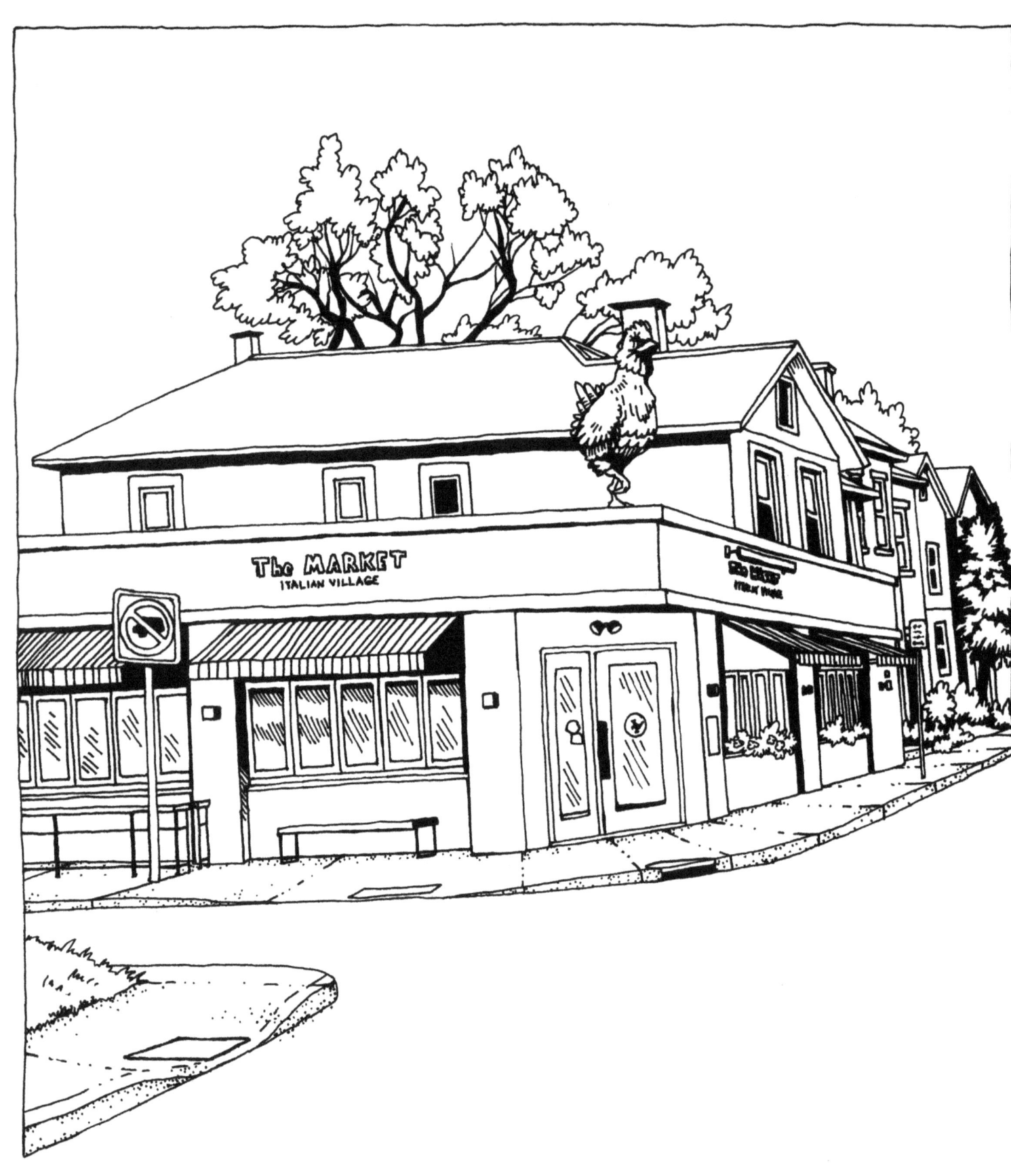

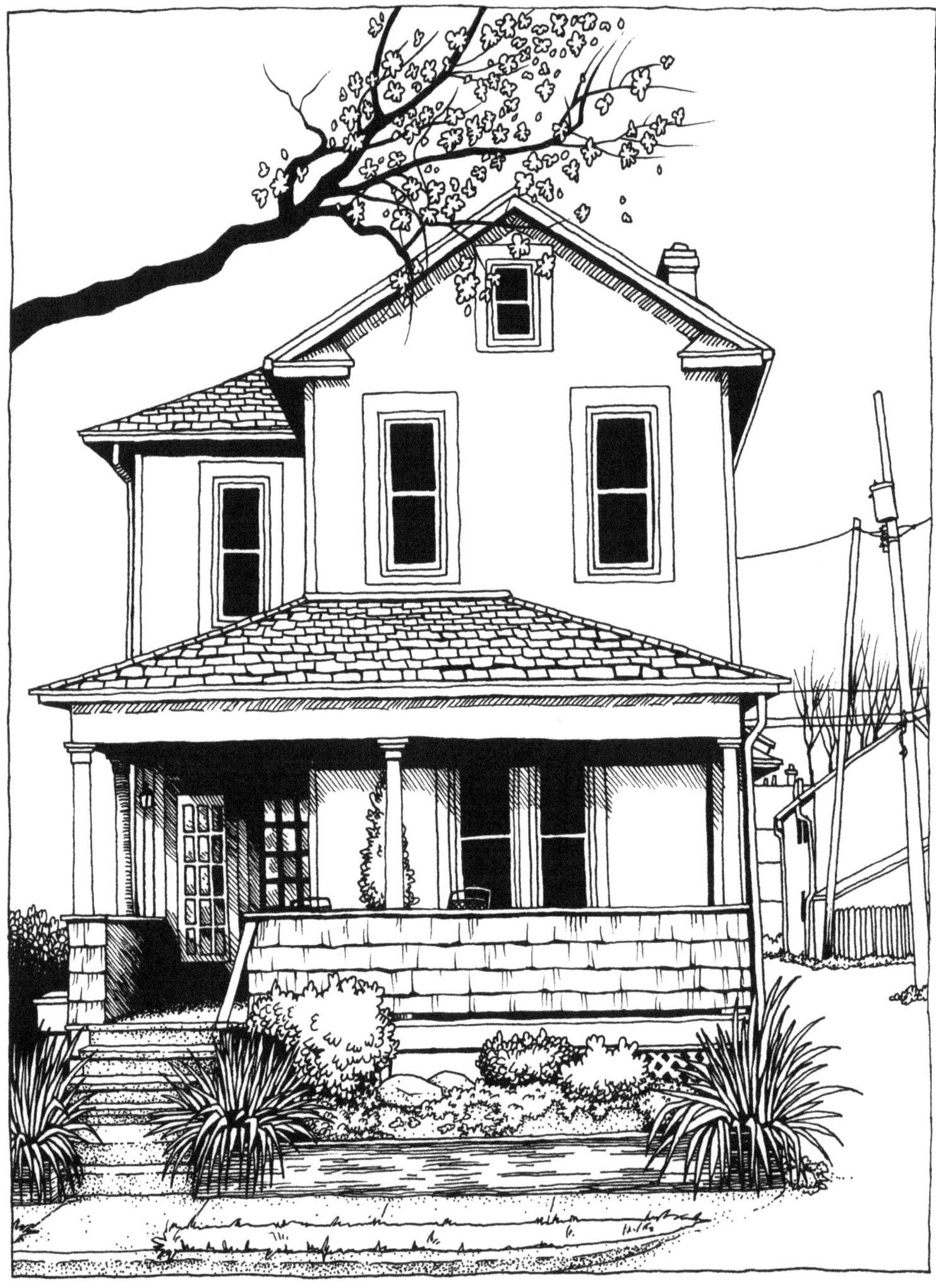

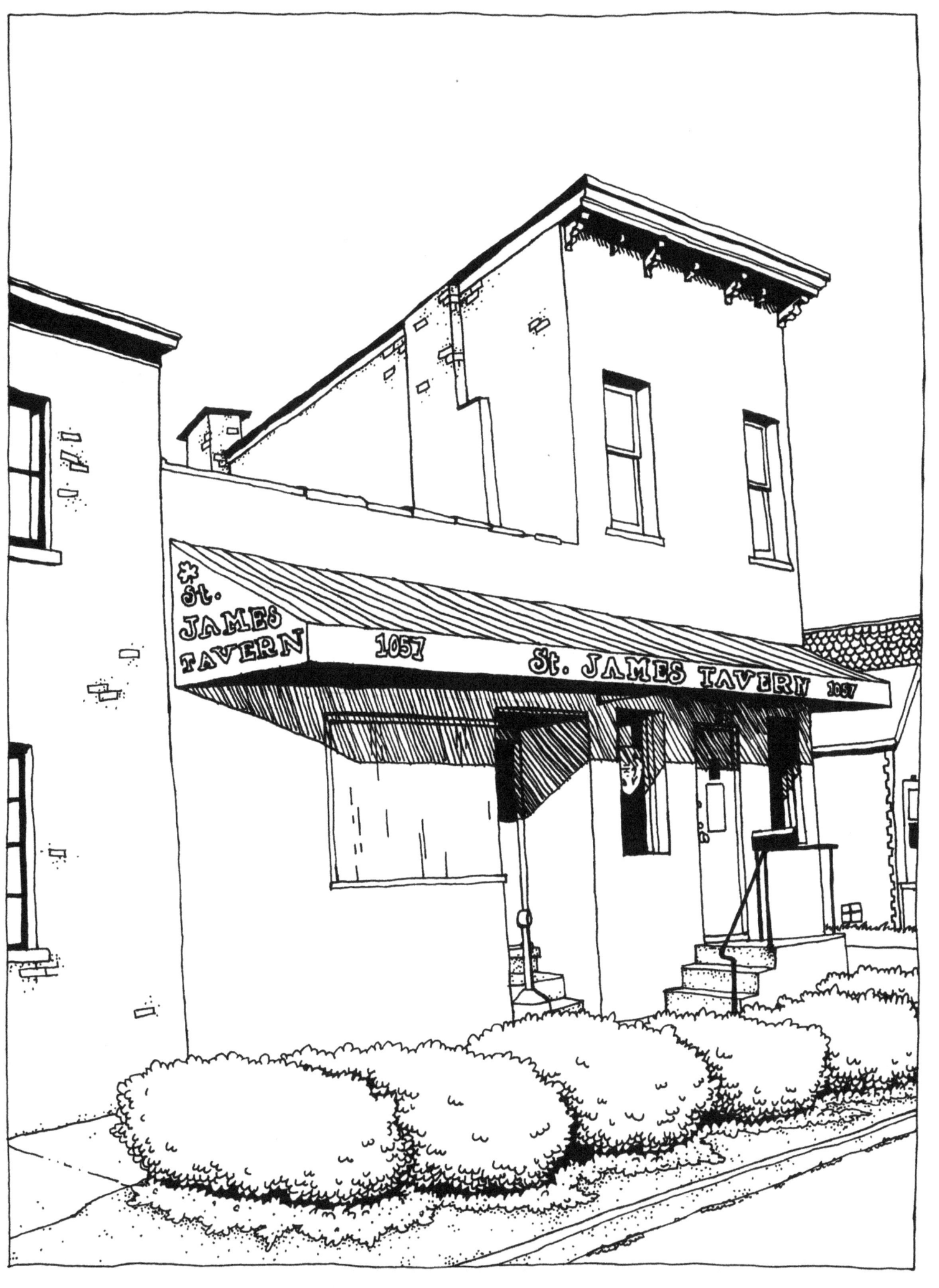

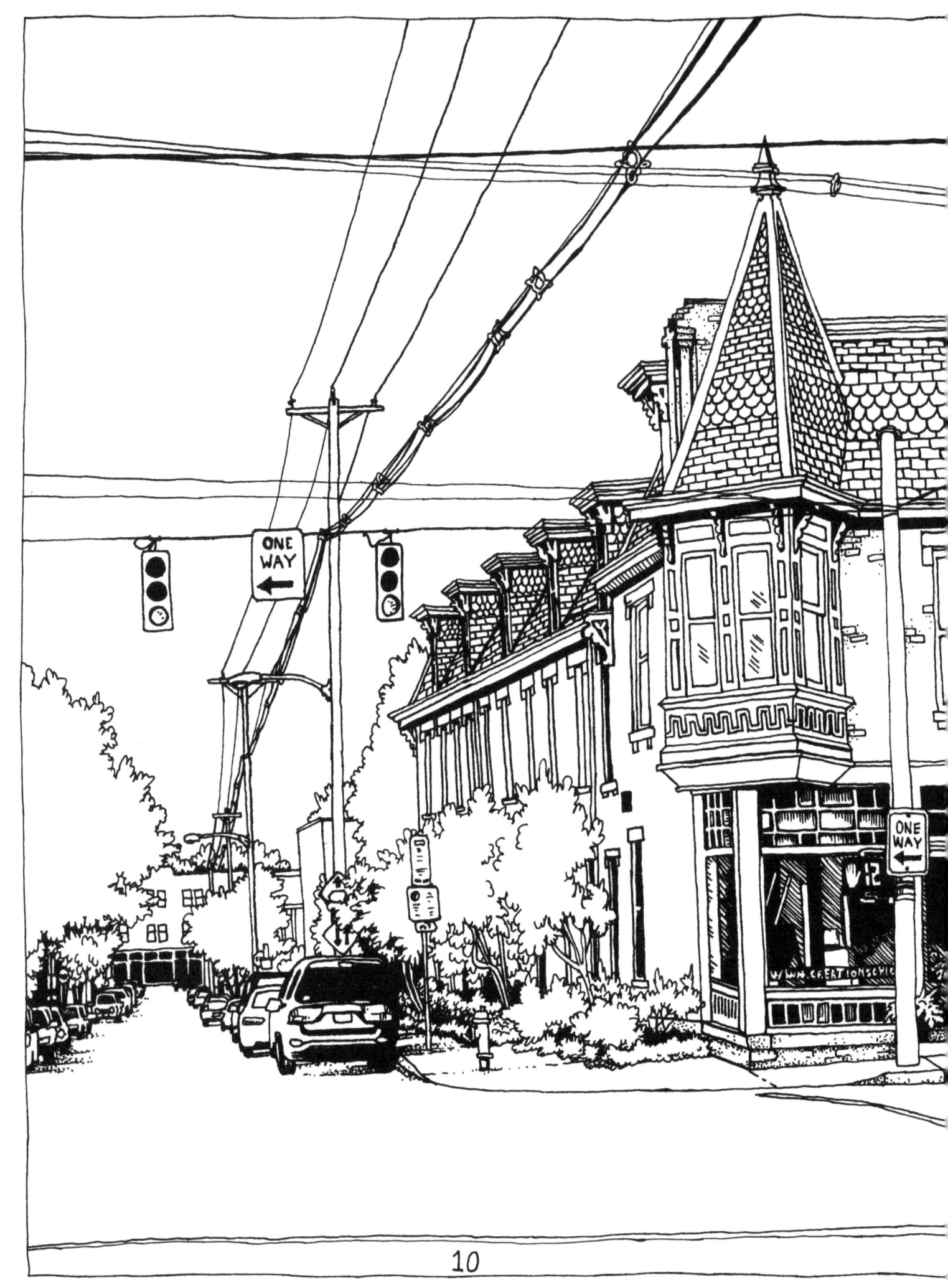

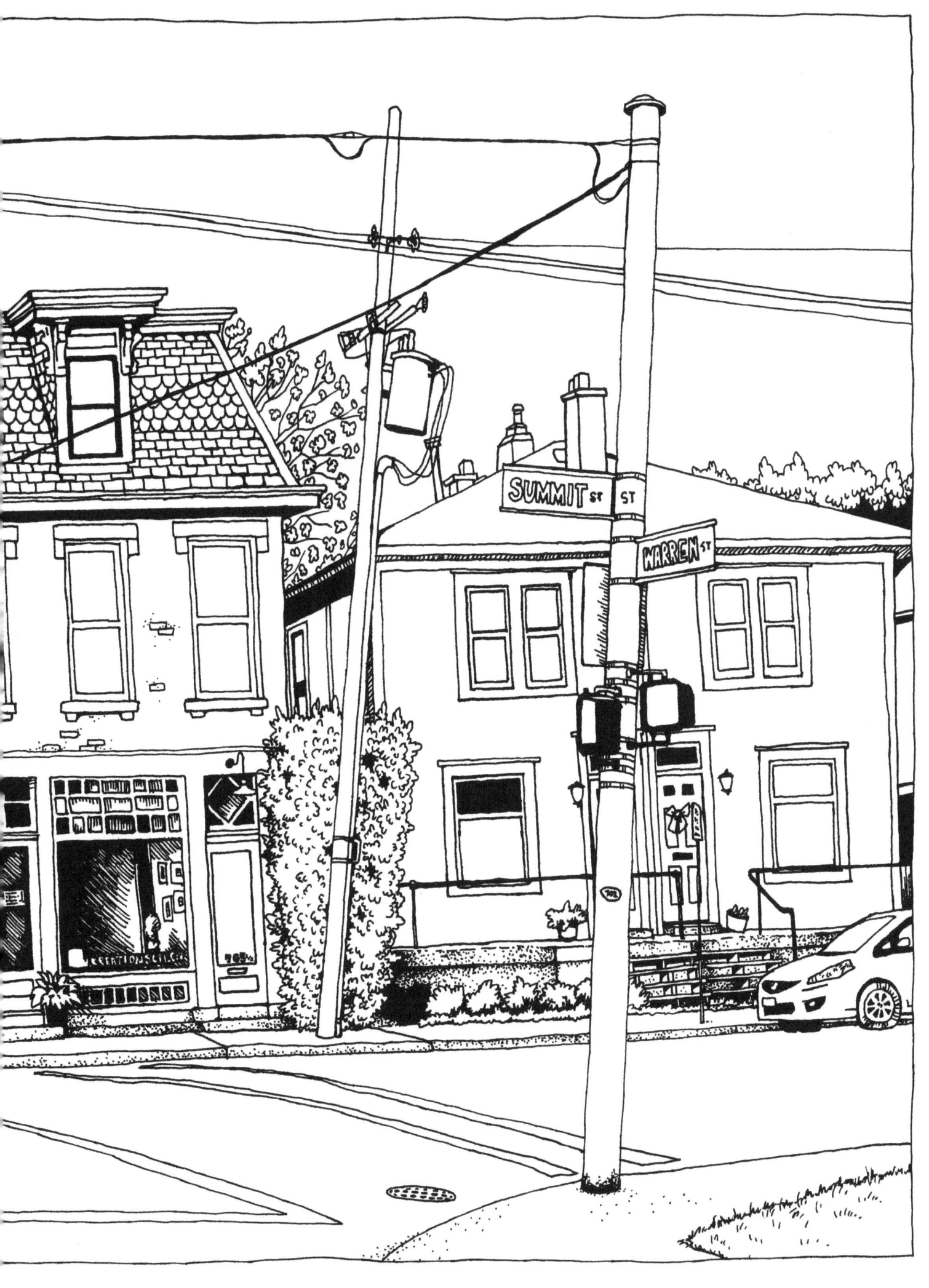

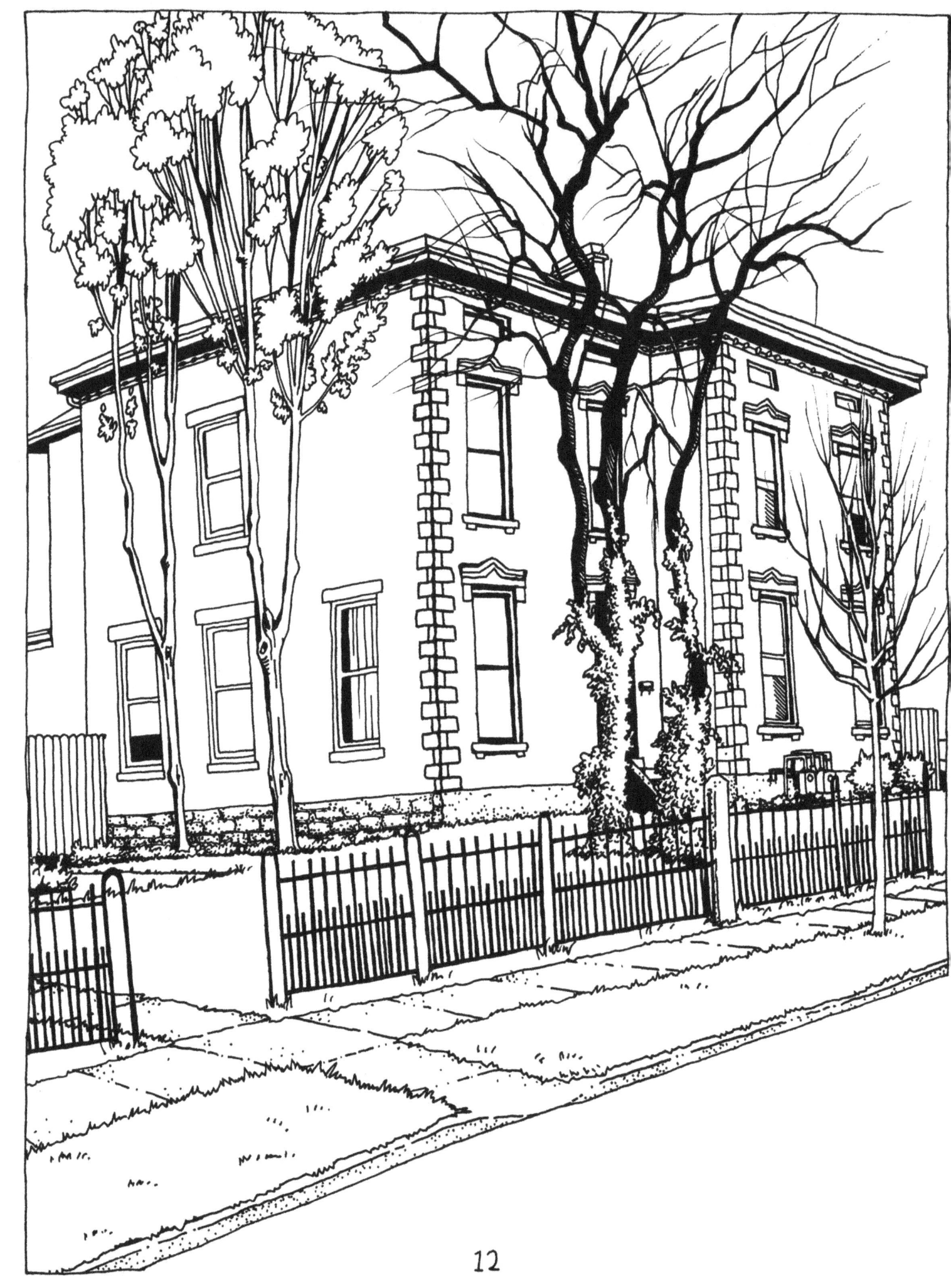

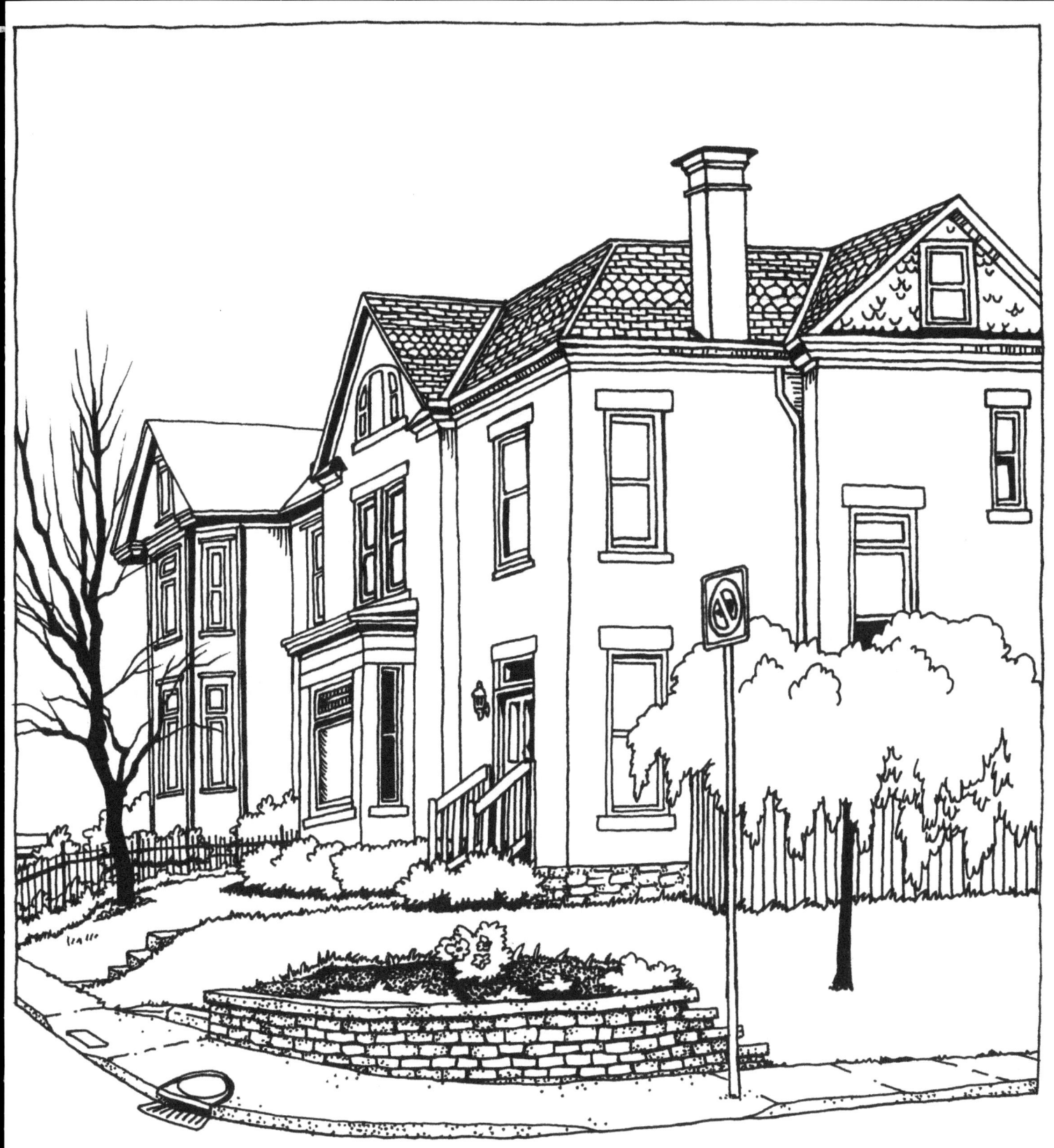

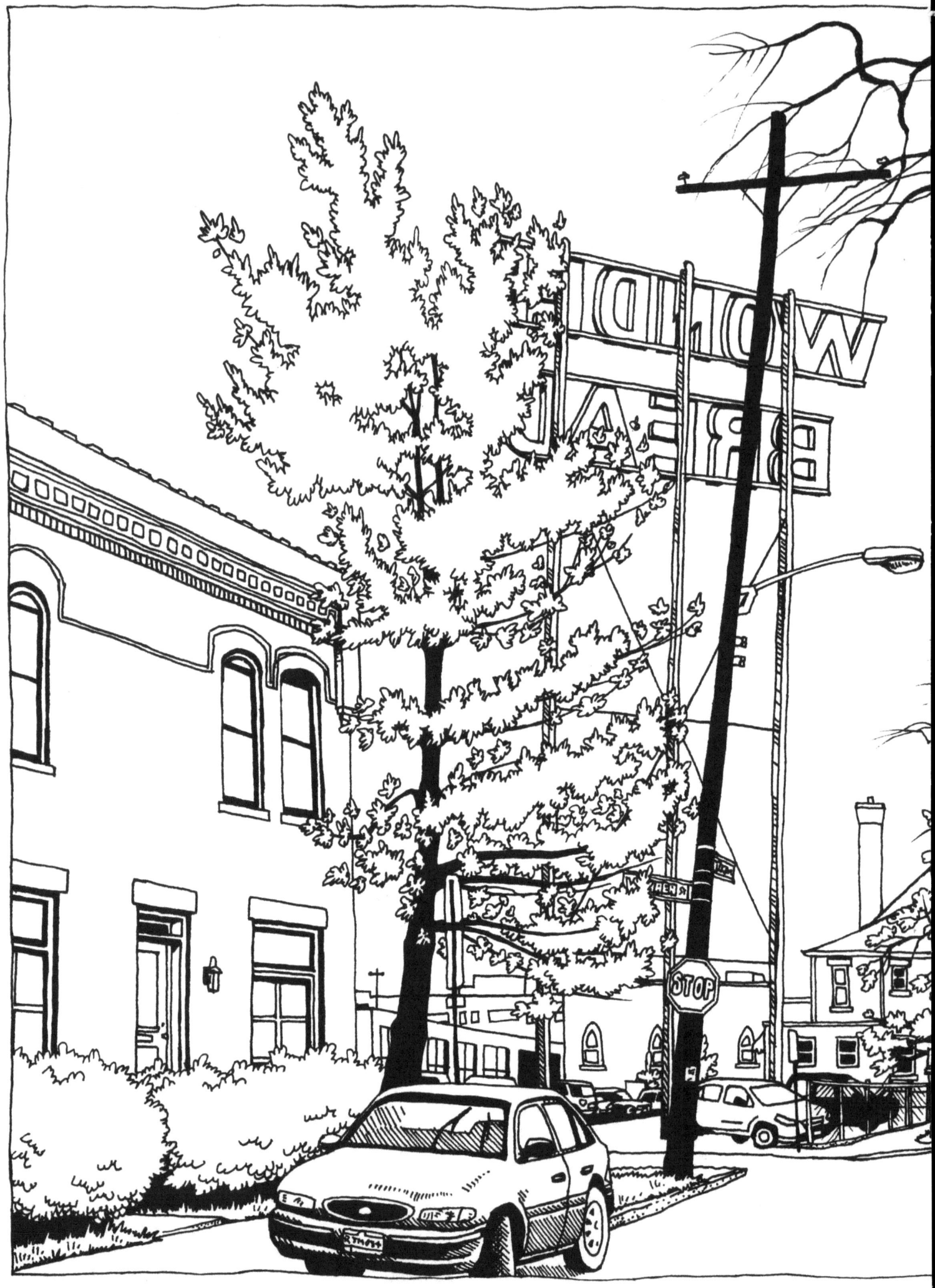

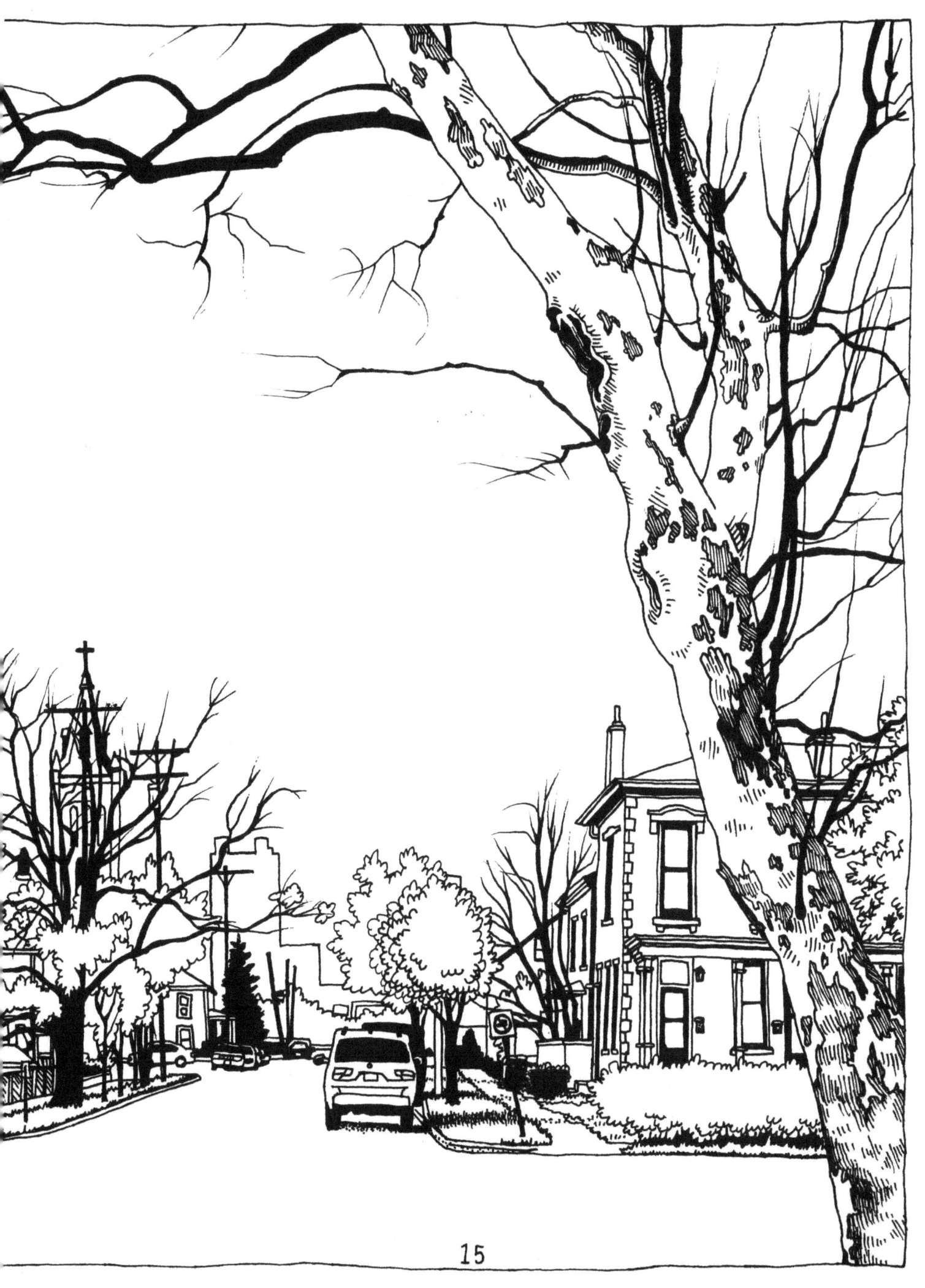

There are 10 differences between these two pictures. Can you find them all?

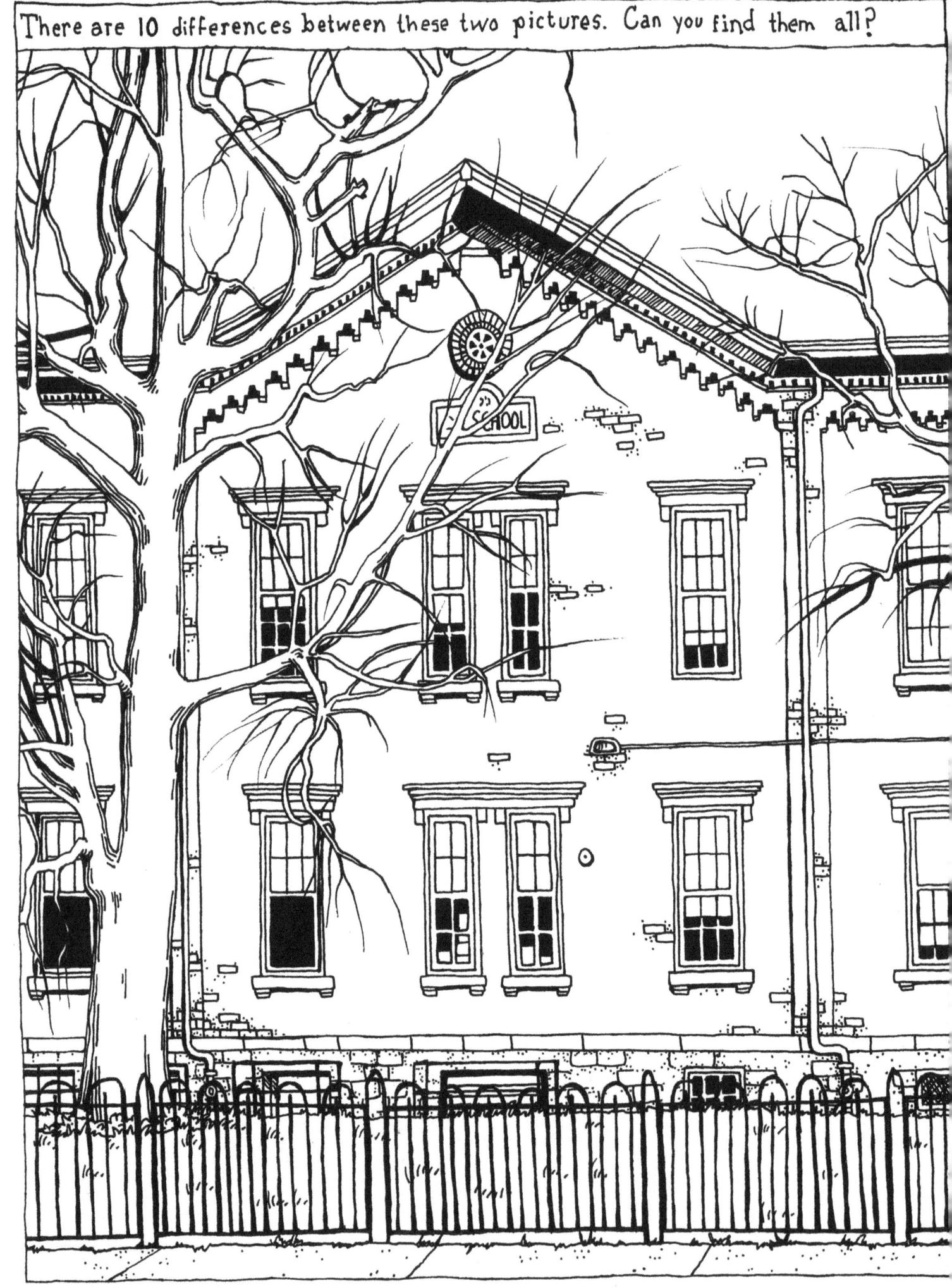

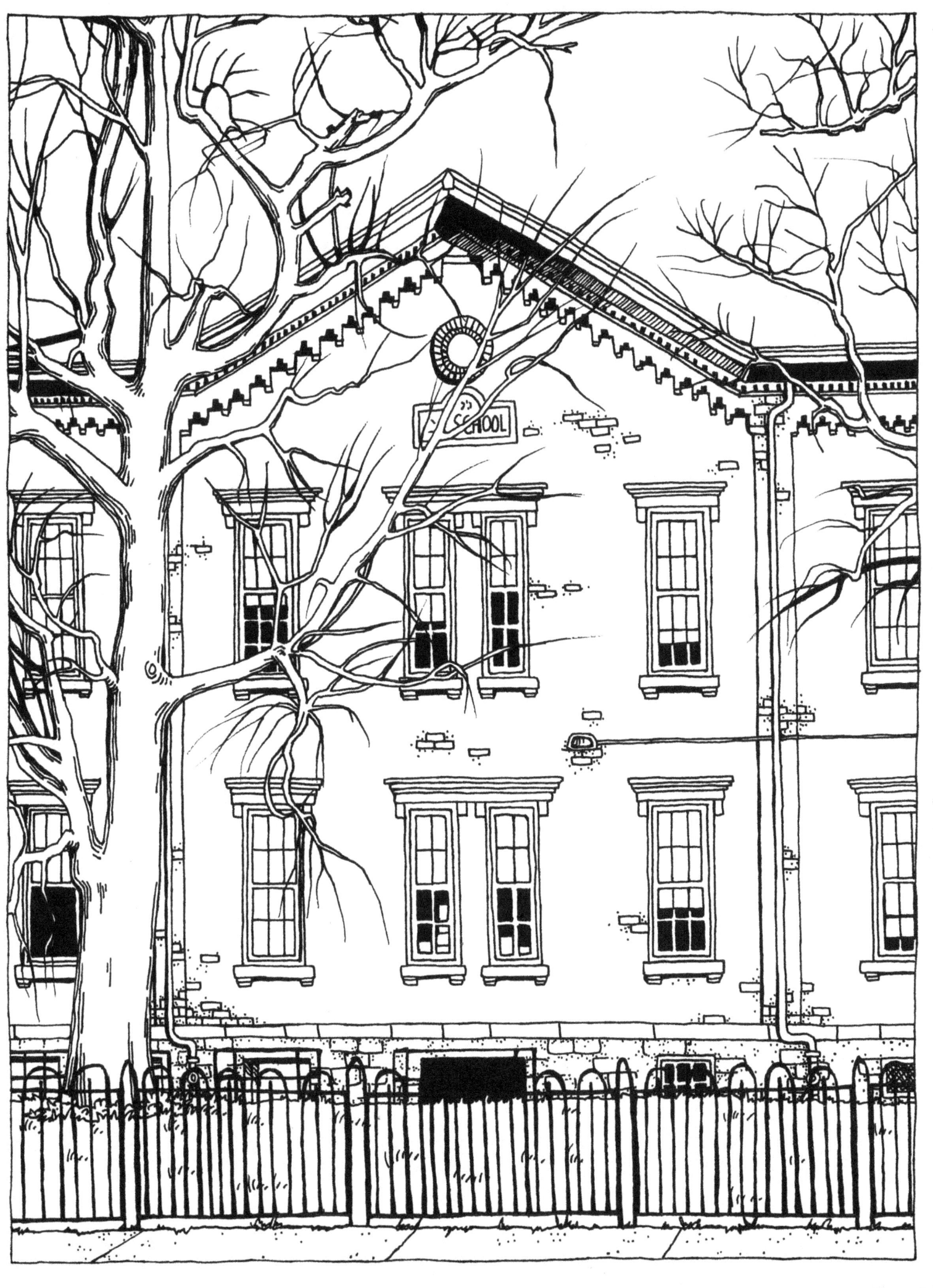

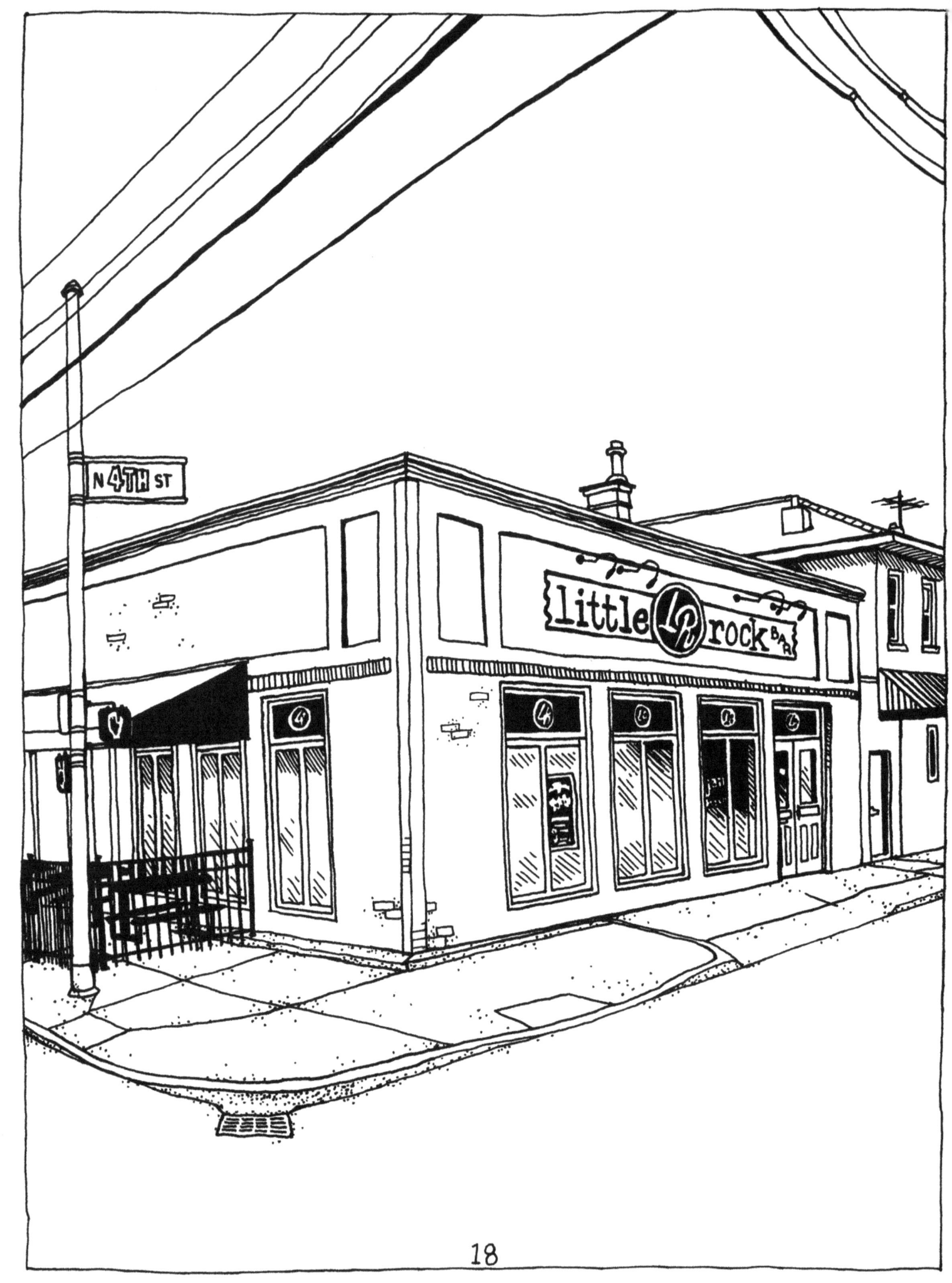

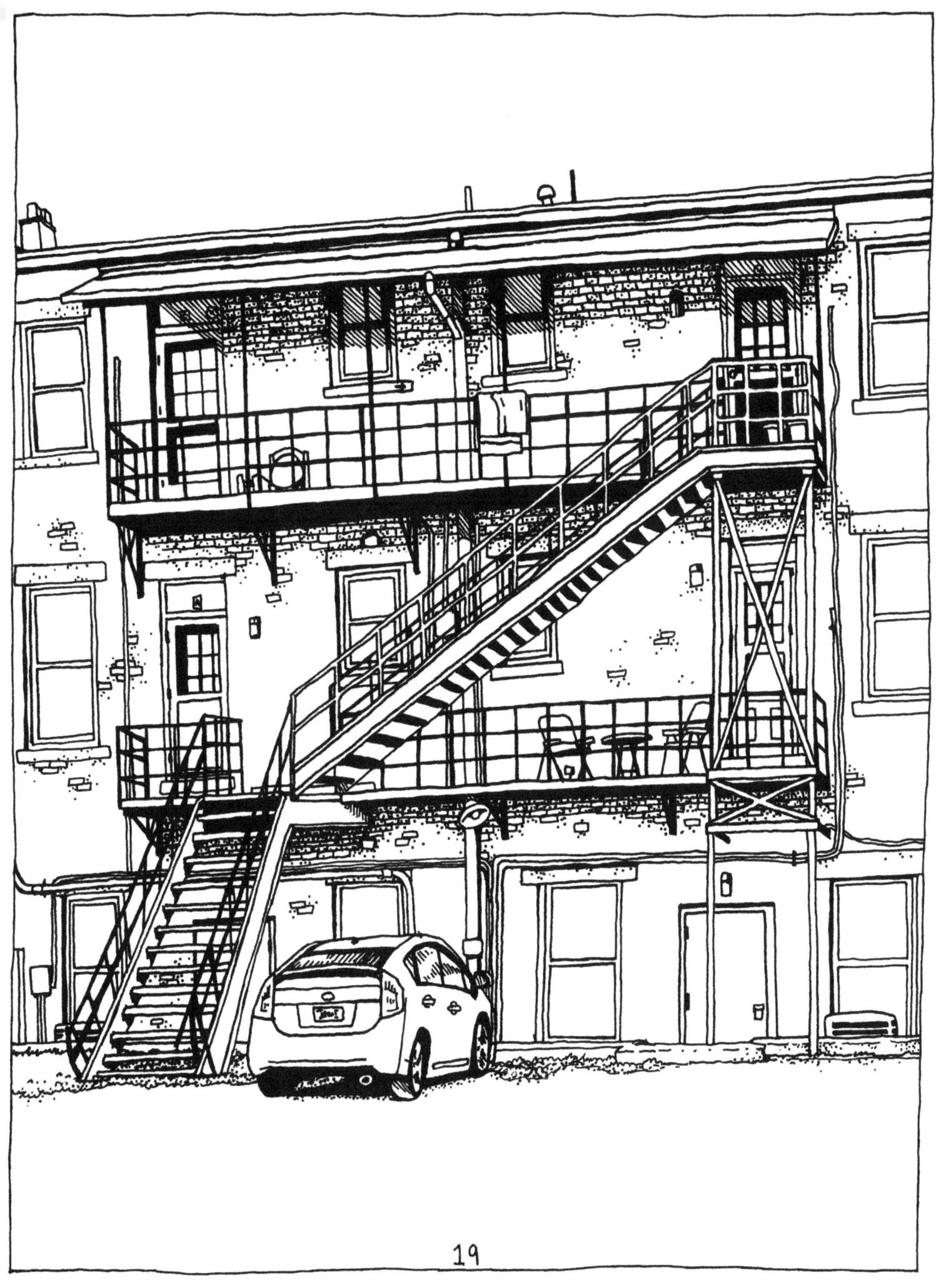

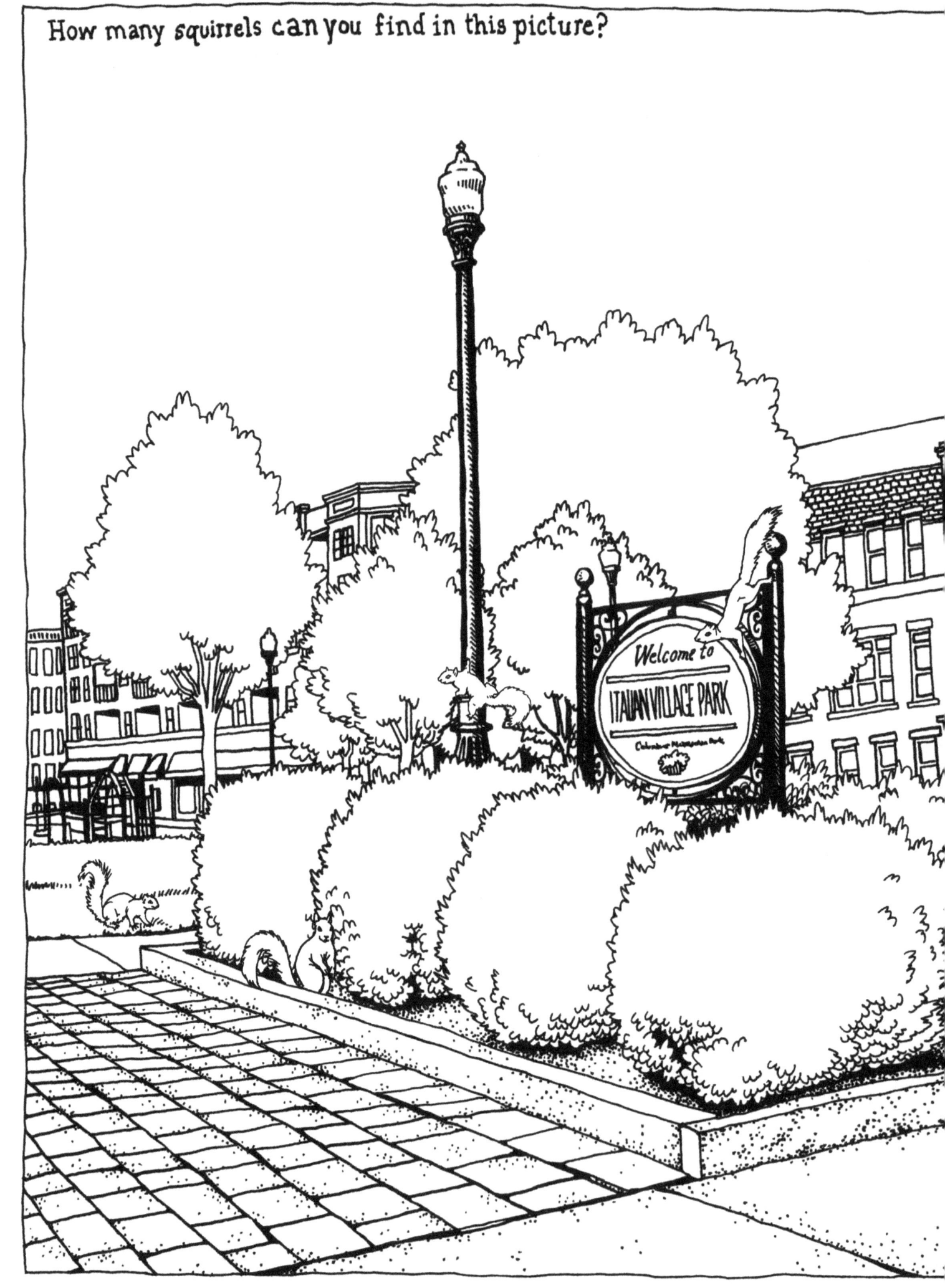

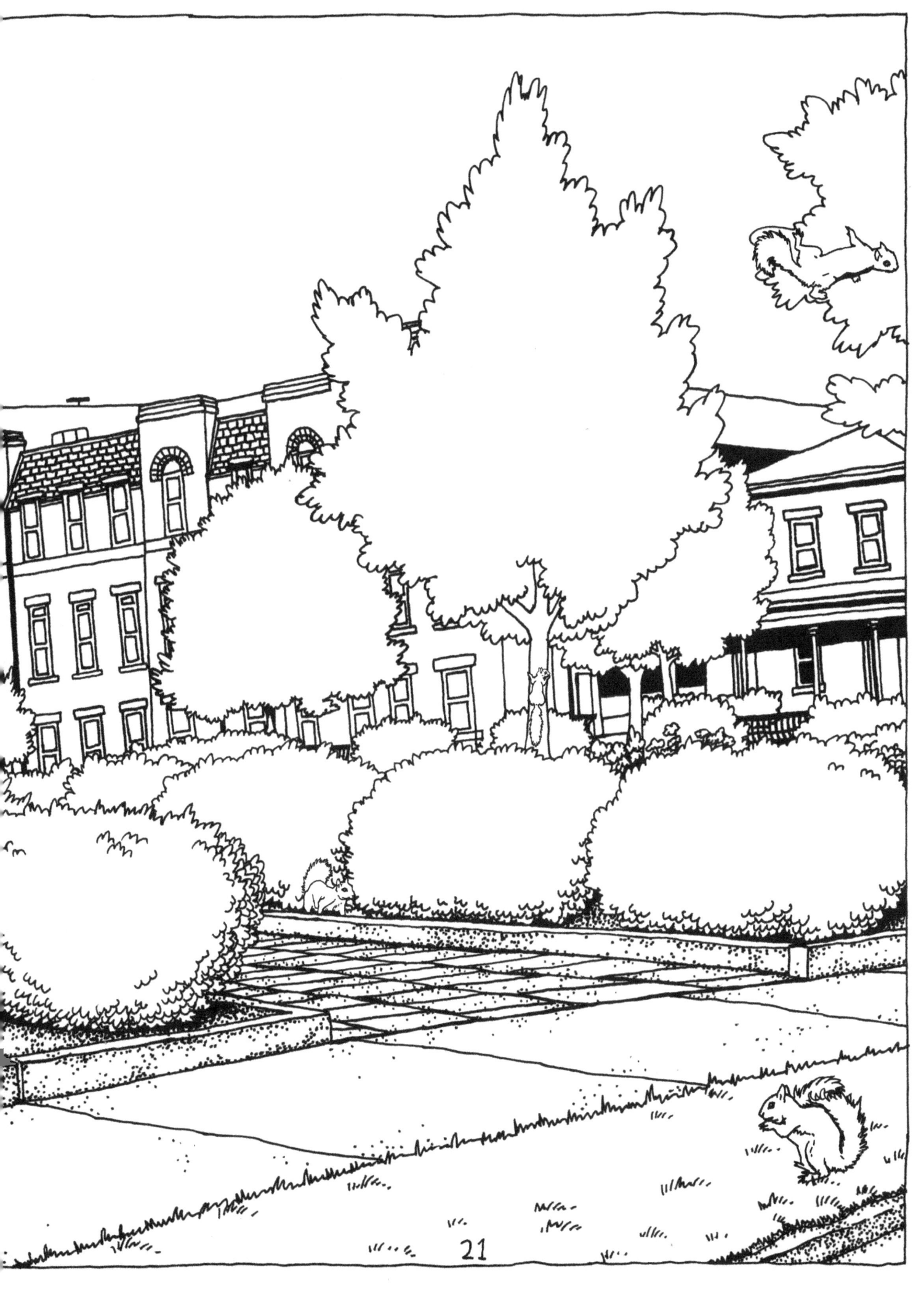

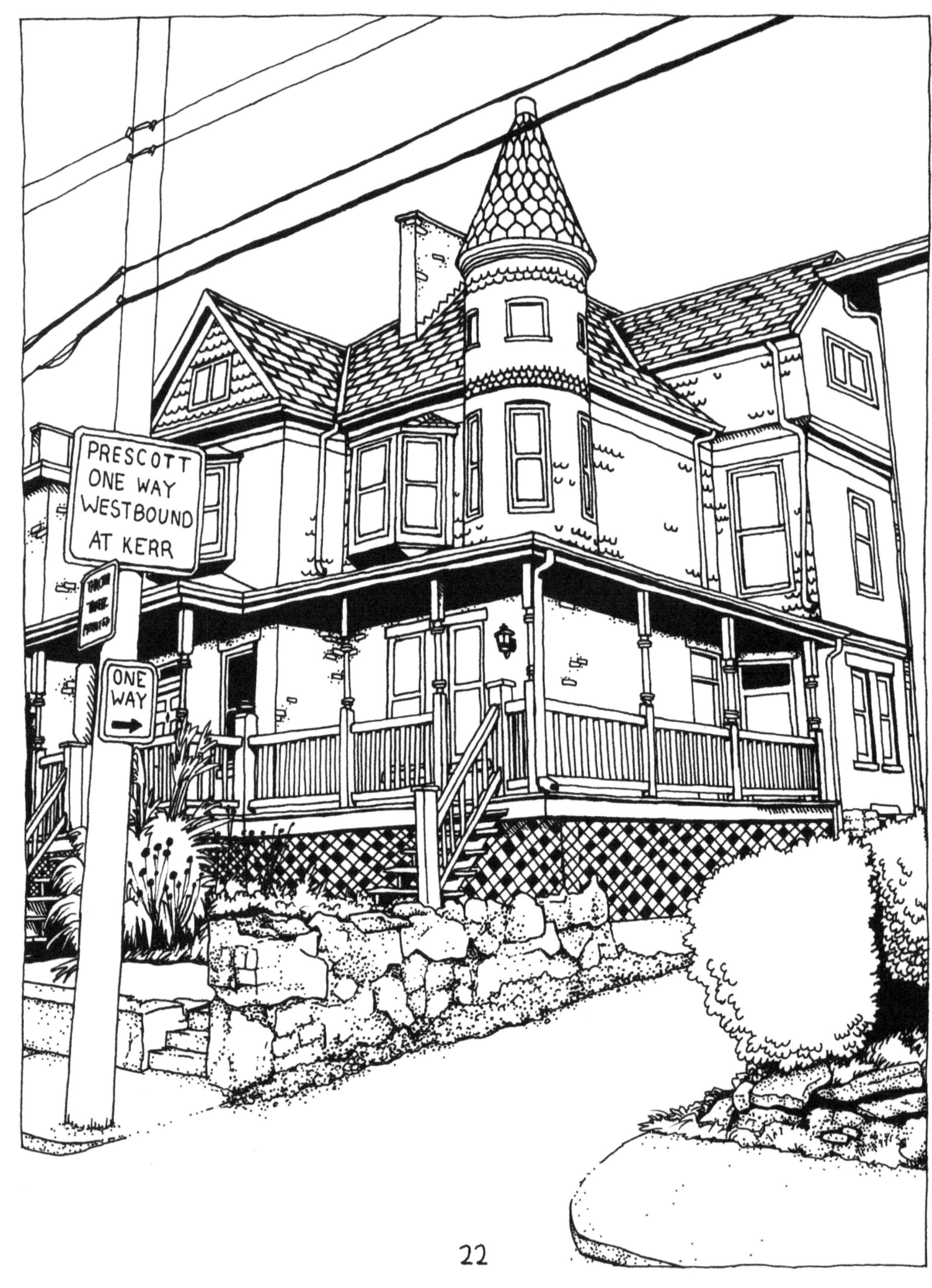

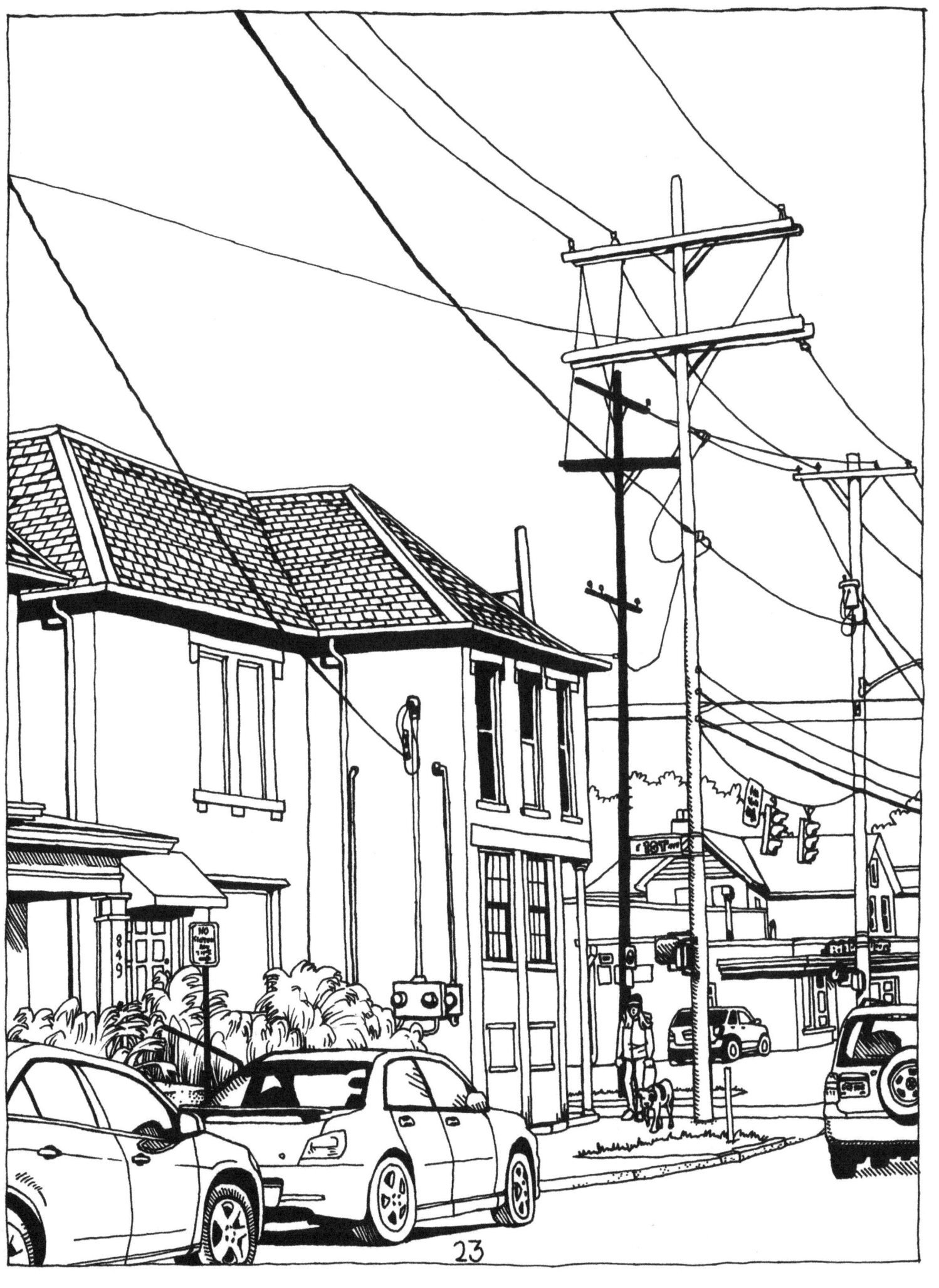

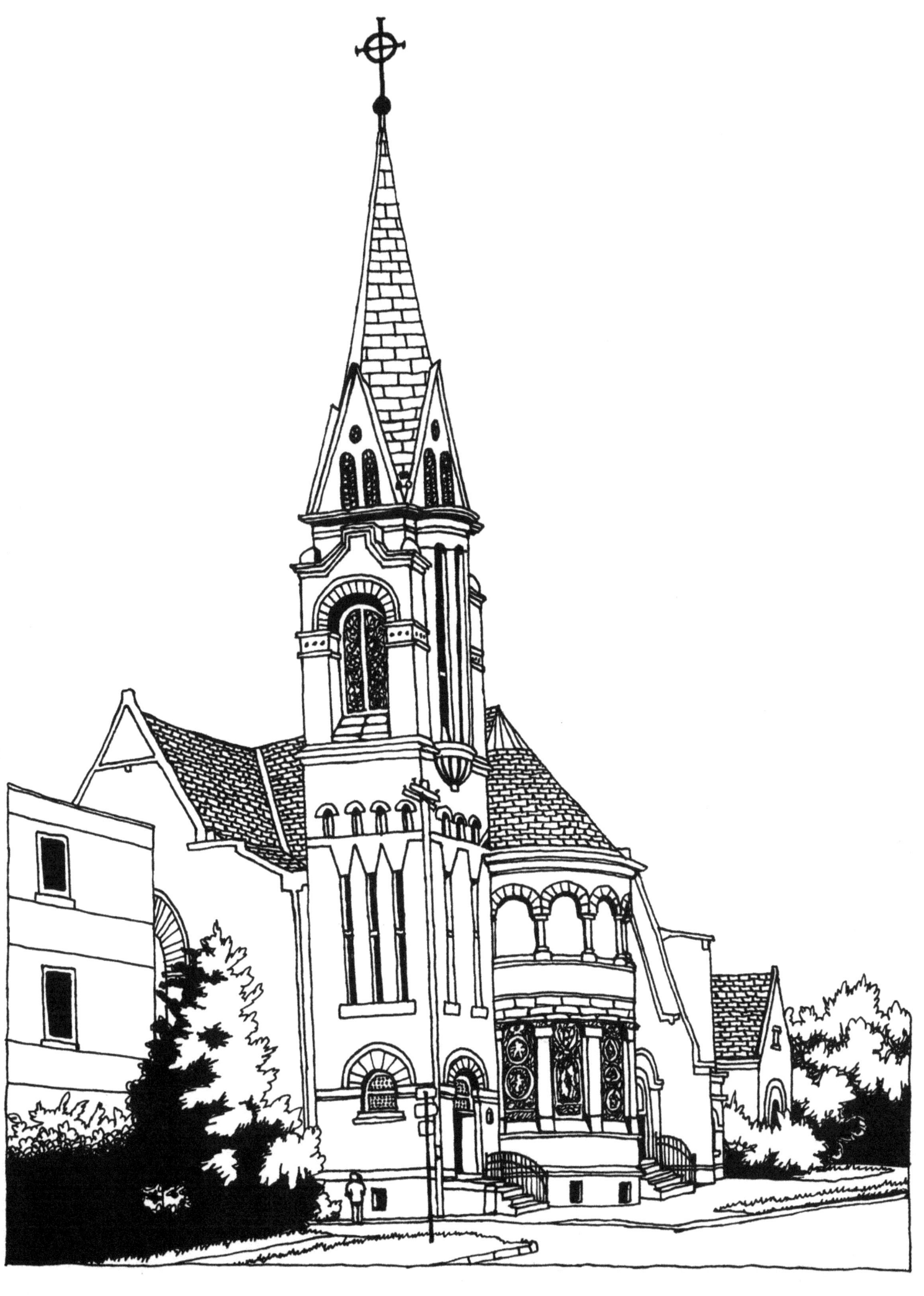

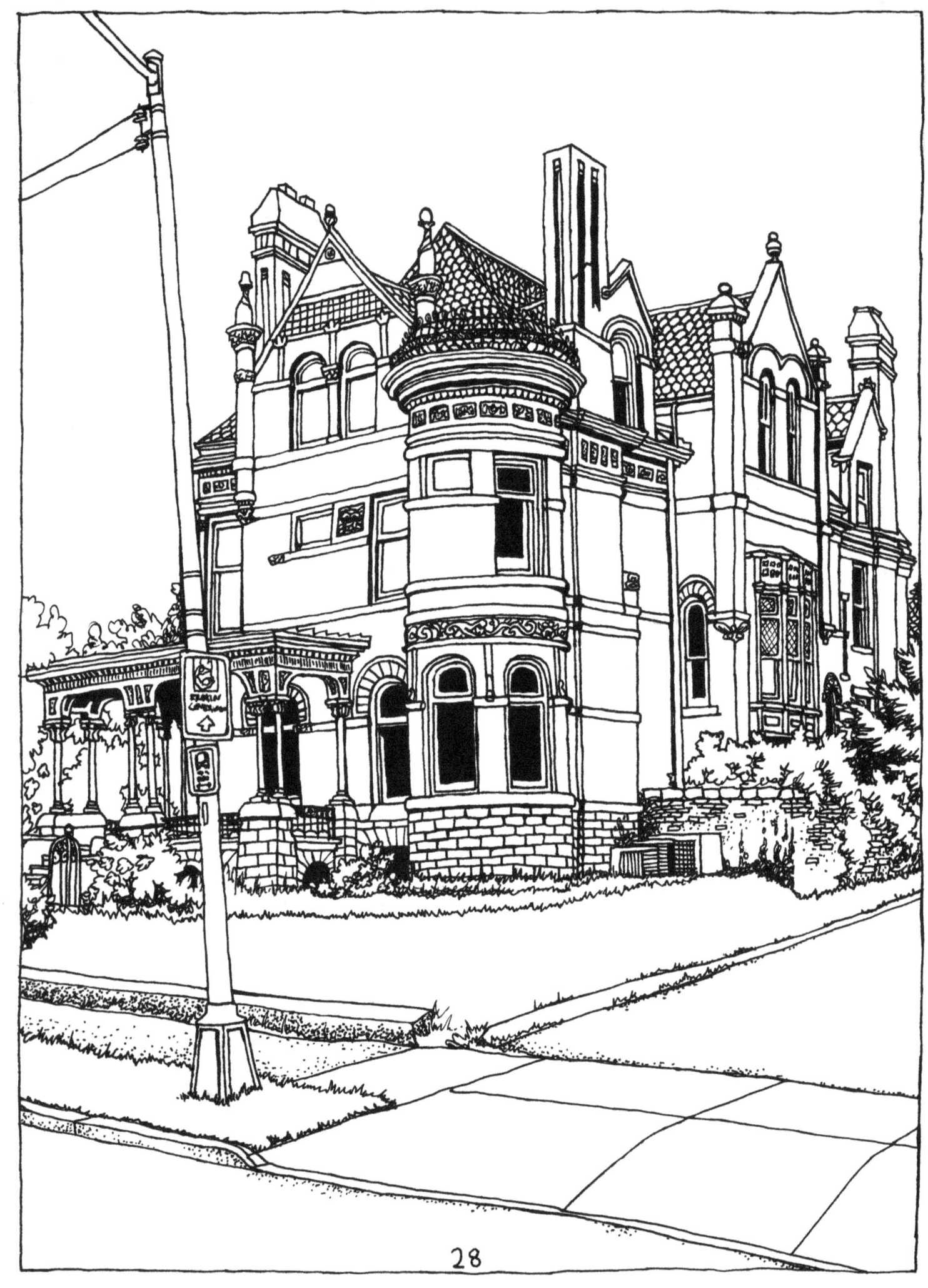

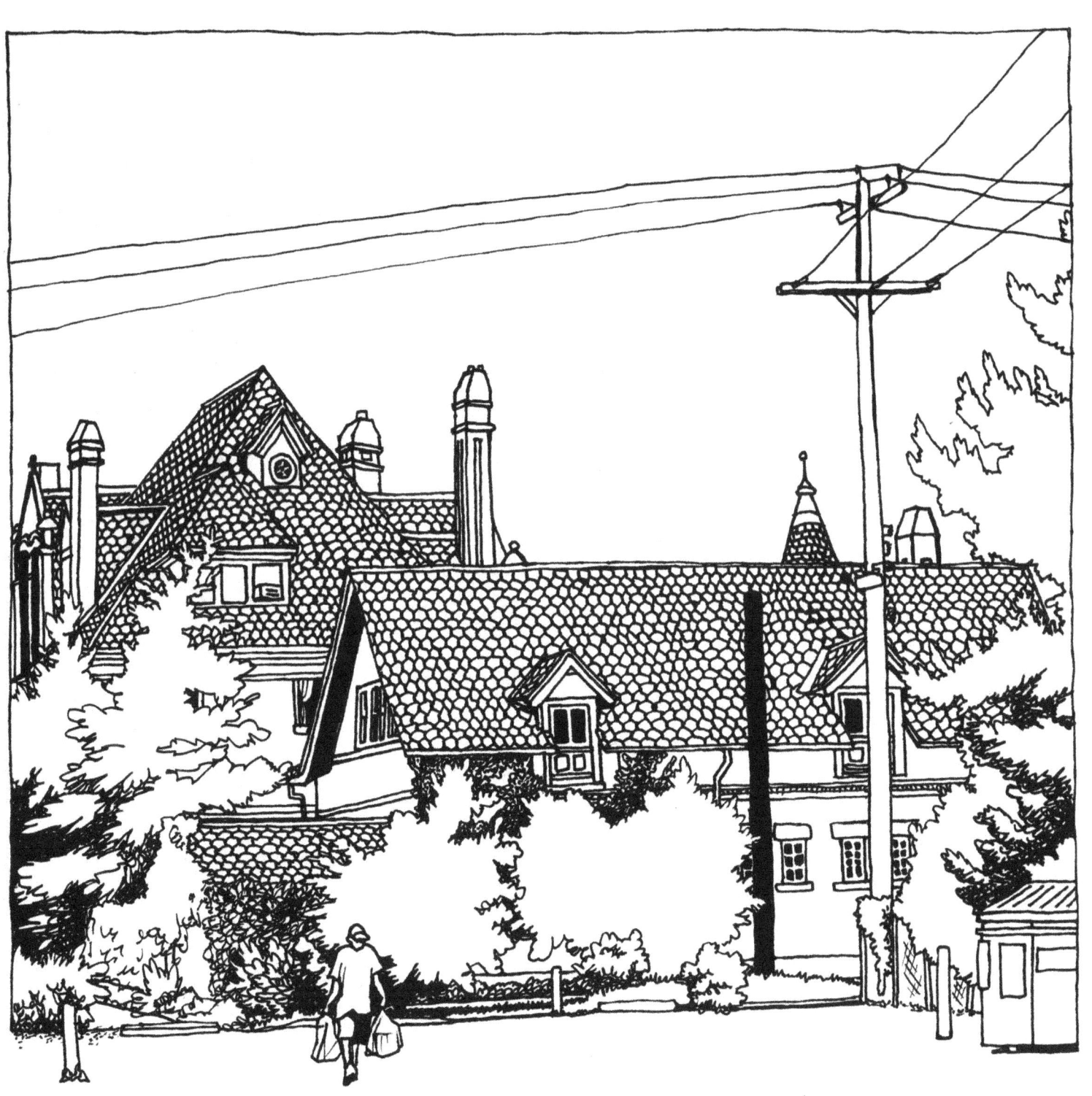

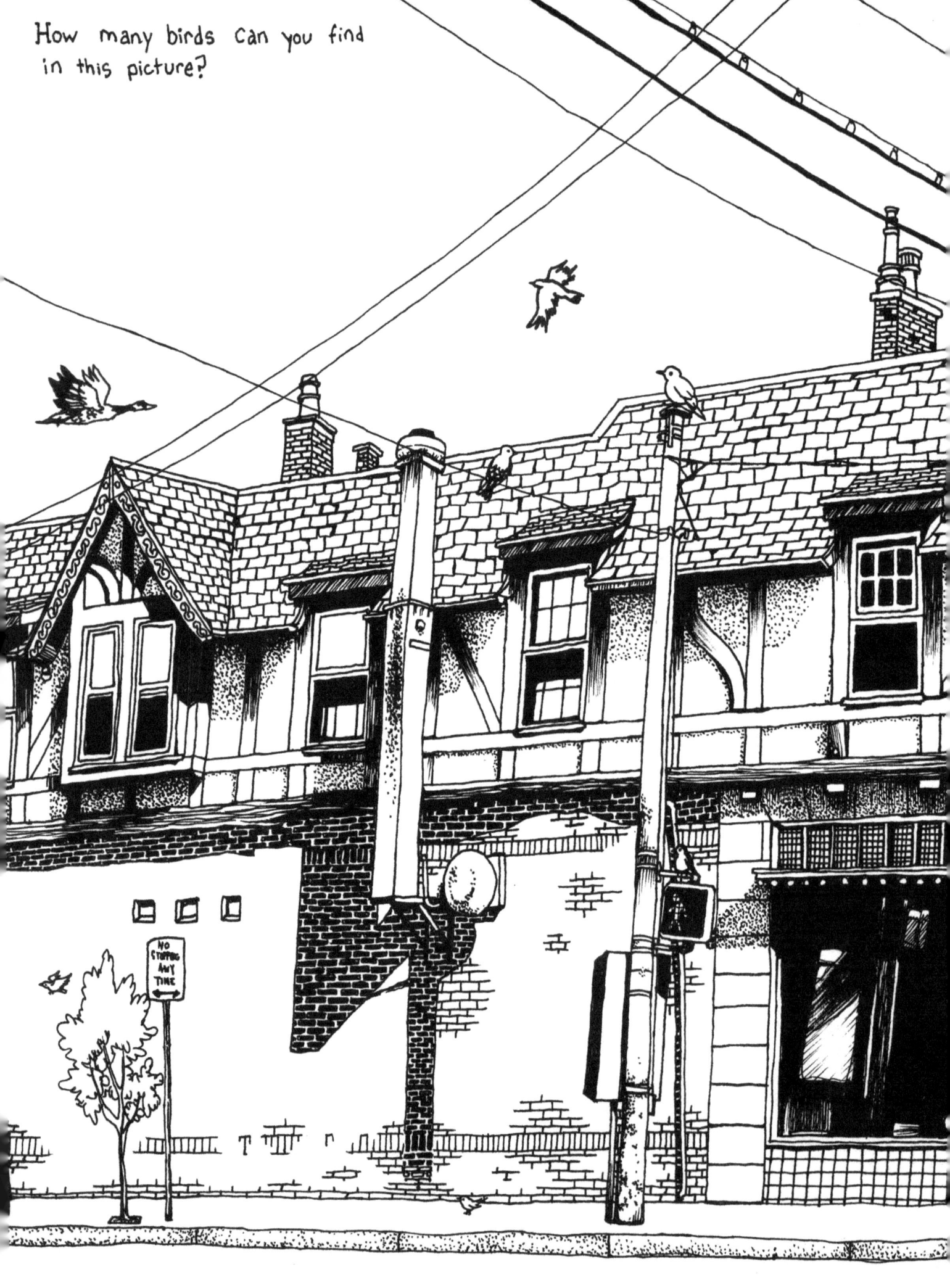

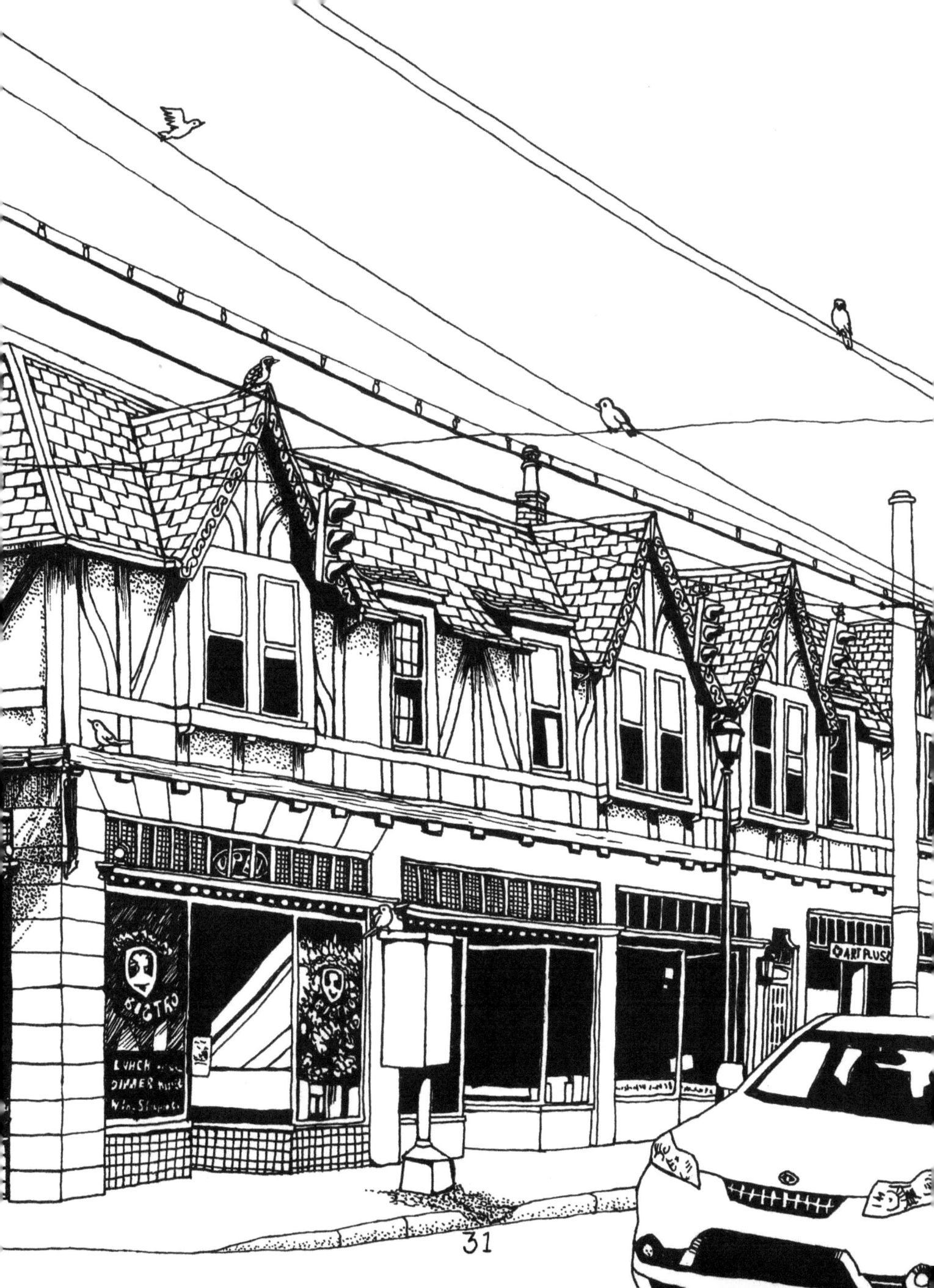

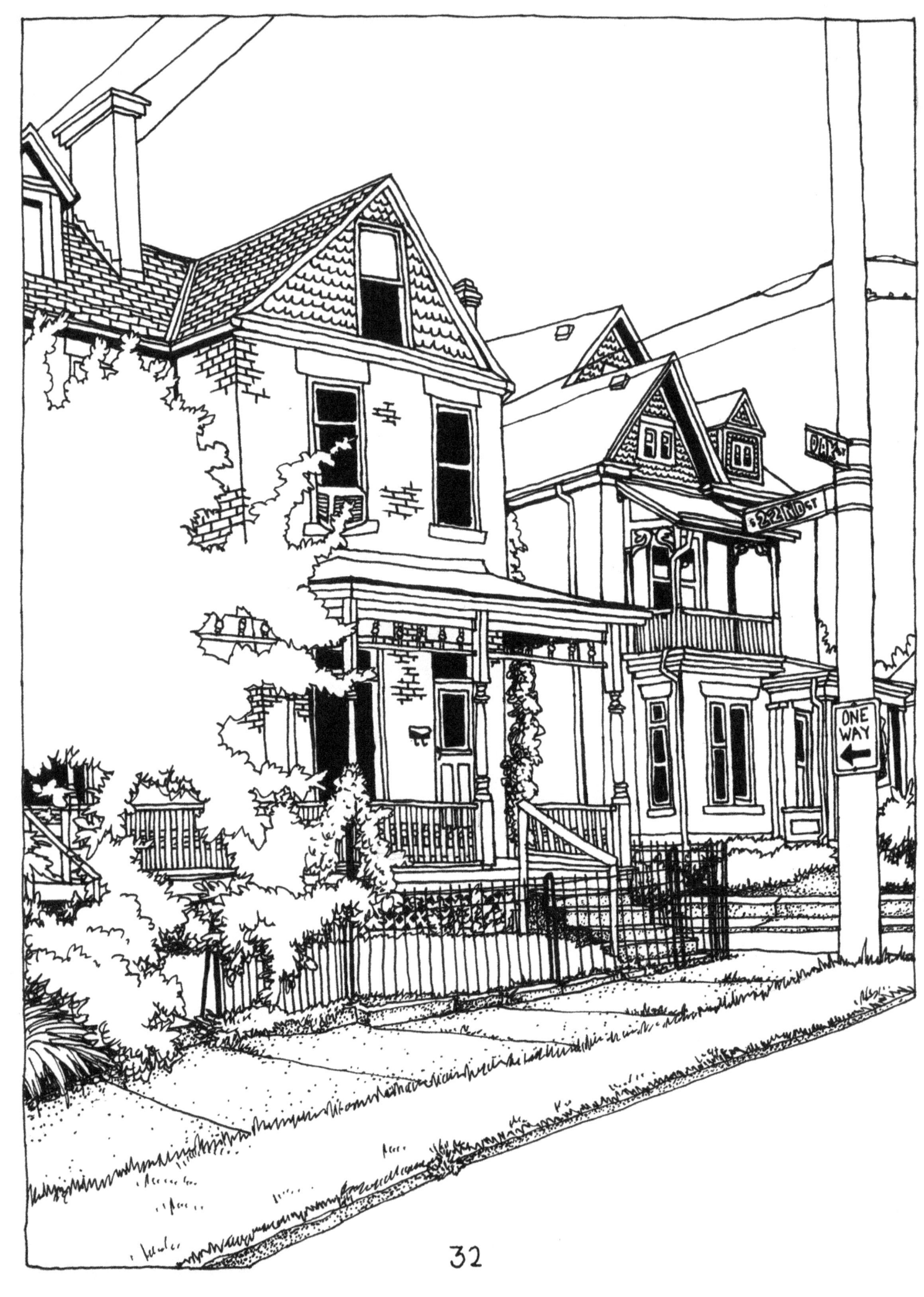

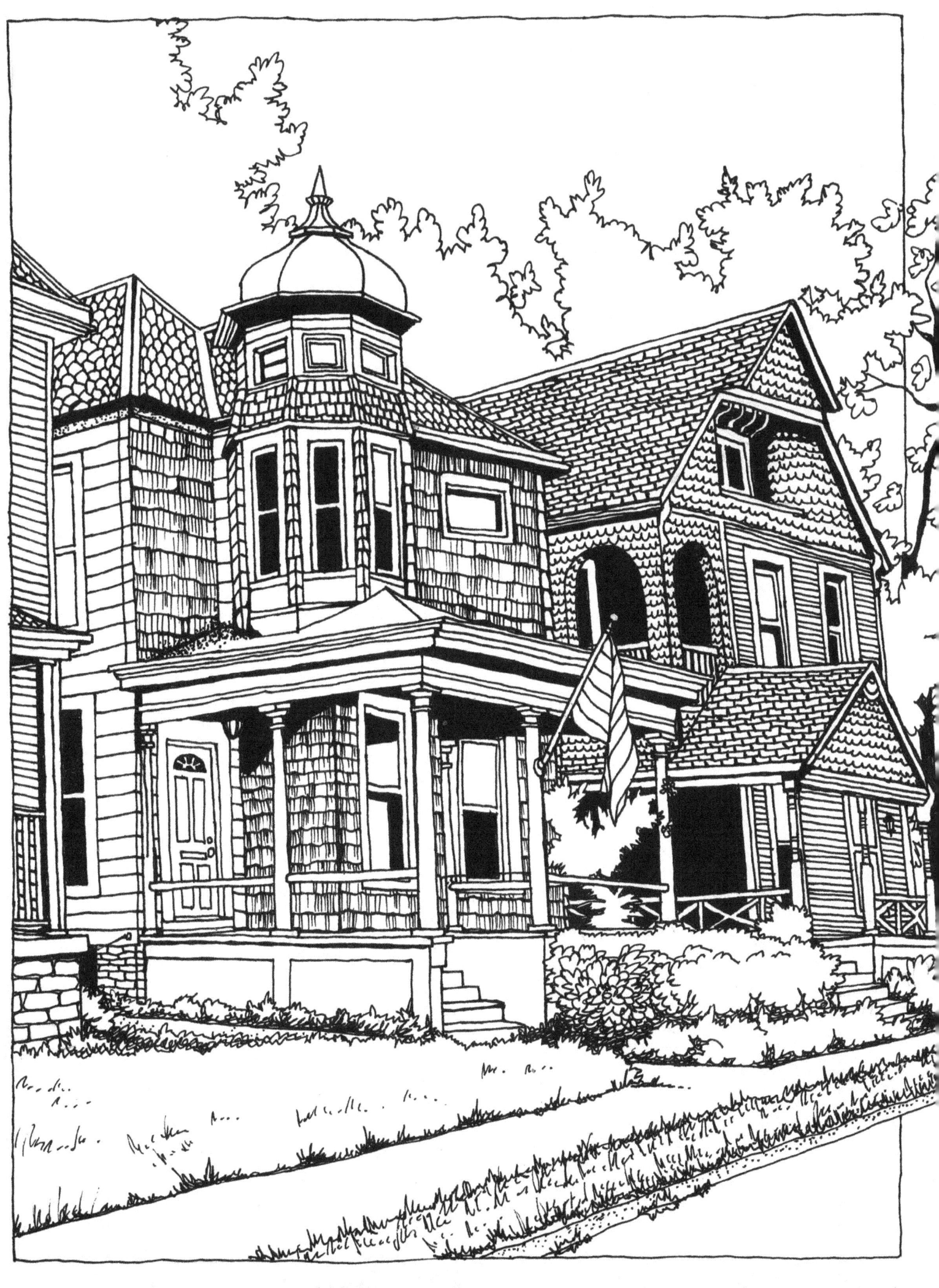

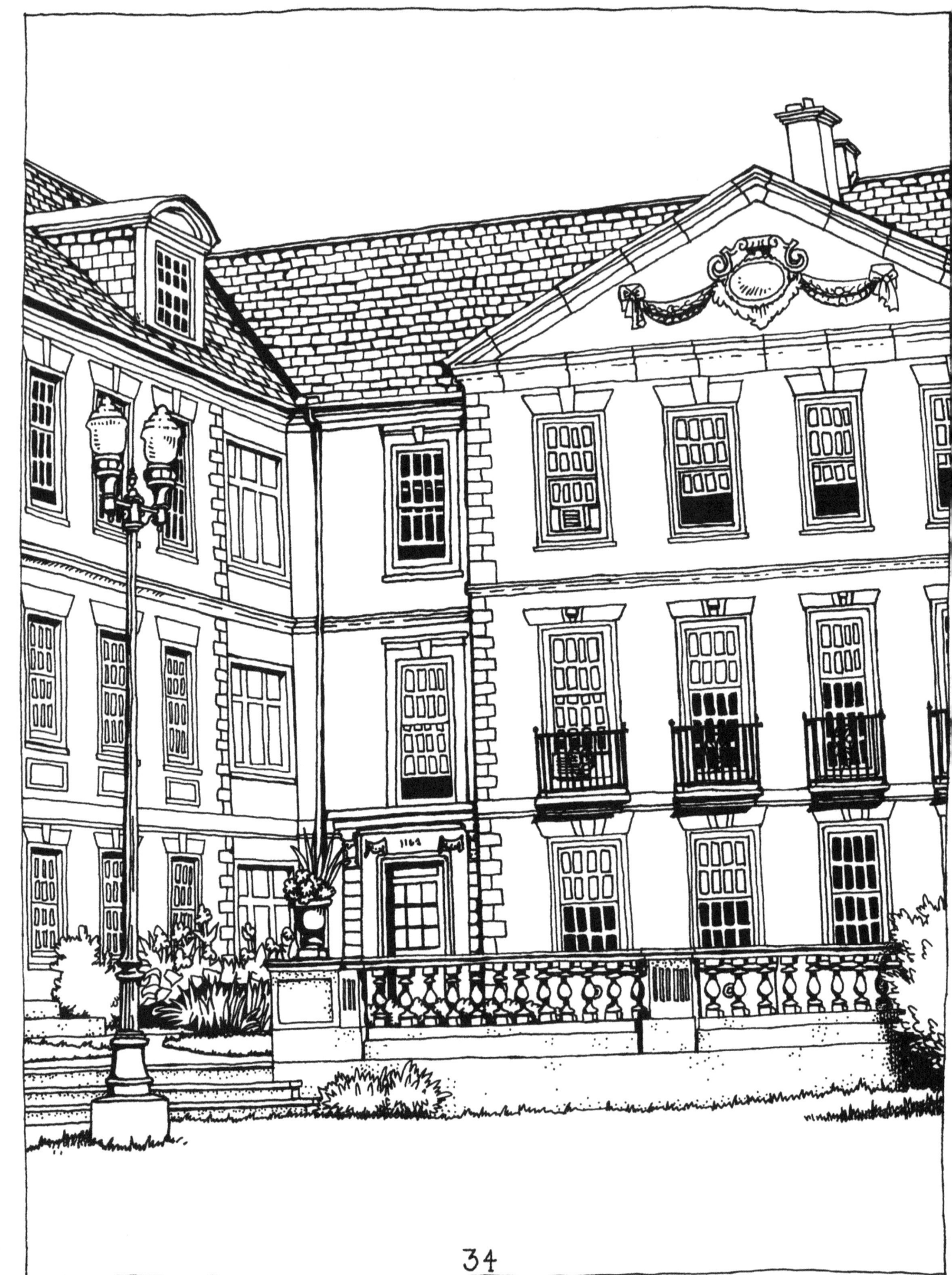

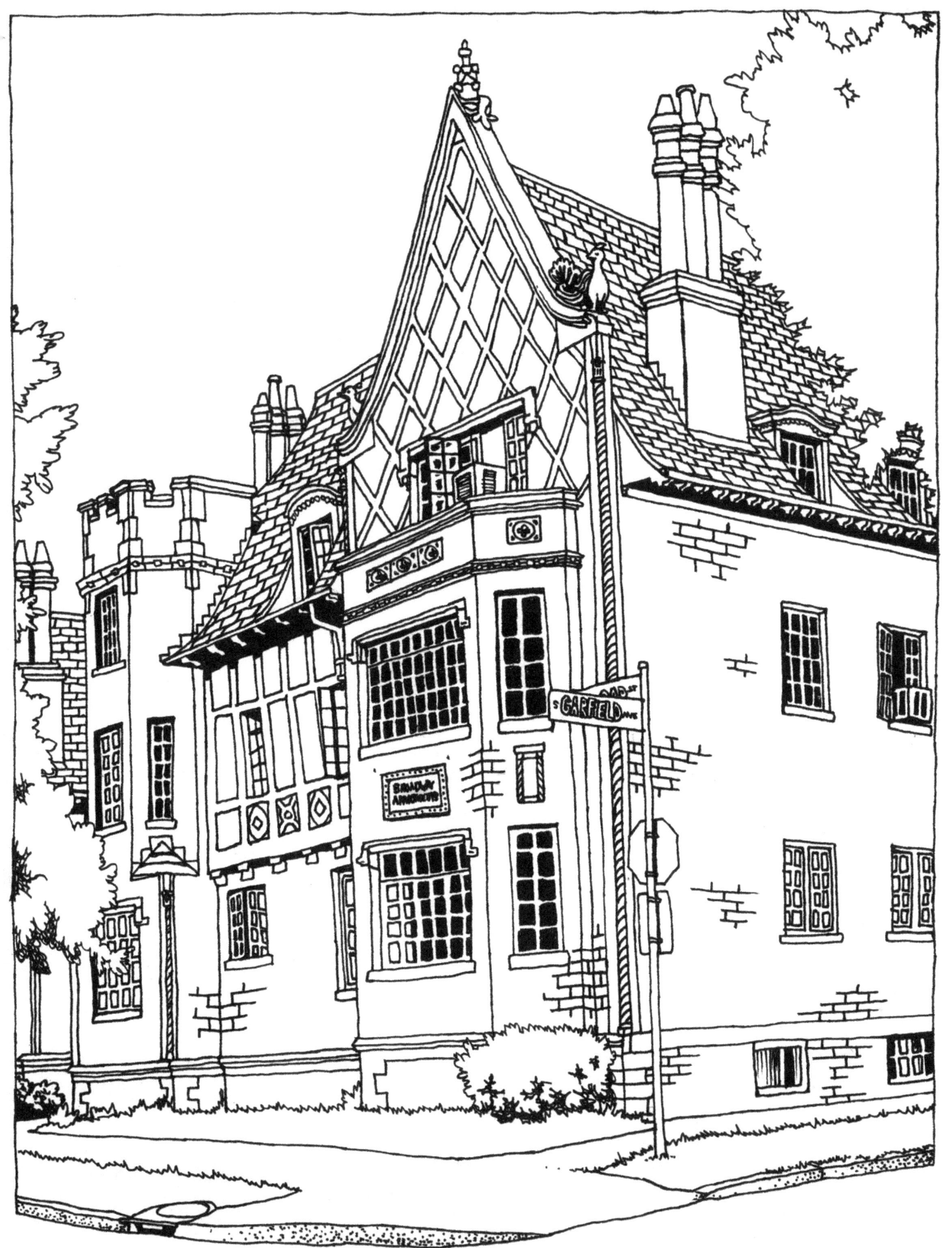

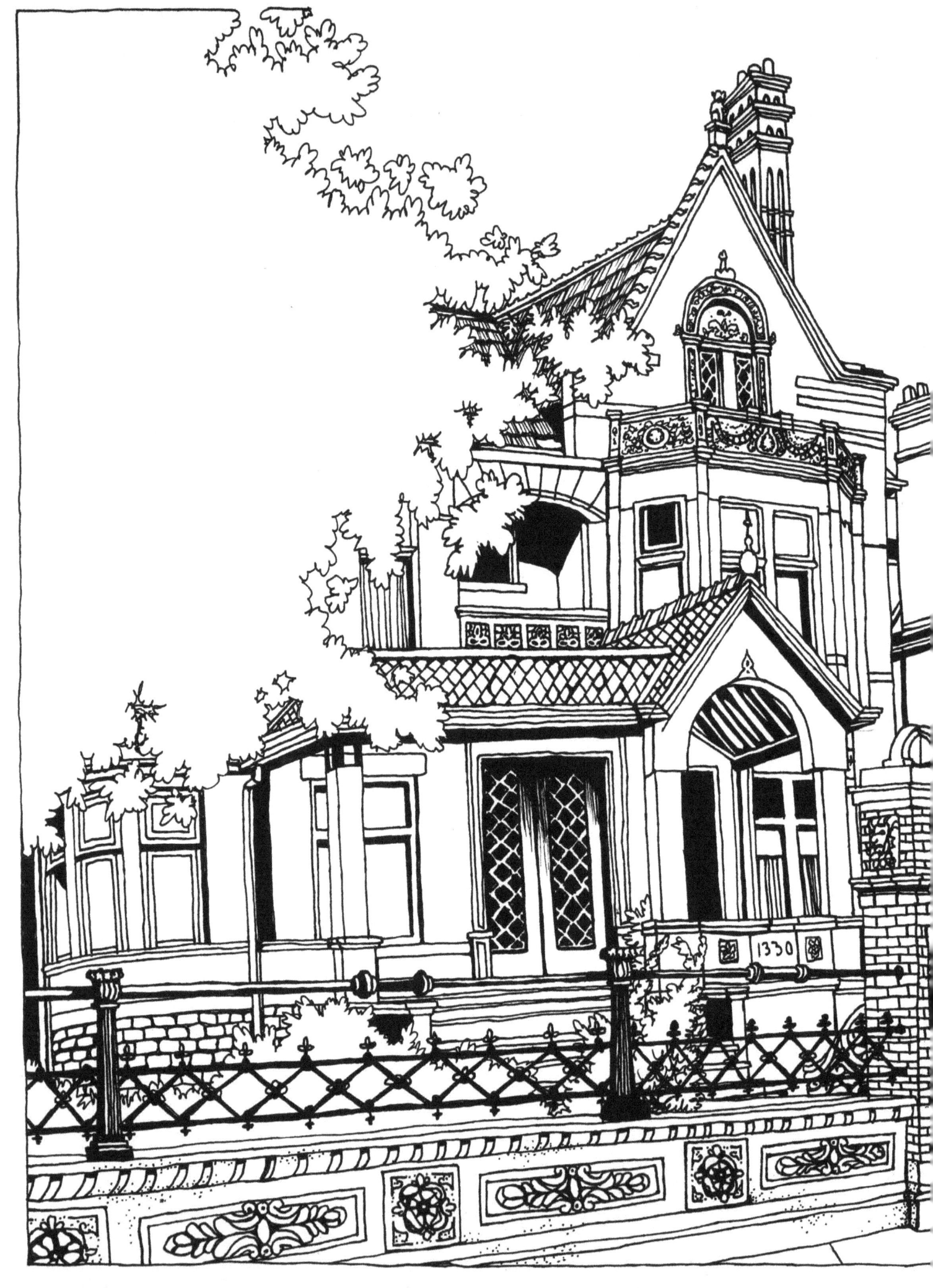

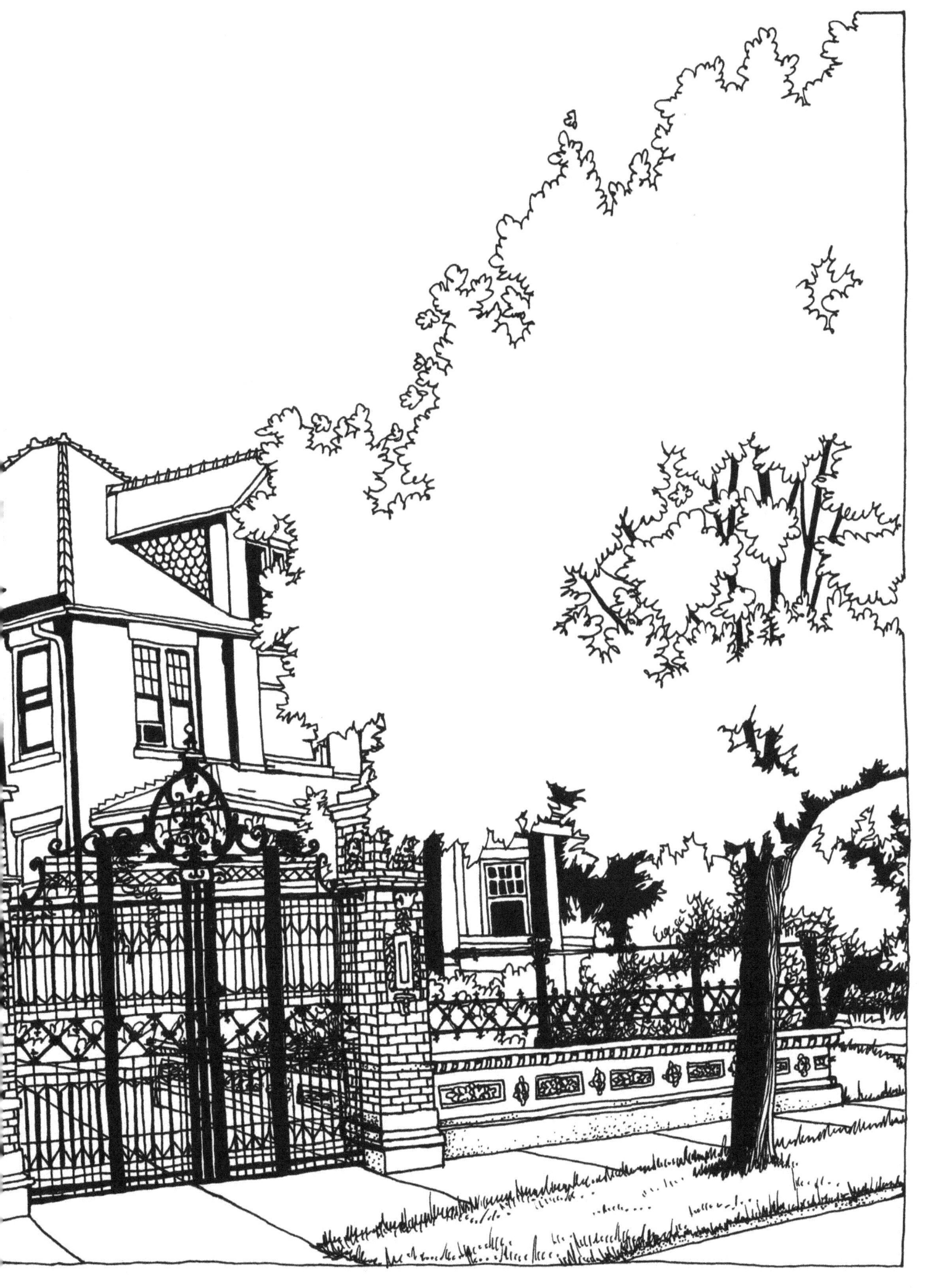

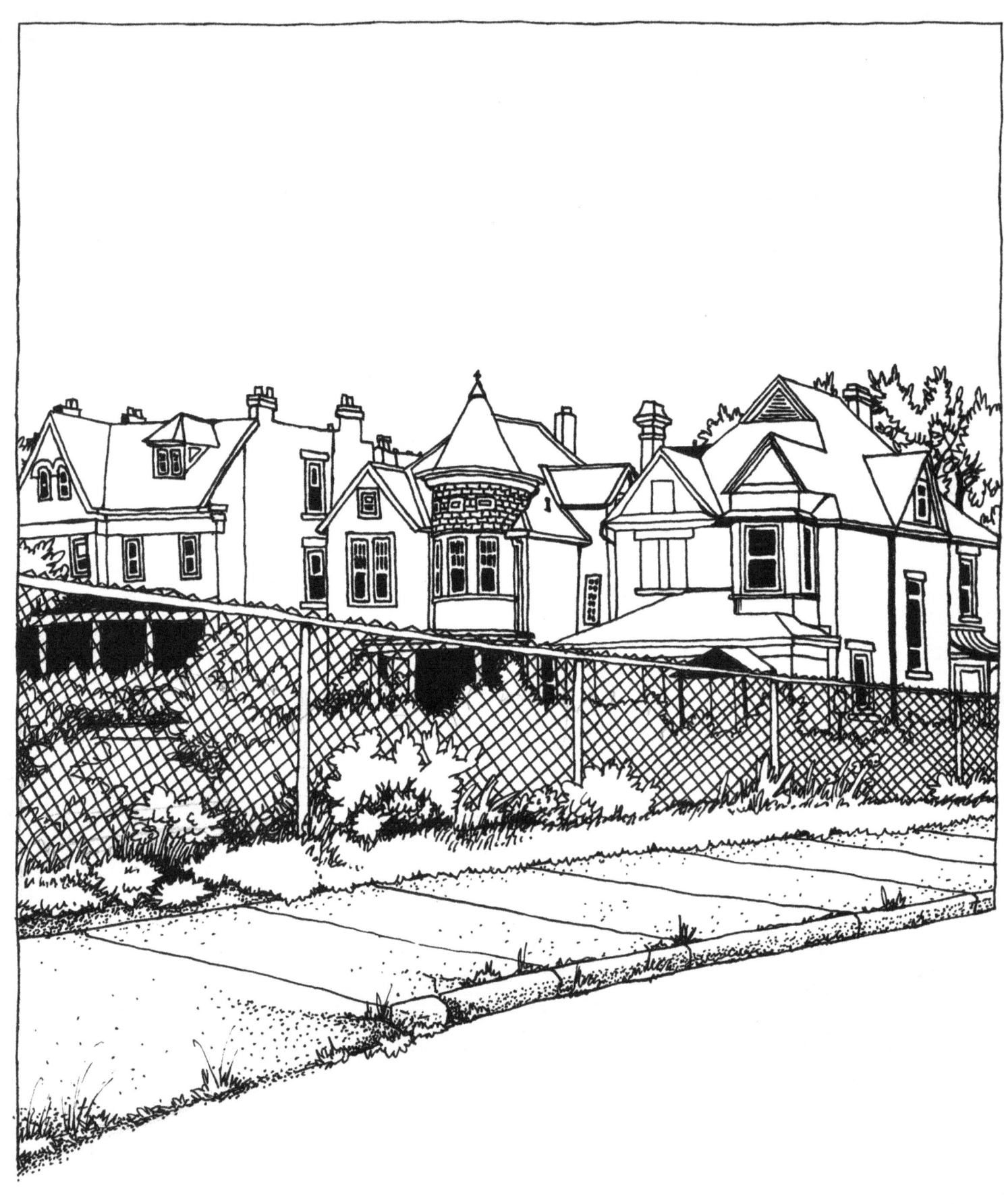

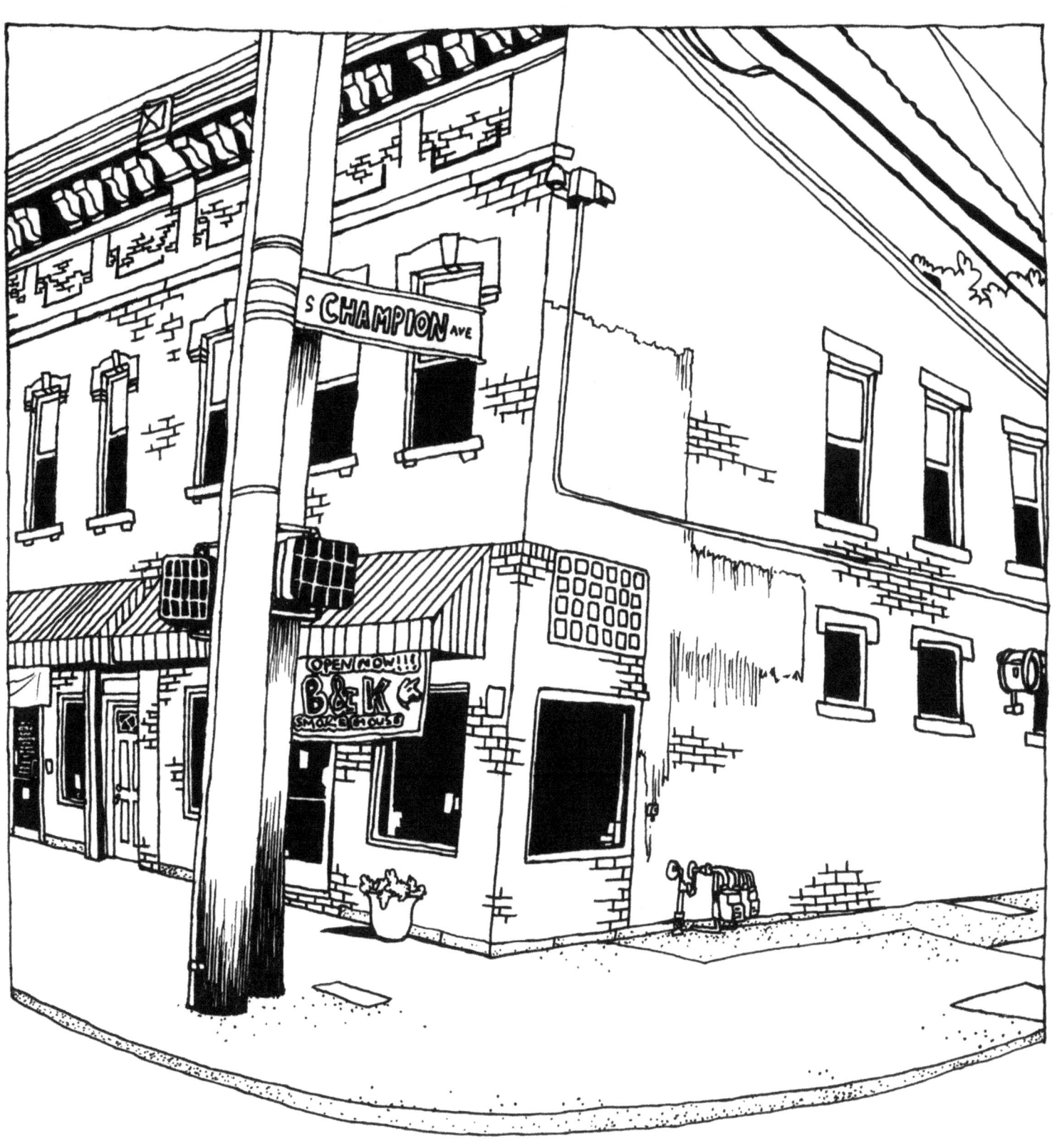

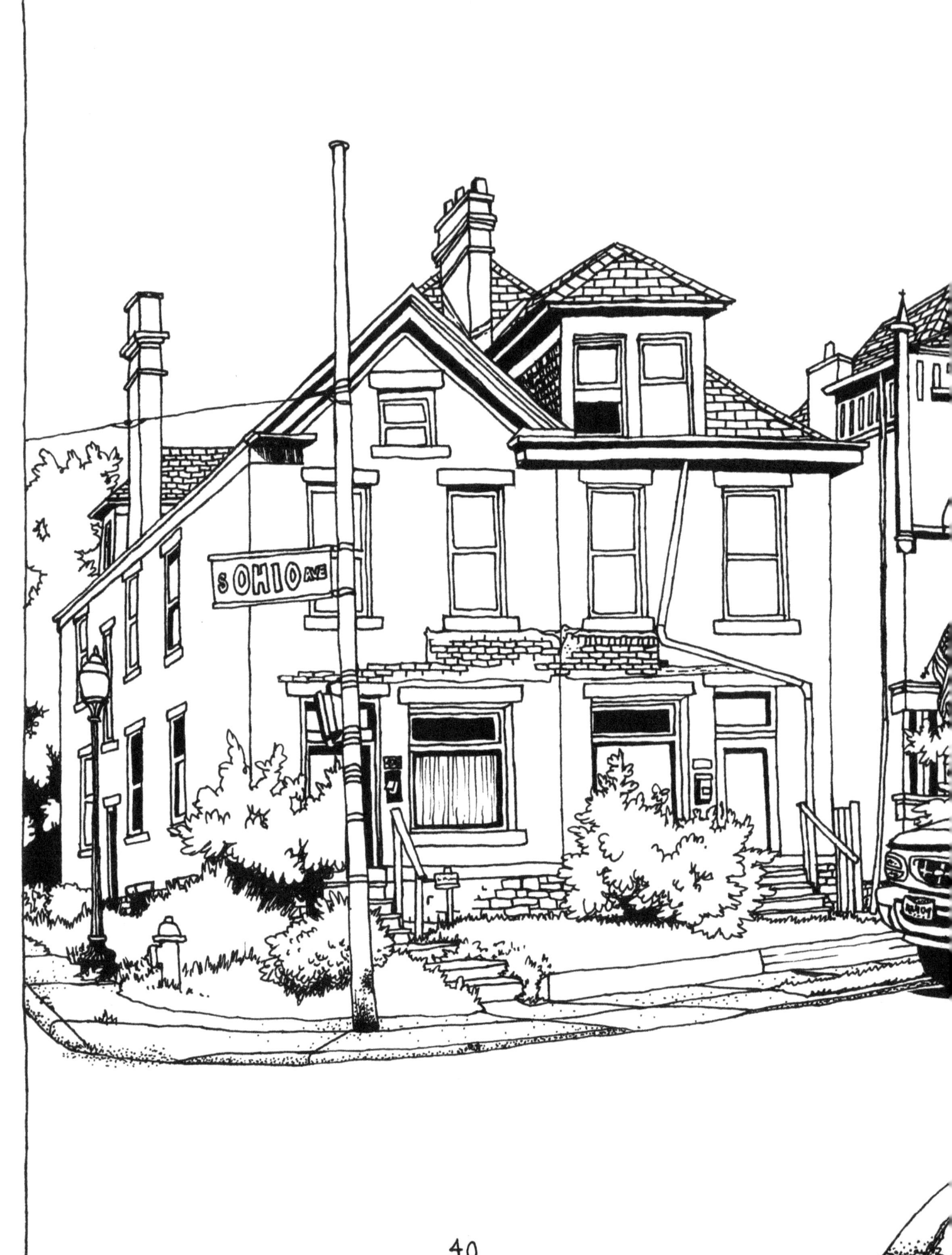

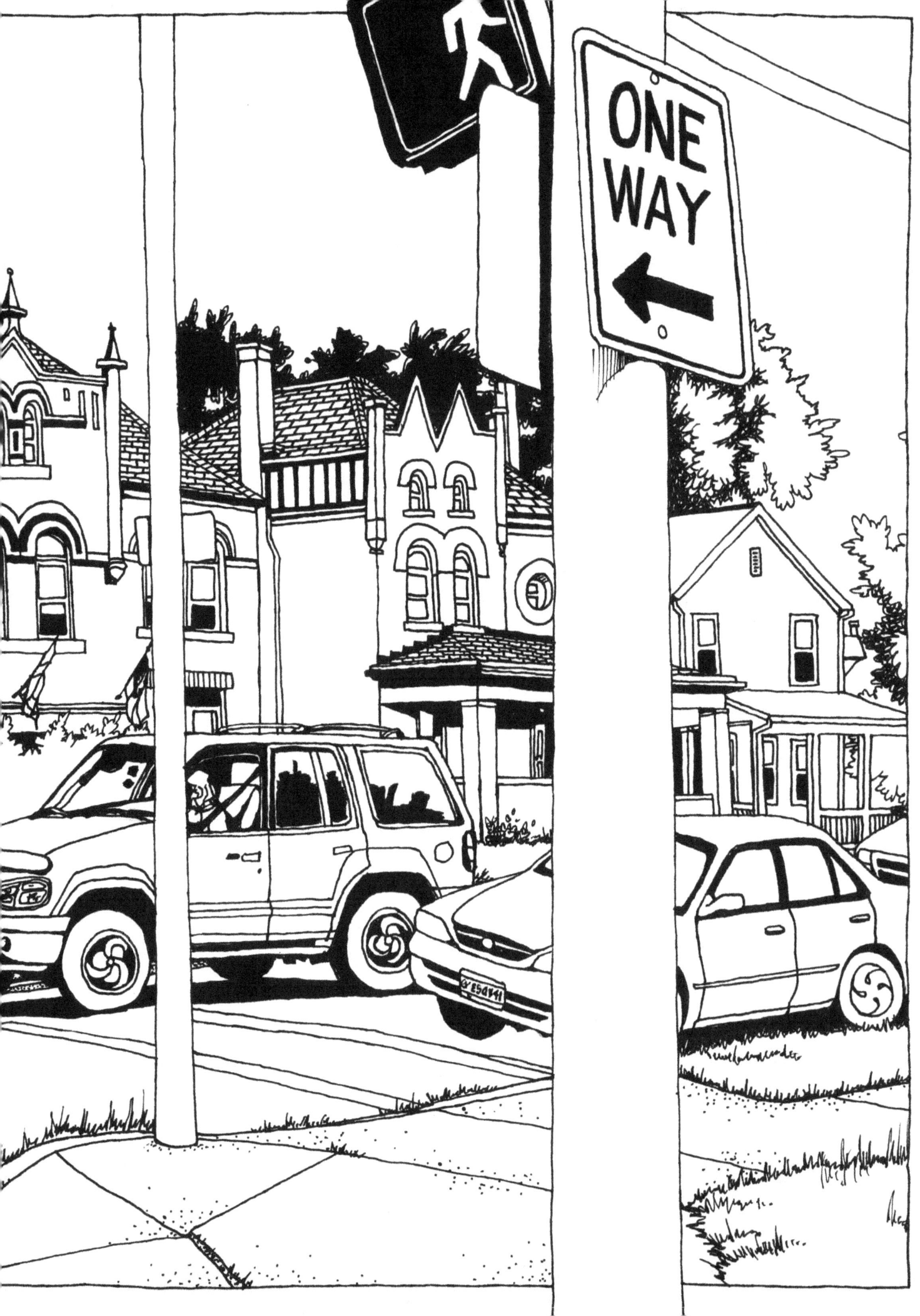

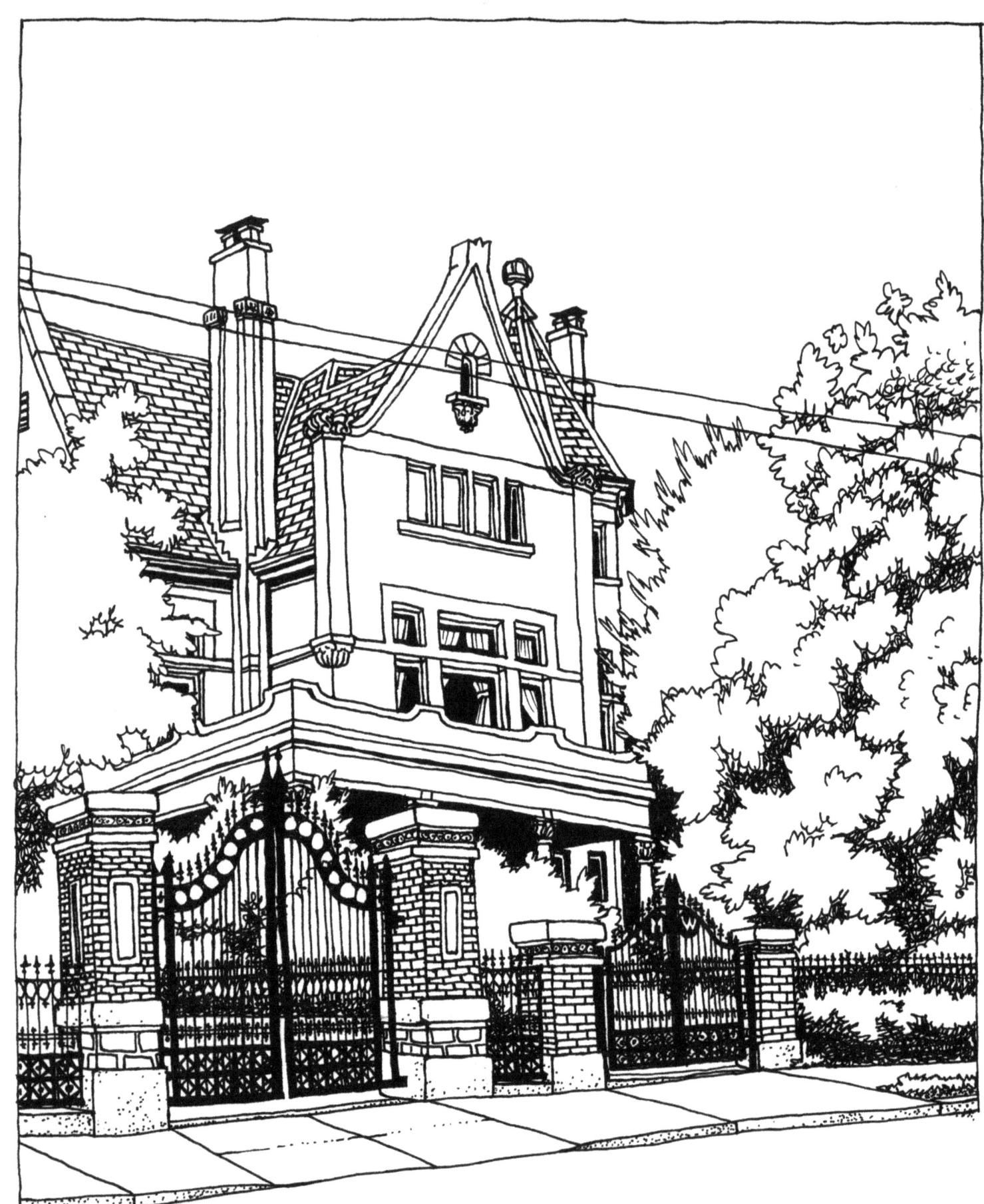

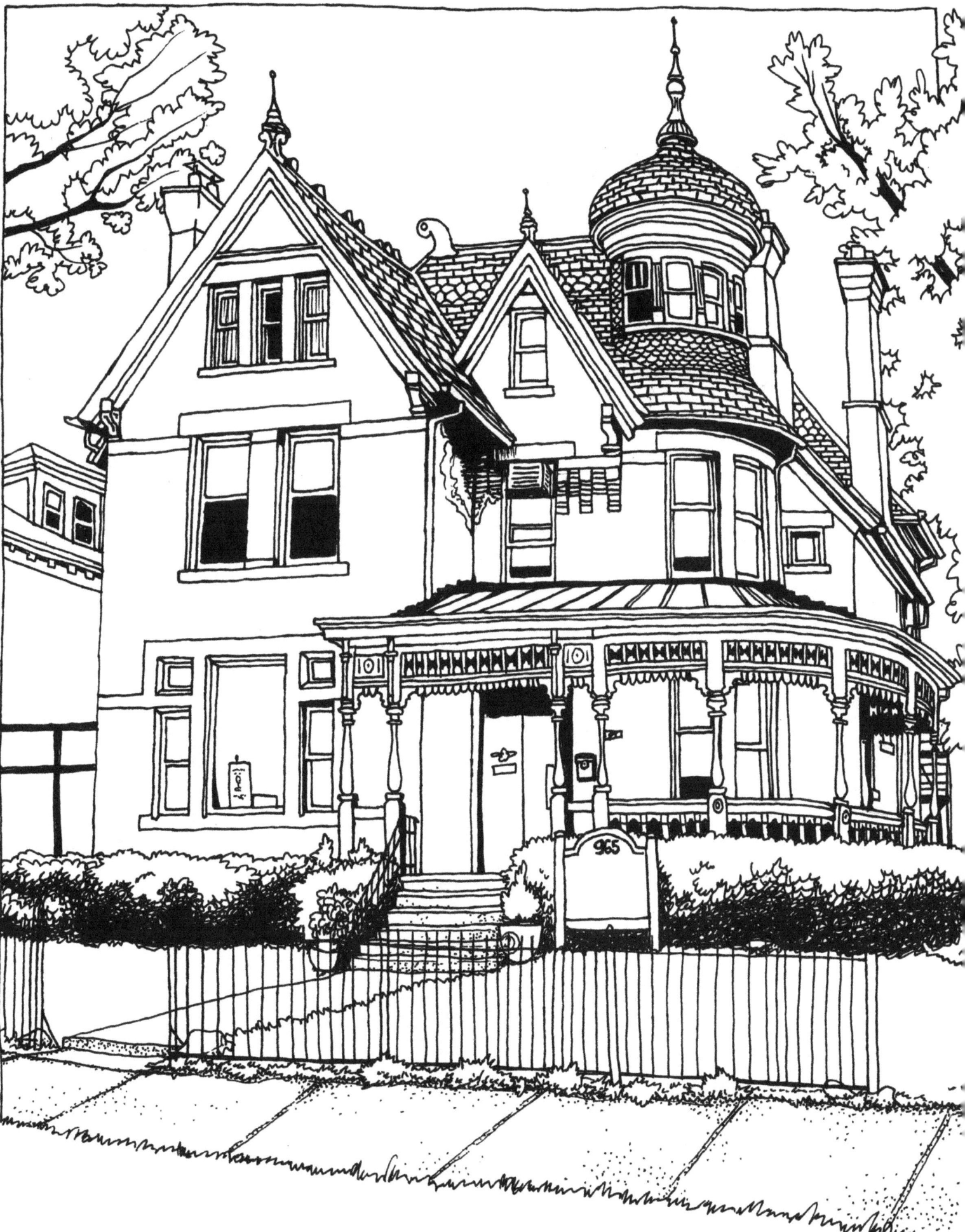

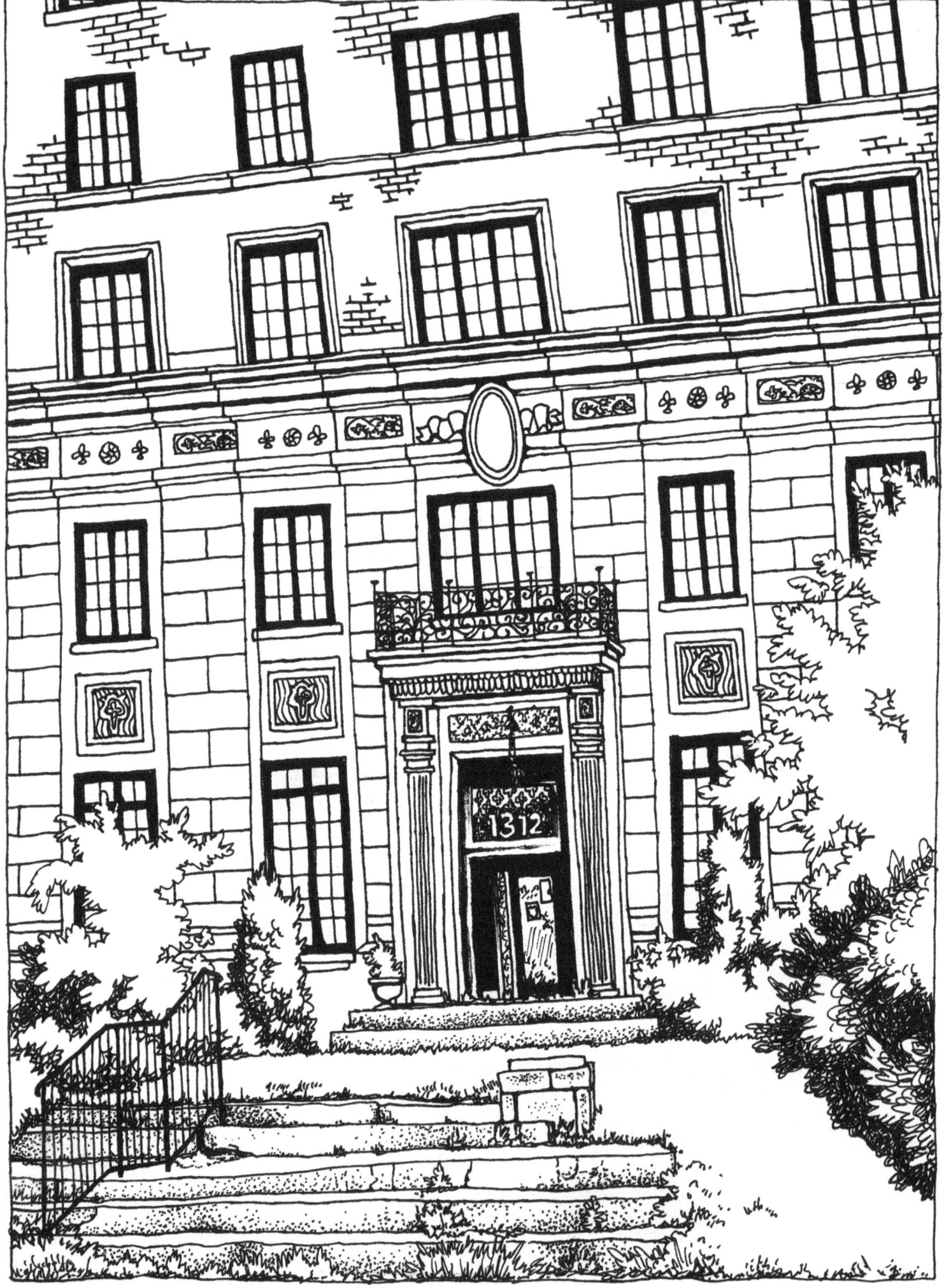

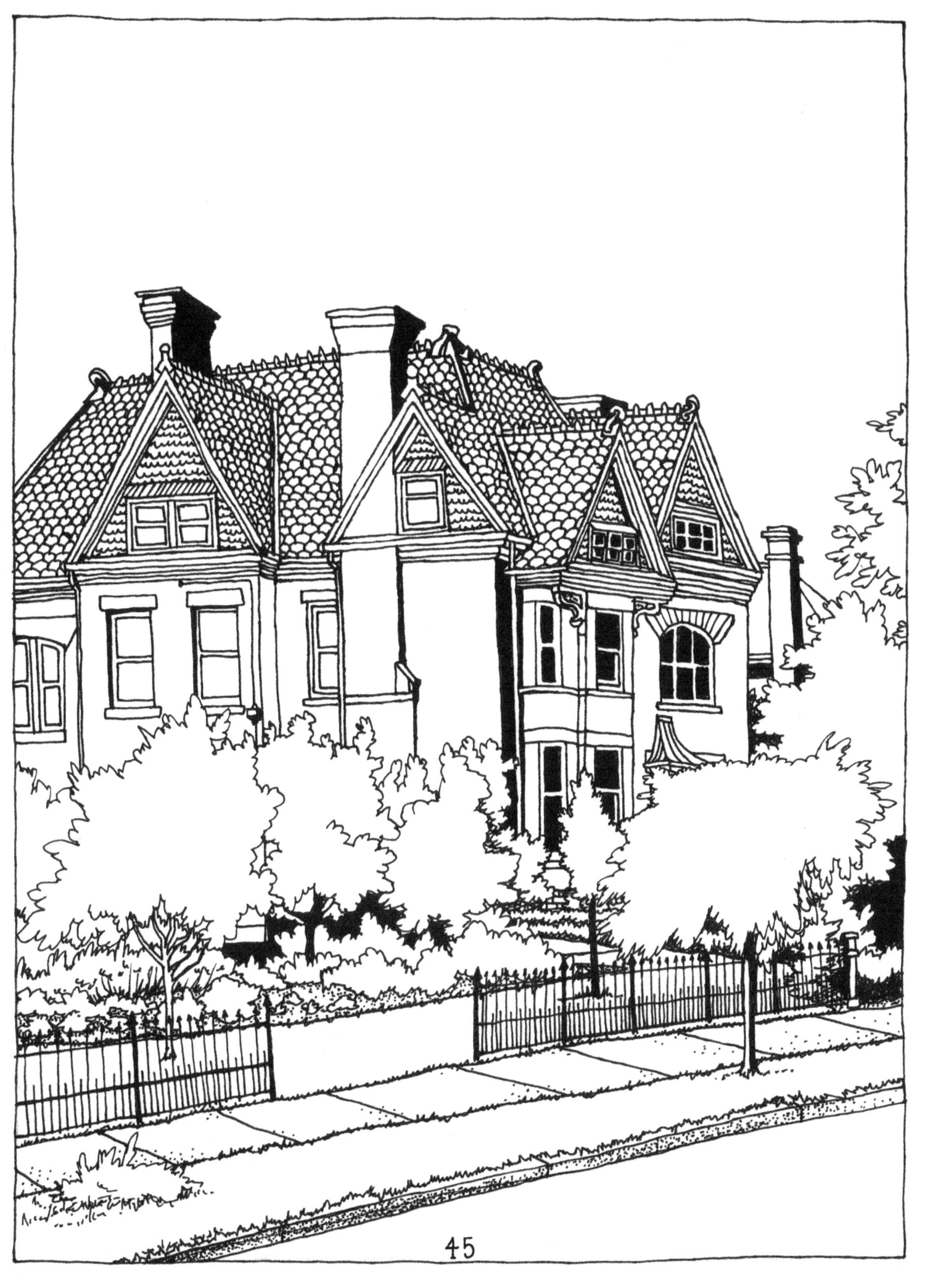

There are 10 differences between each side of this picture. Can you find them all?

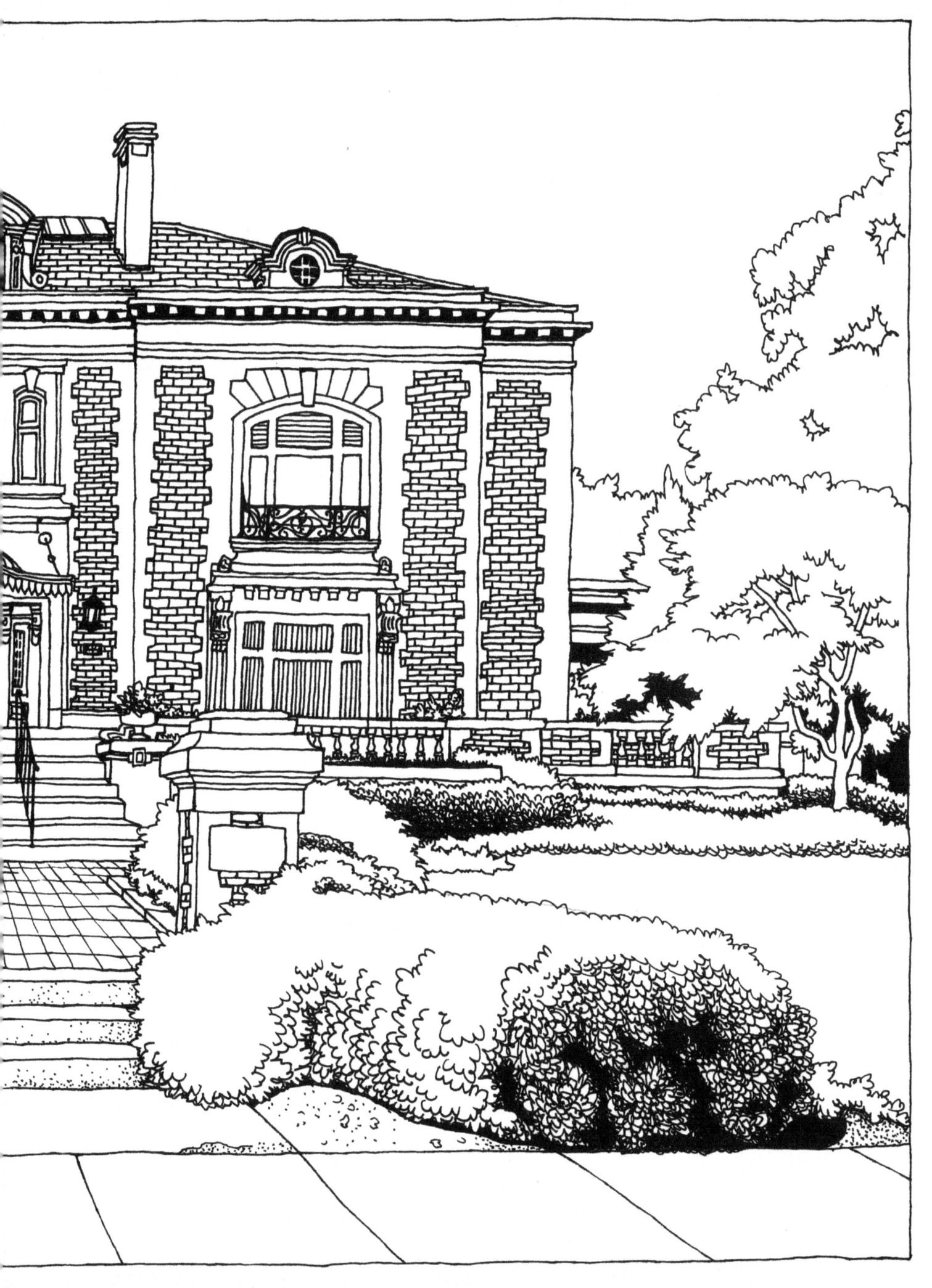

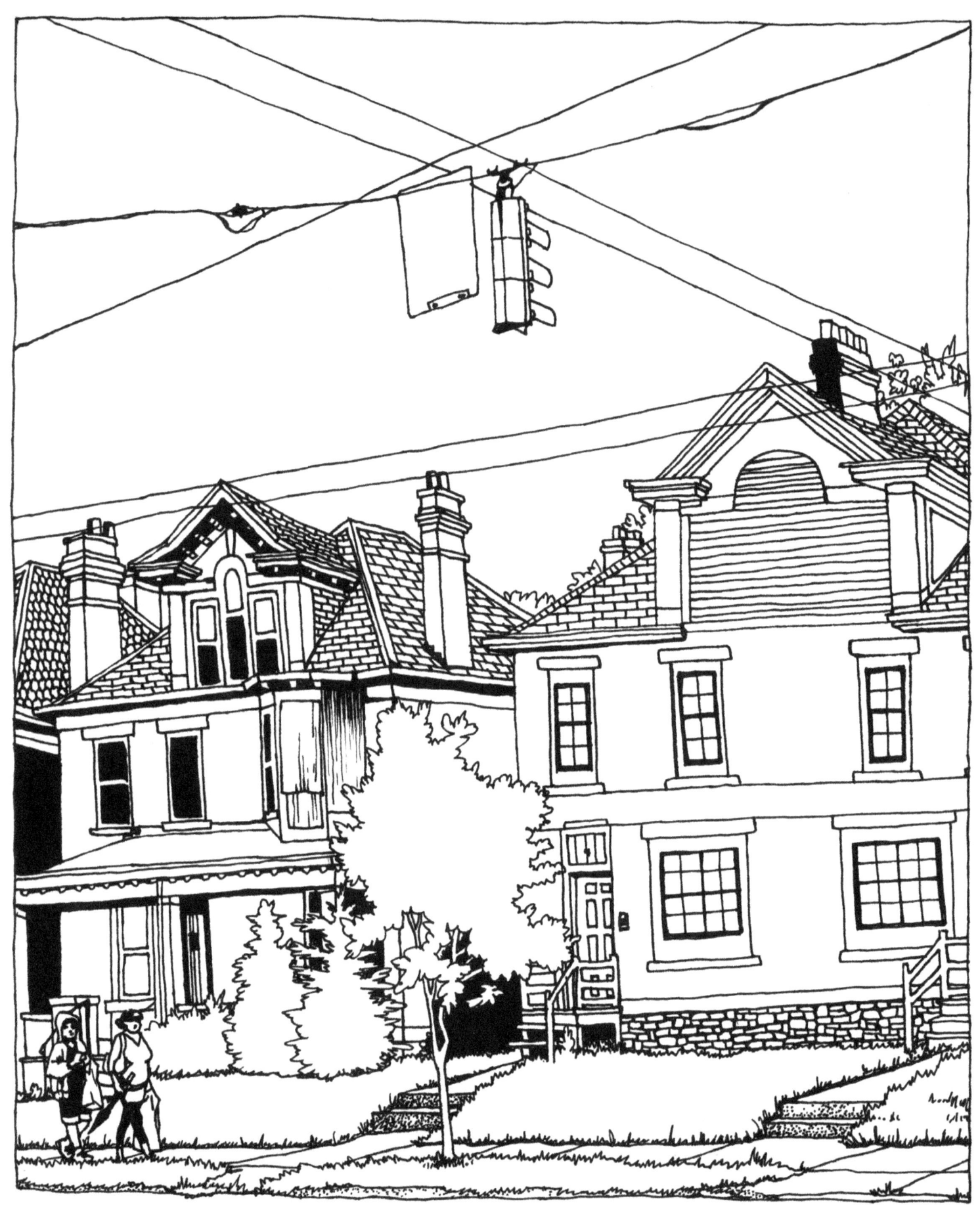

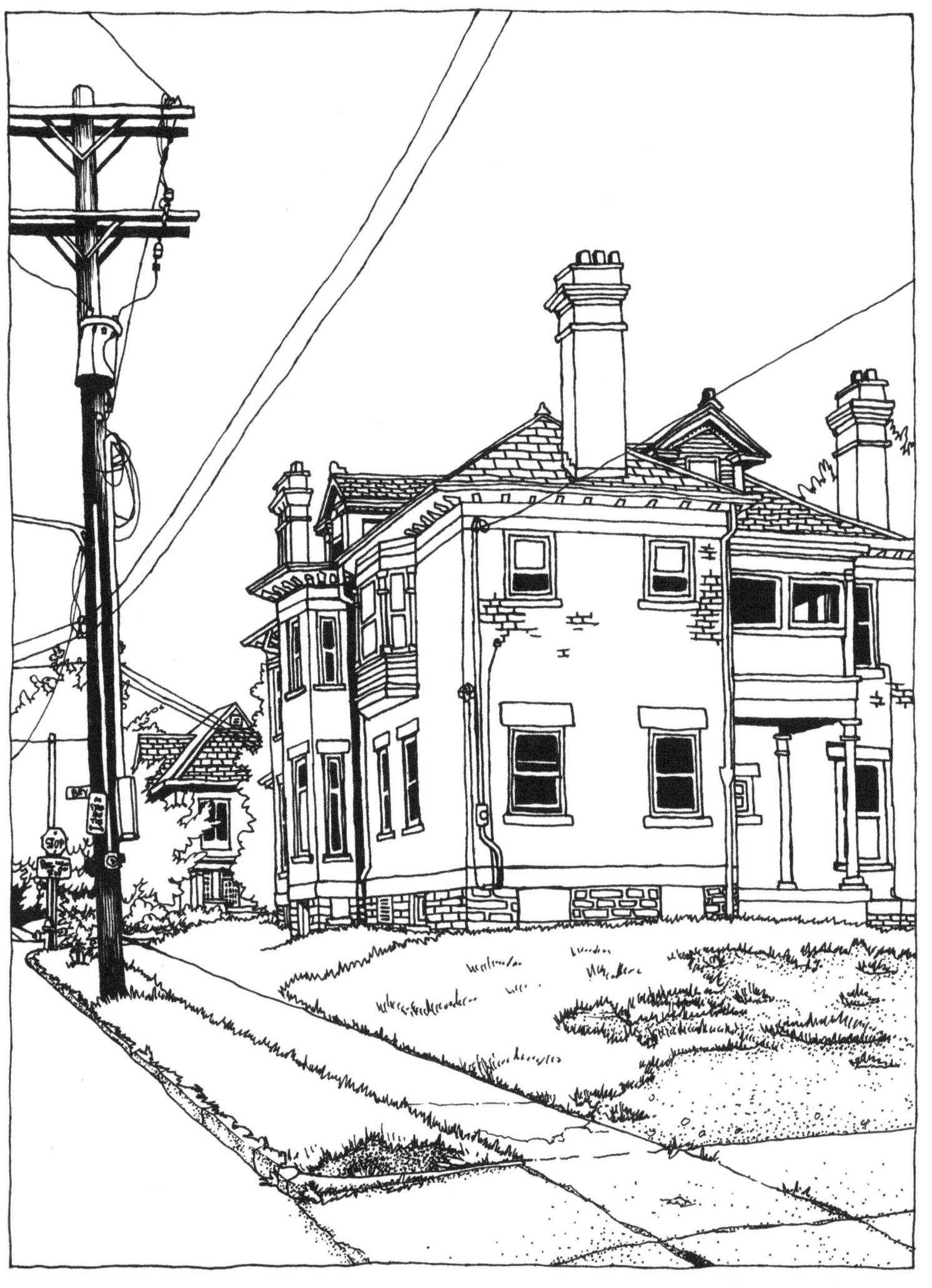

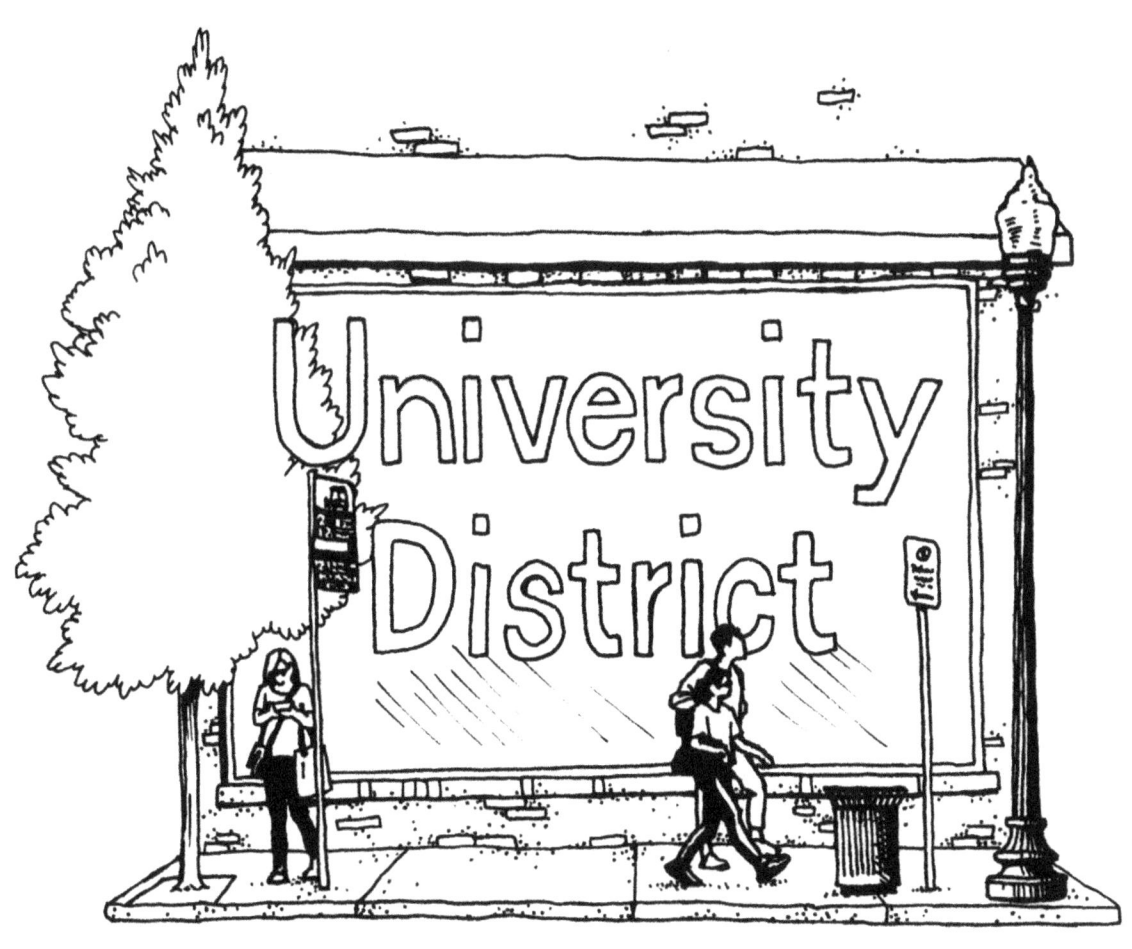

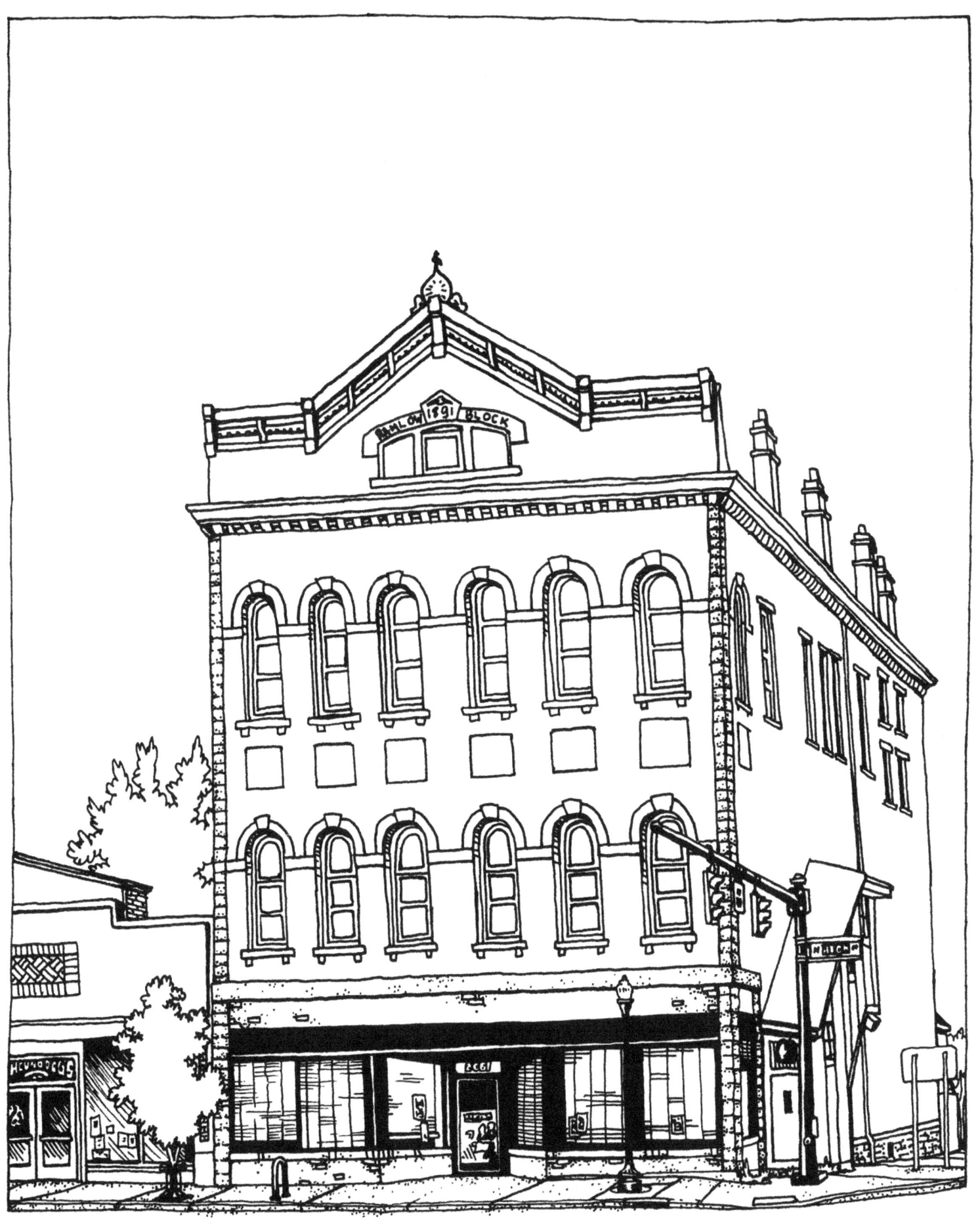

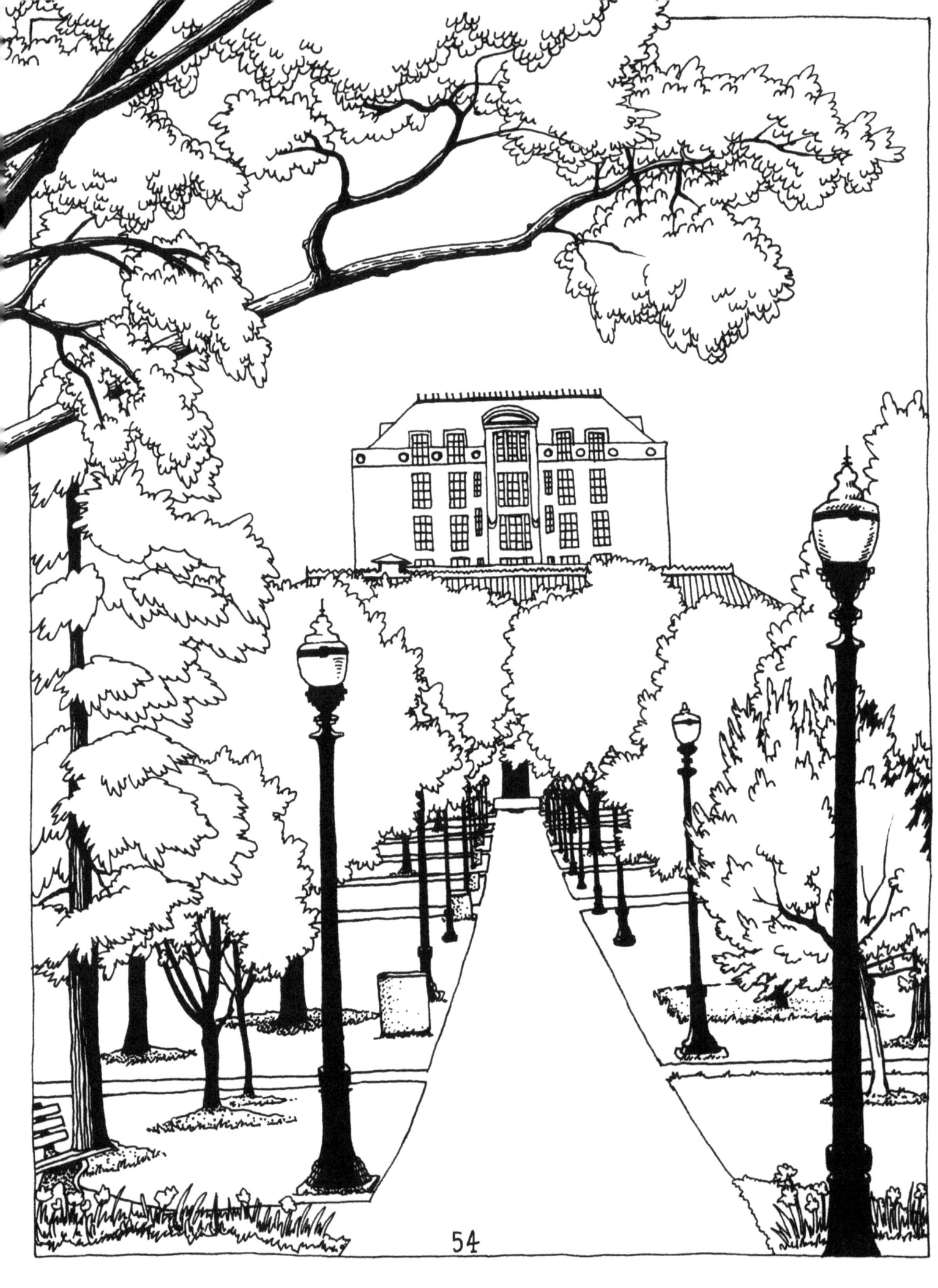

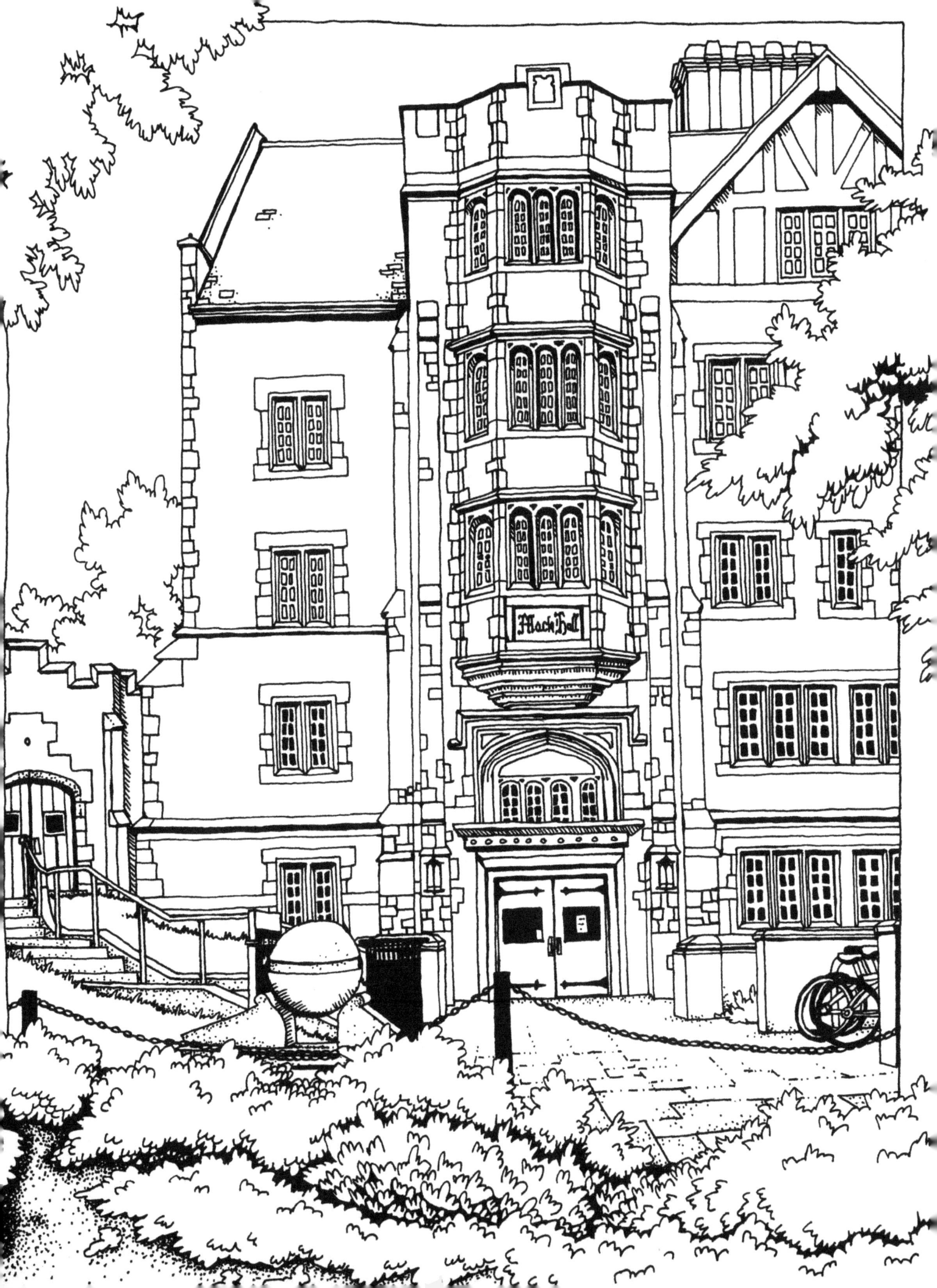

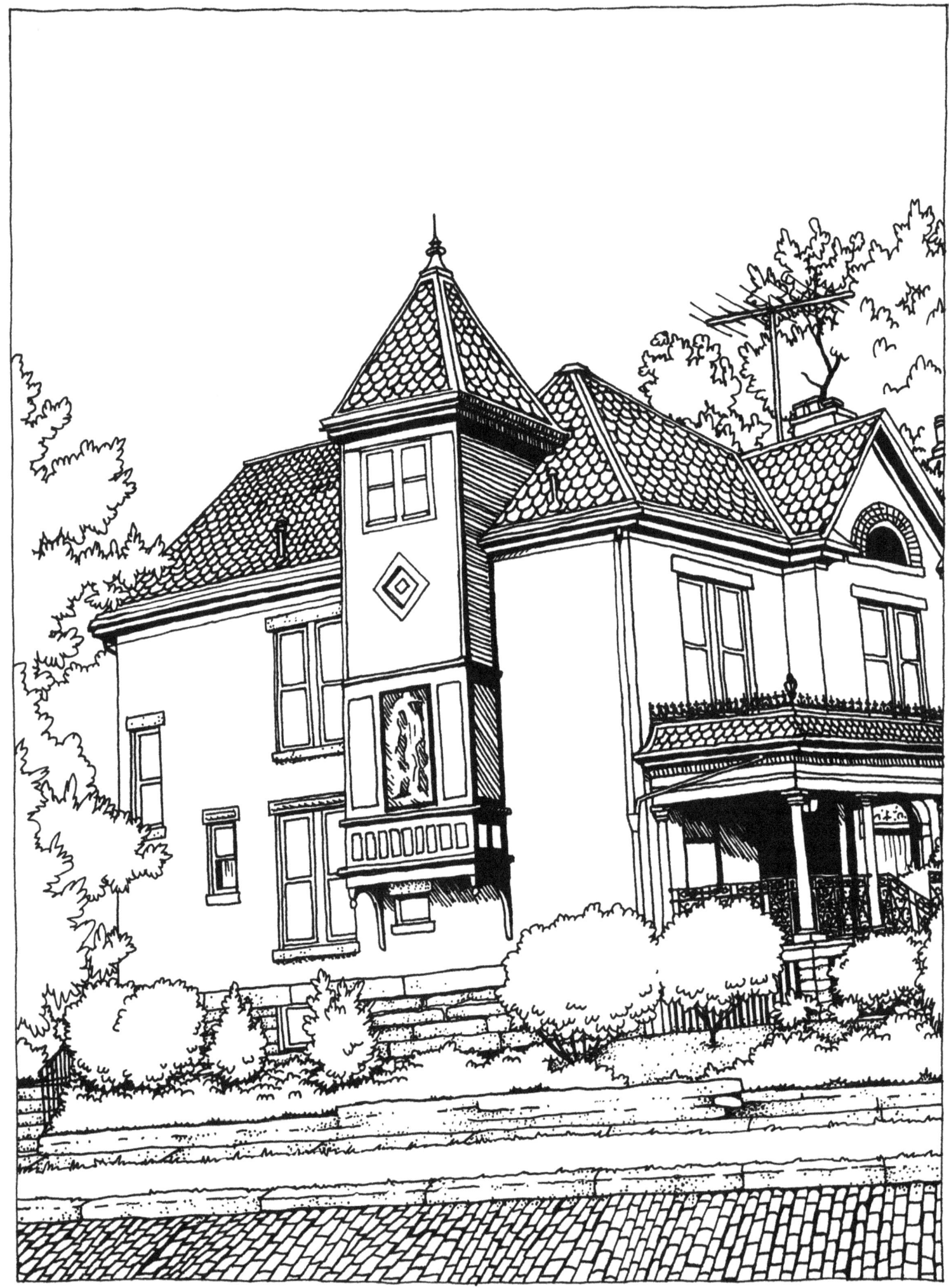

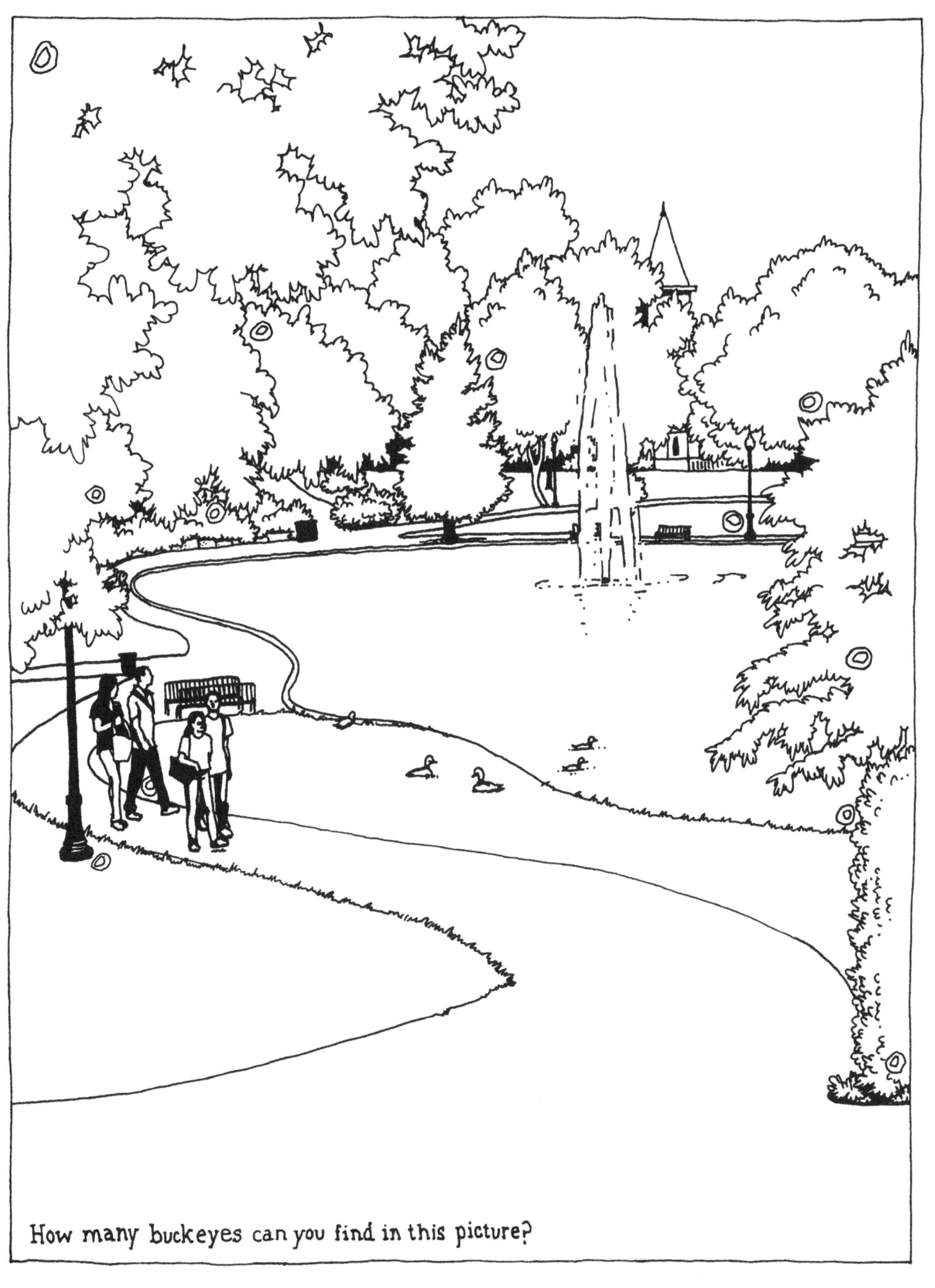

How many buckeyes can you find in this picture?

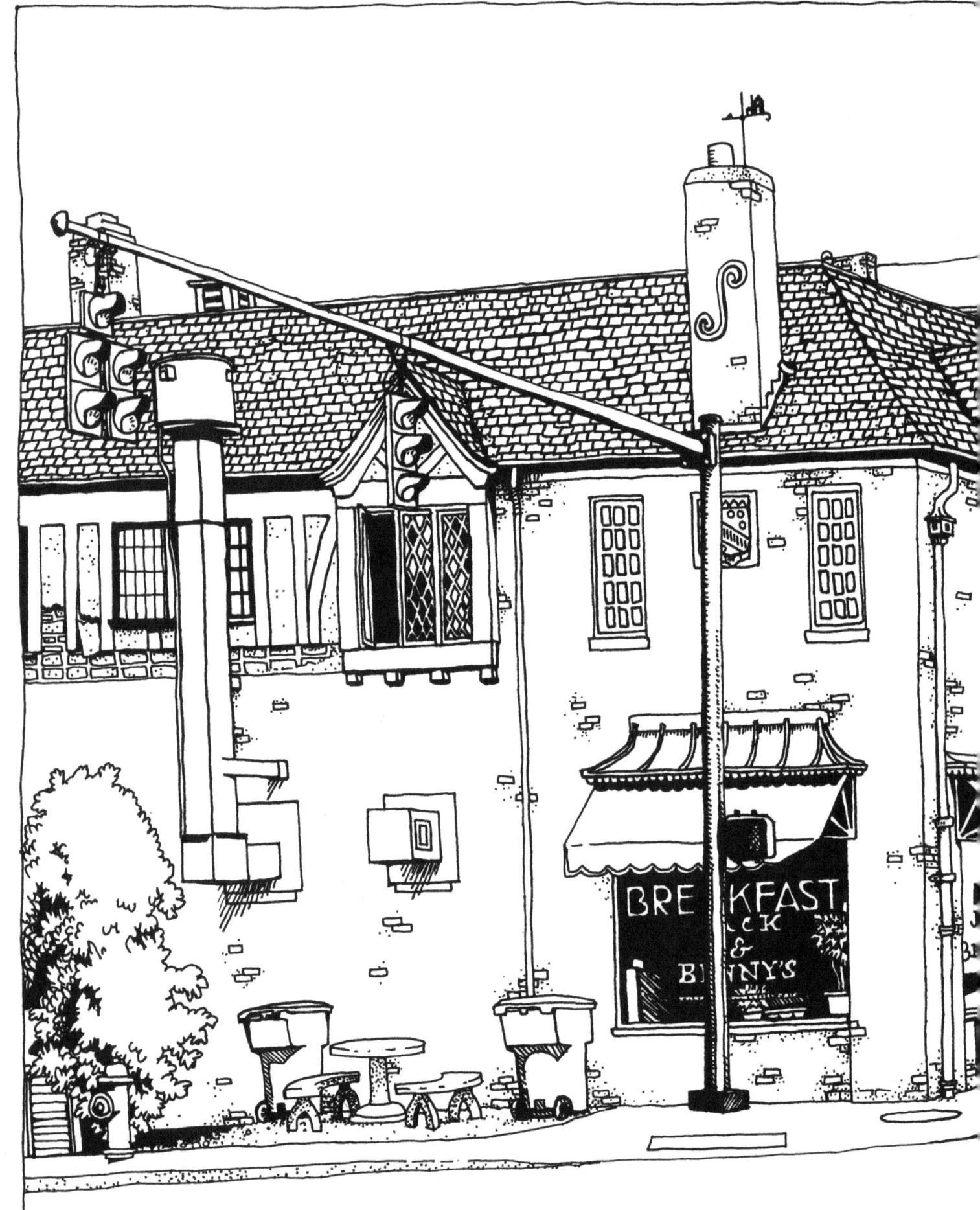

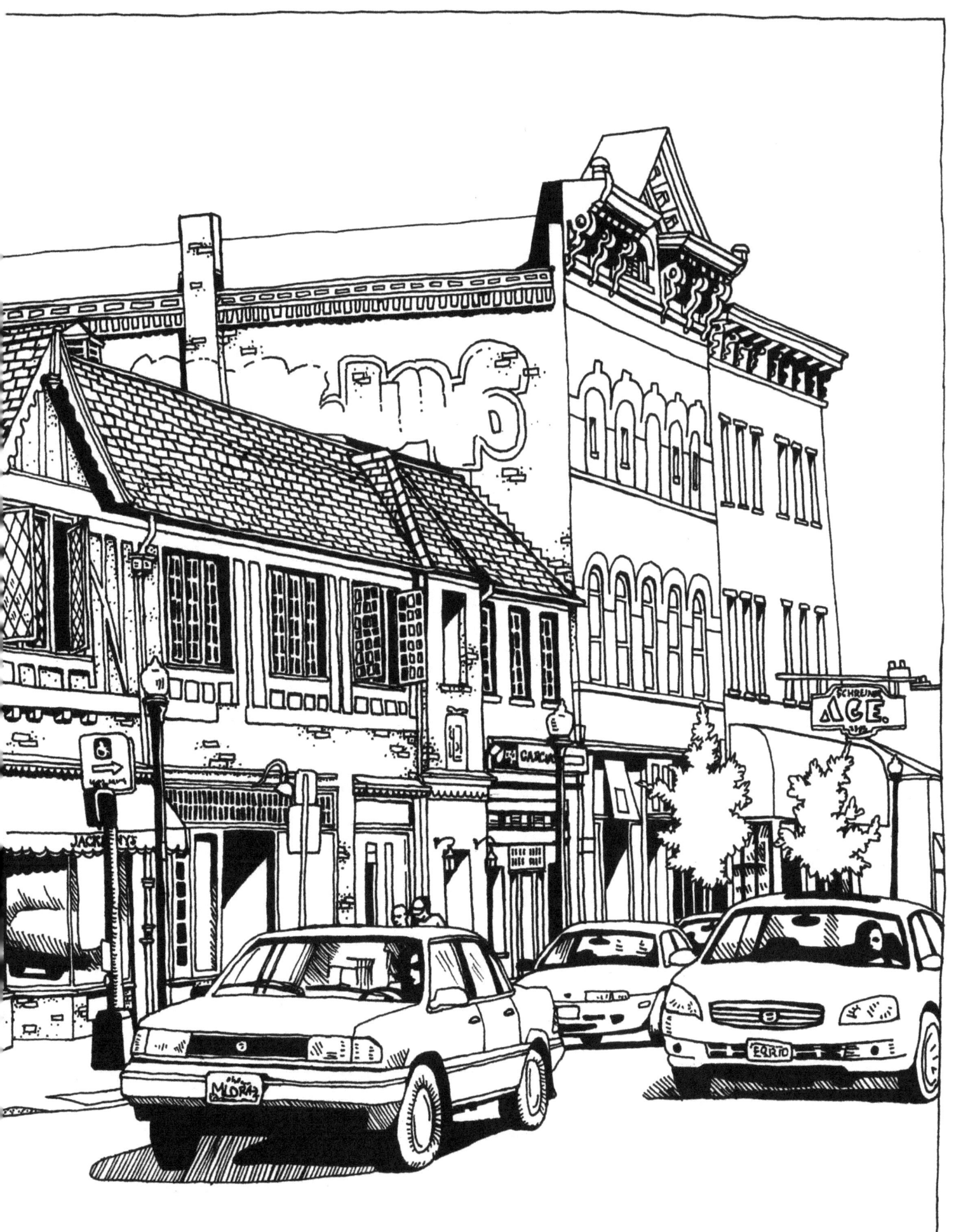

Columbus has a lot of cool murals! If you could paint your own, what would it look like? Use the blank walls to draw your own mural.

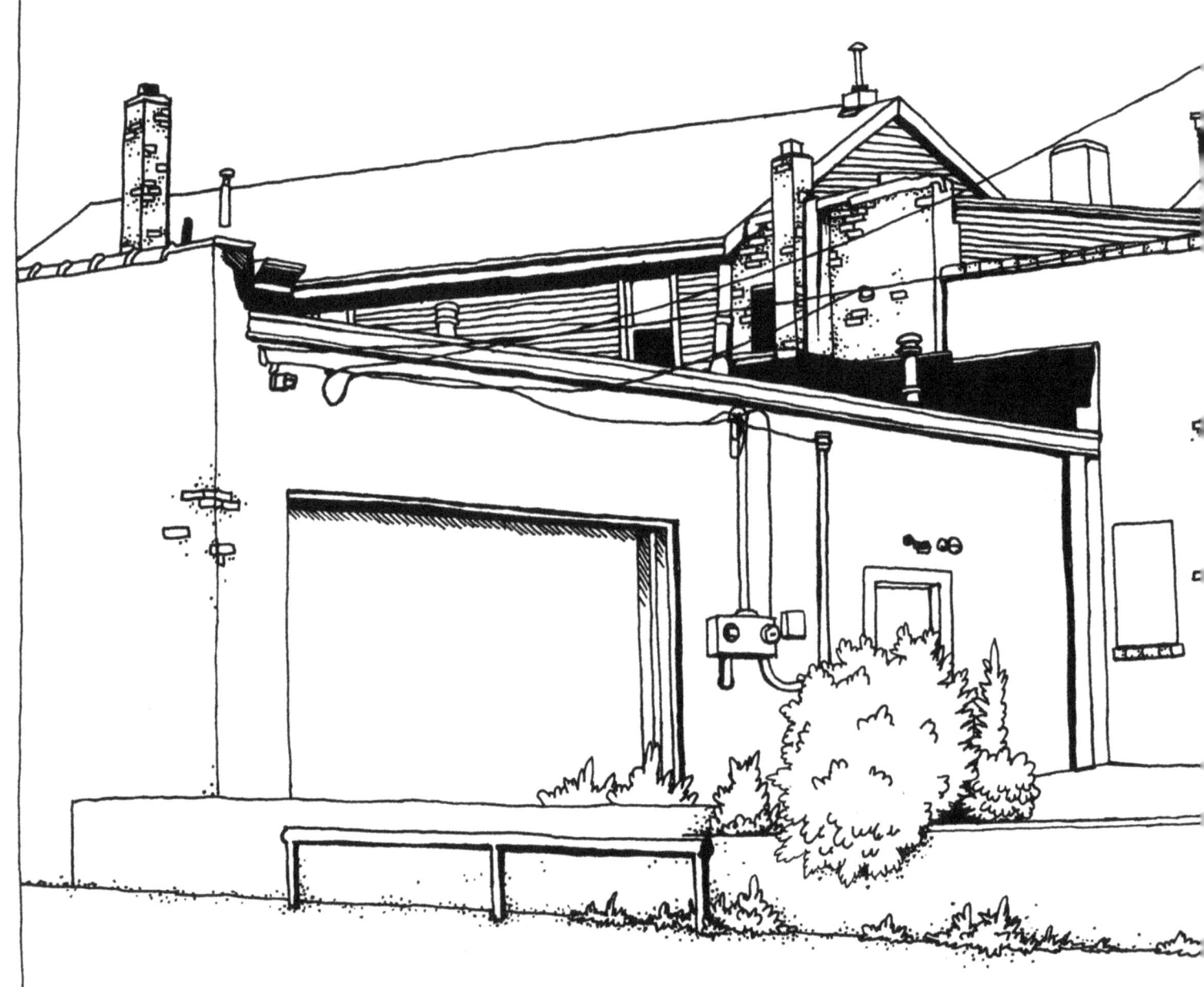

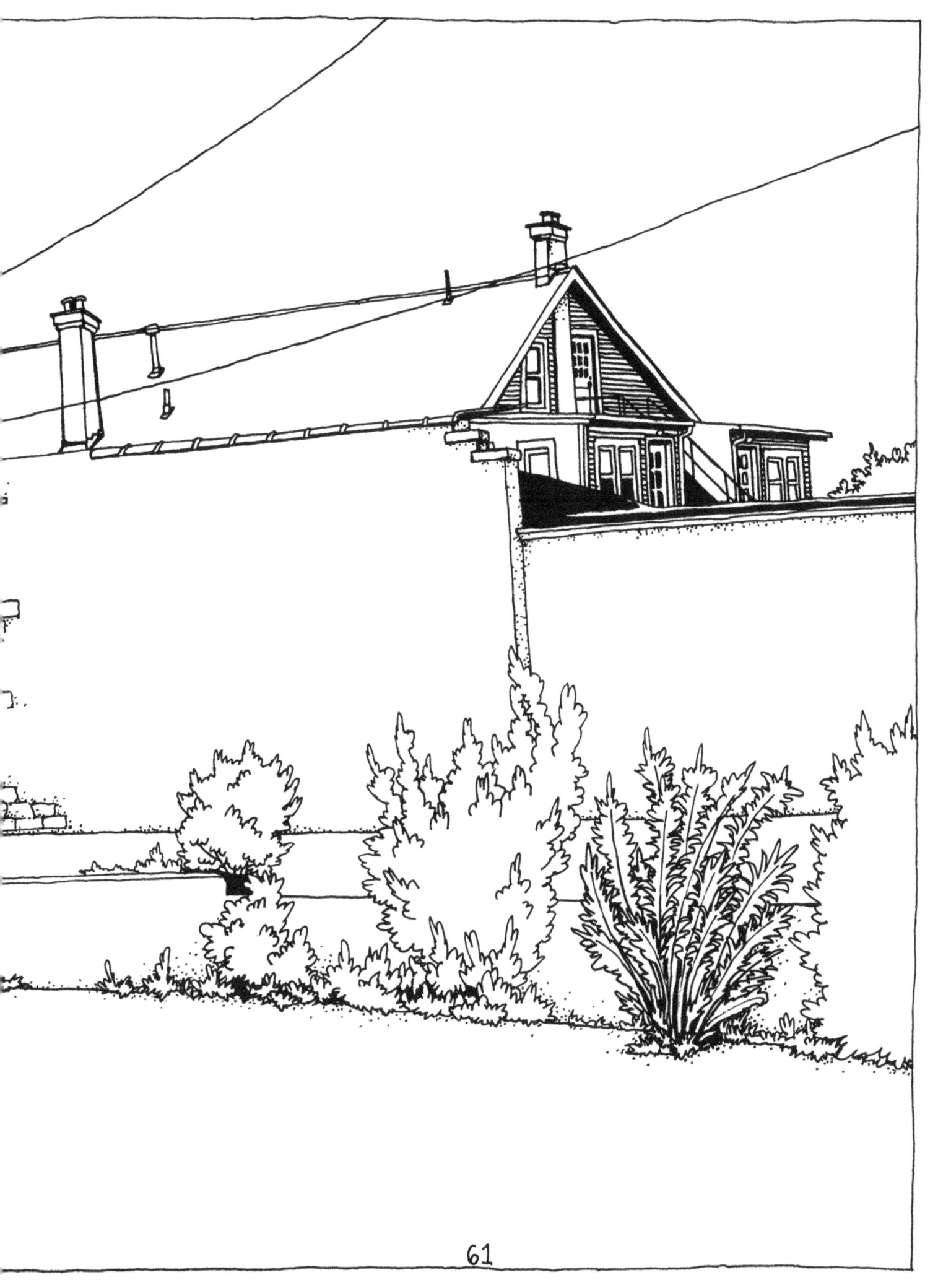

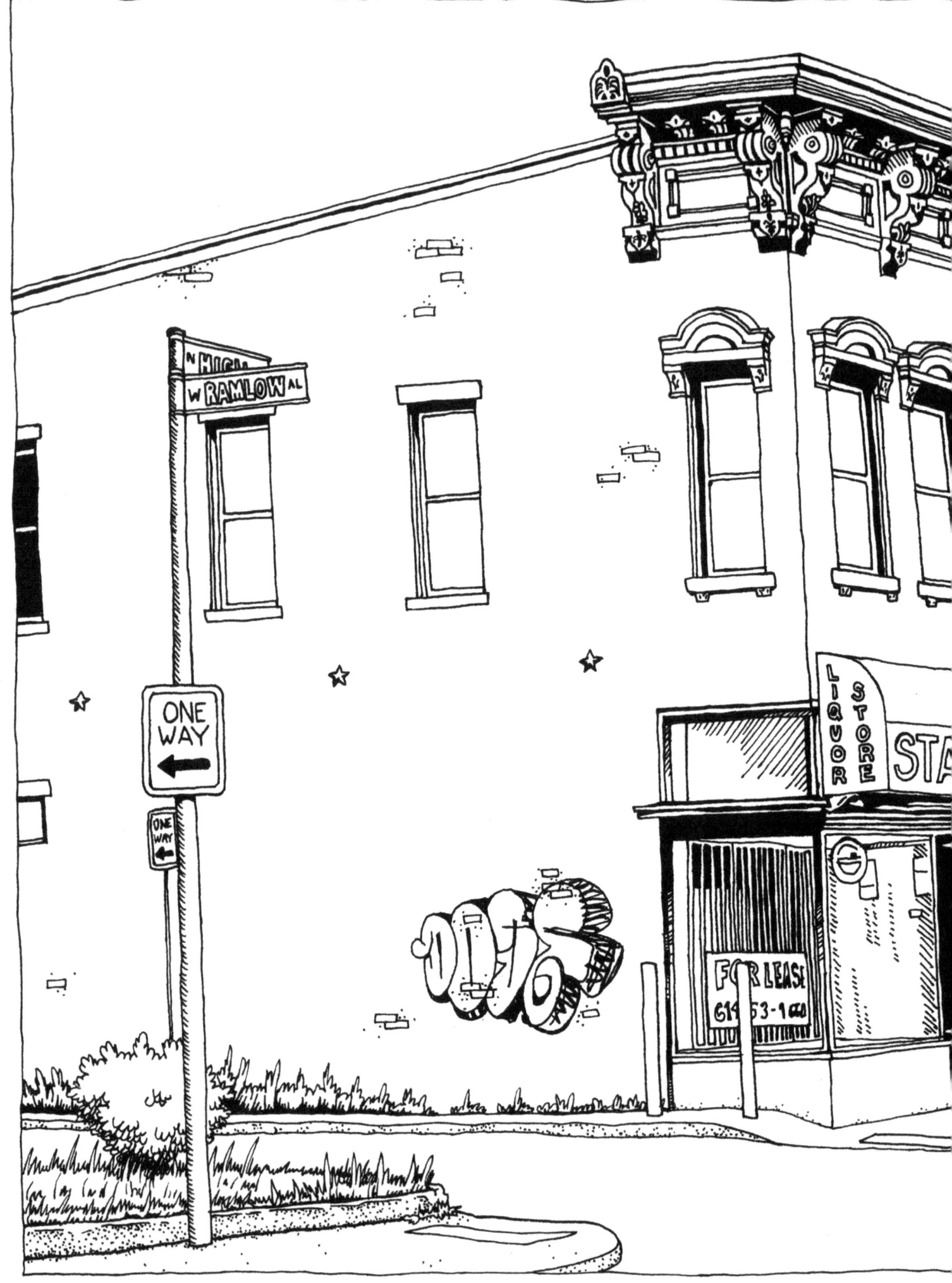

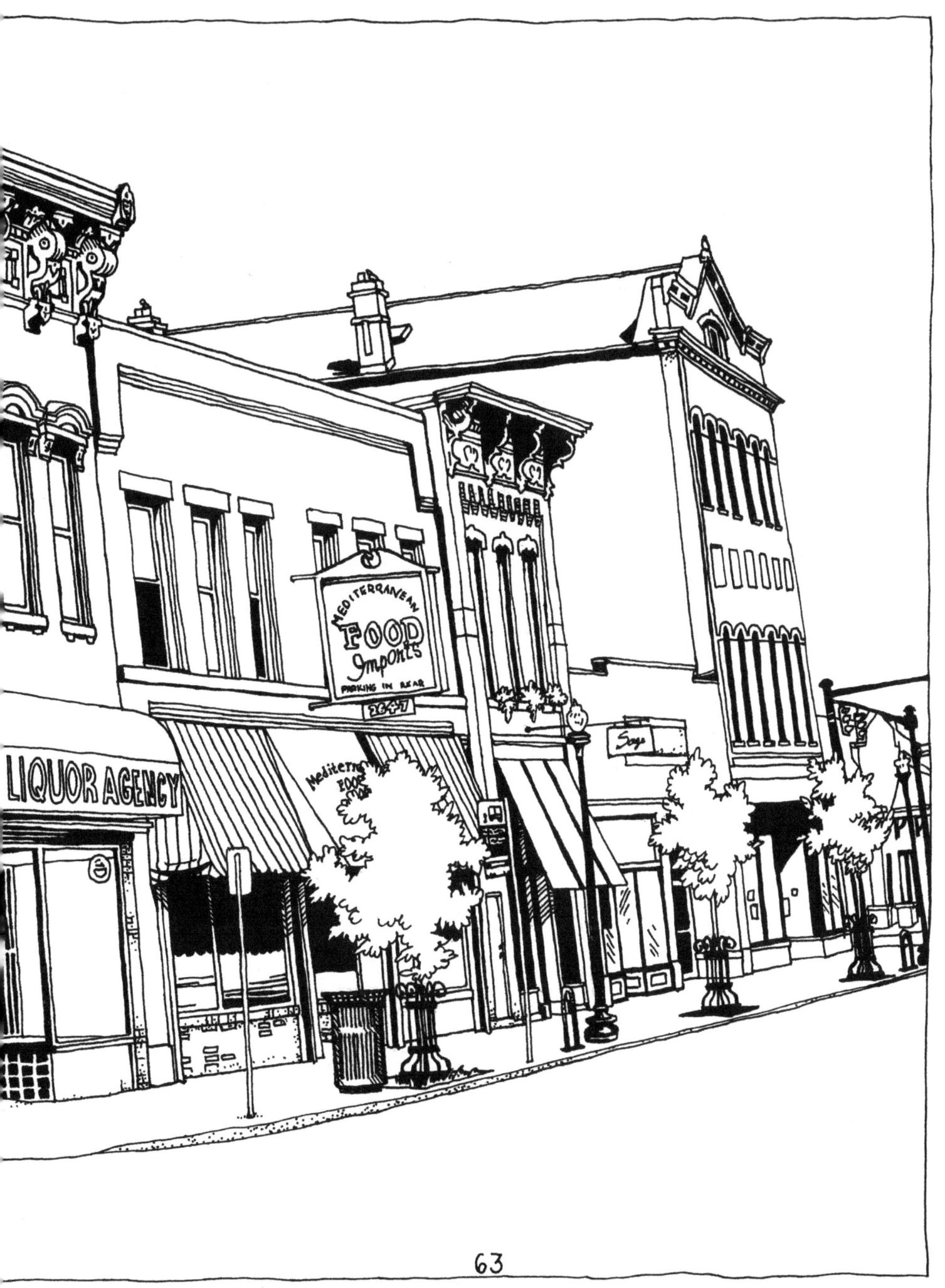

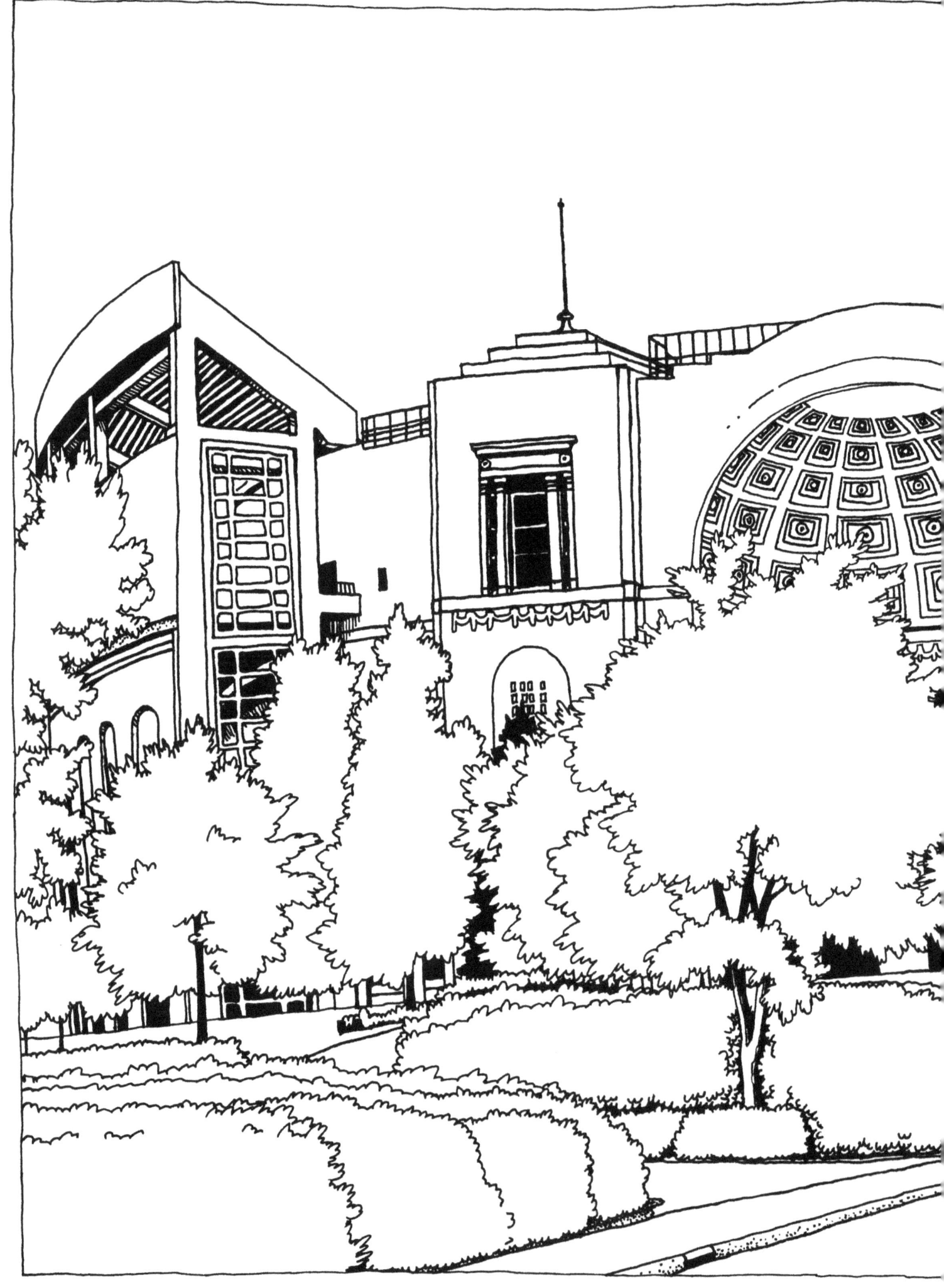

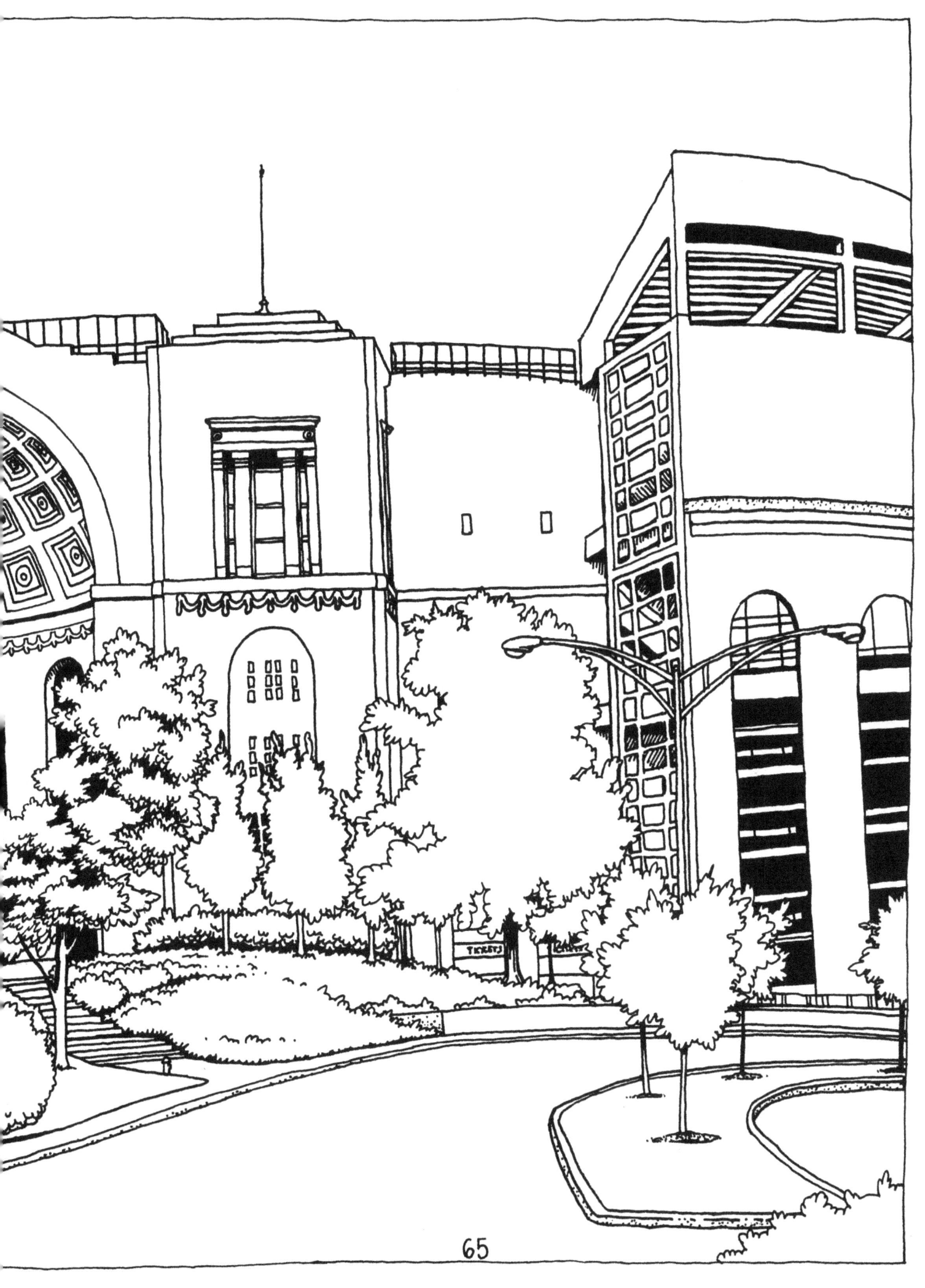

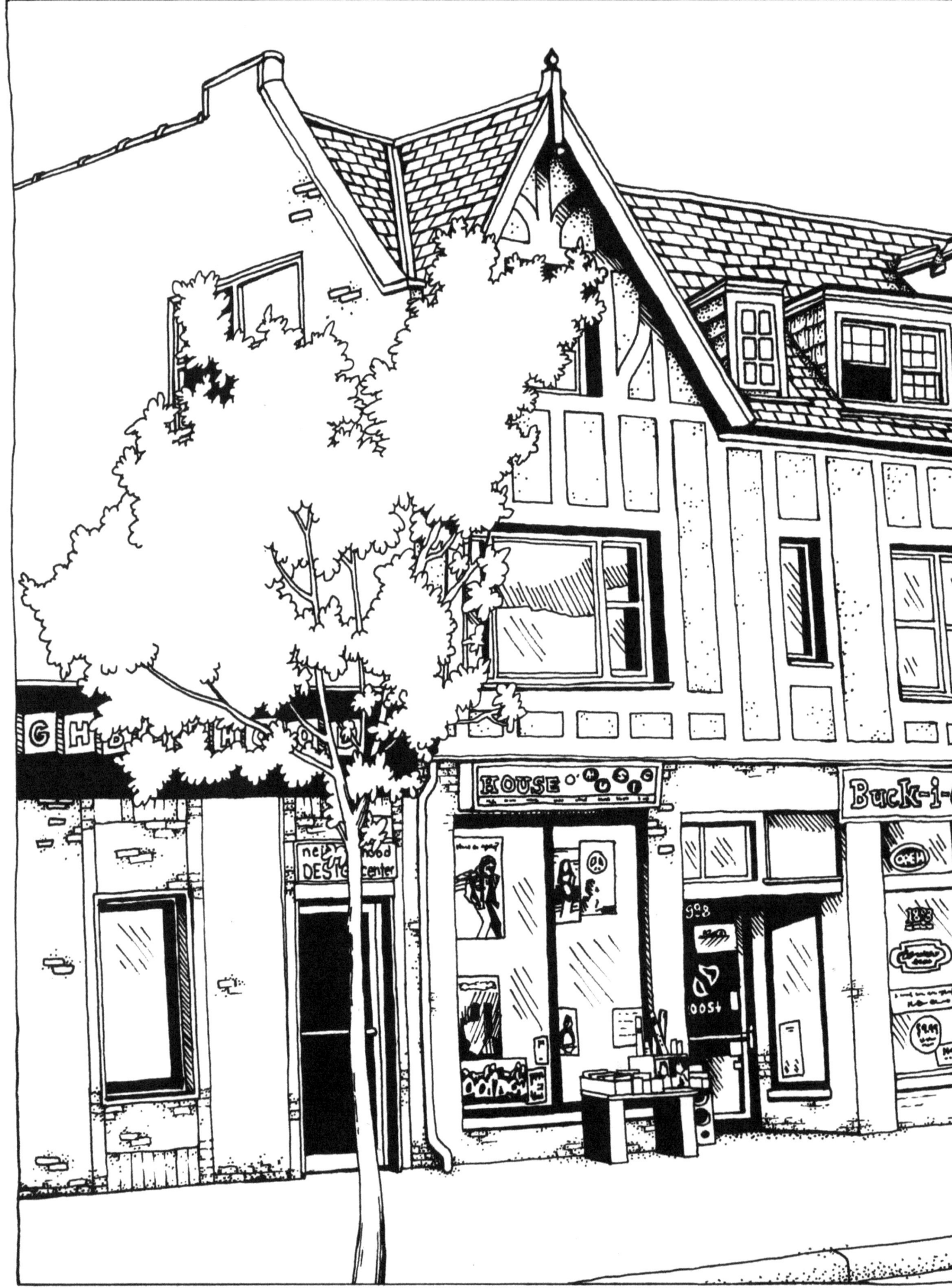

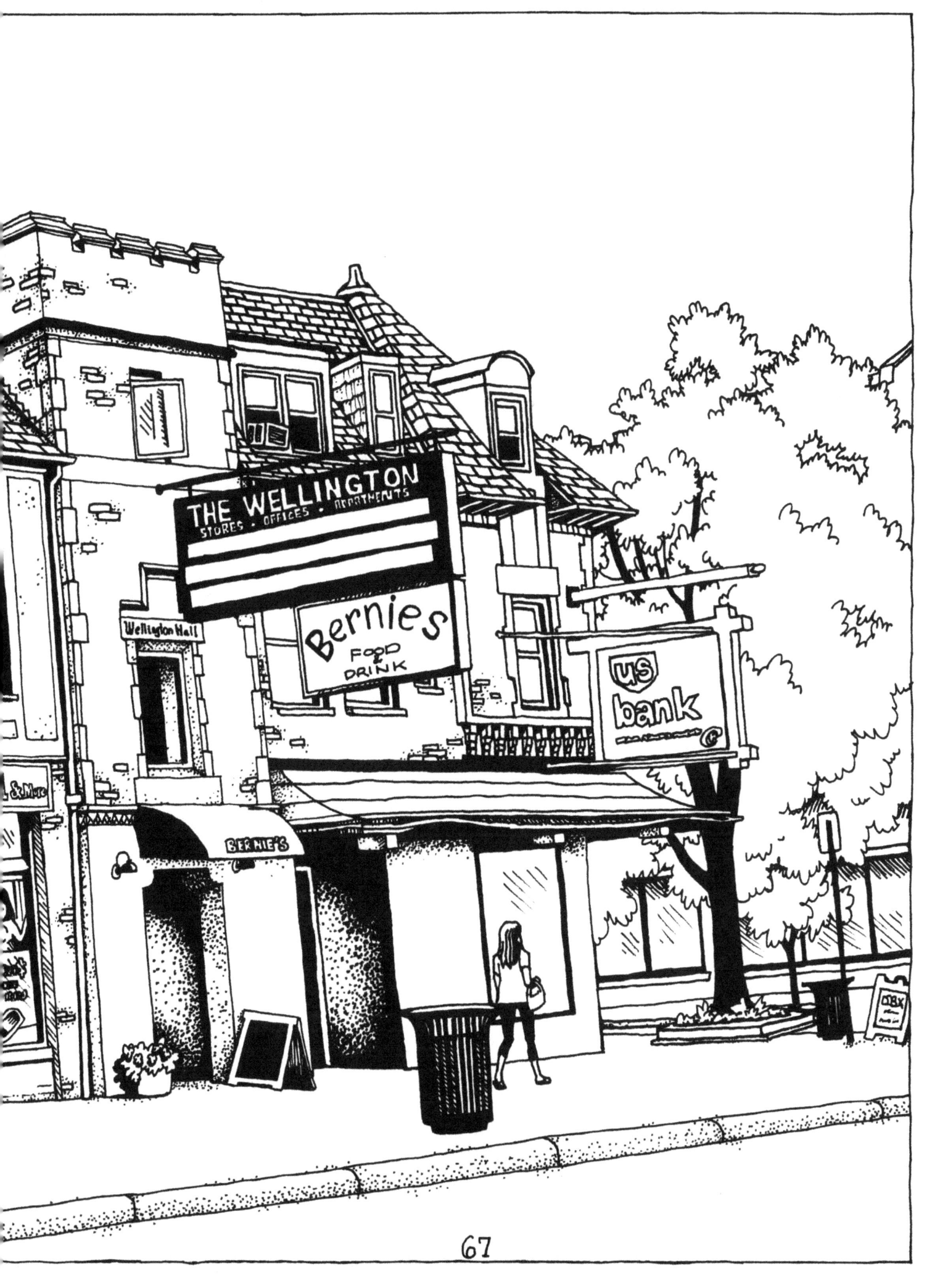

There are 10 differences between each side of this picture. Can you find them all?

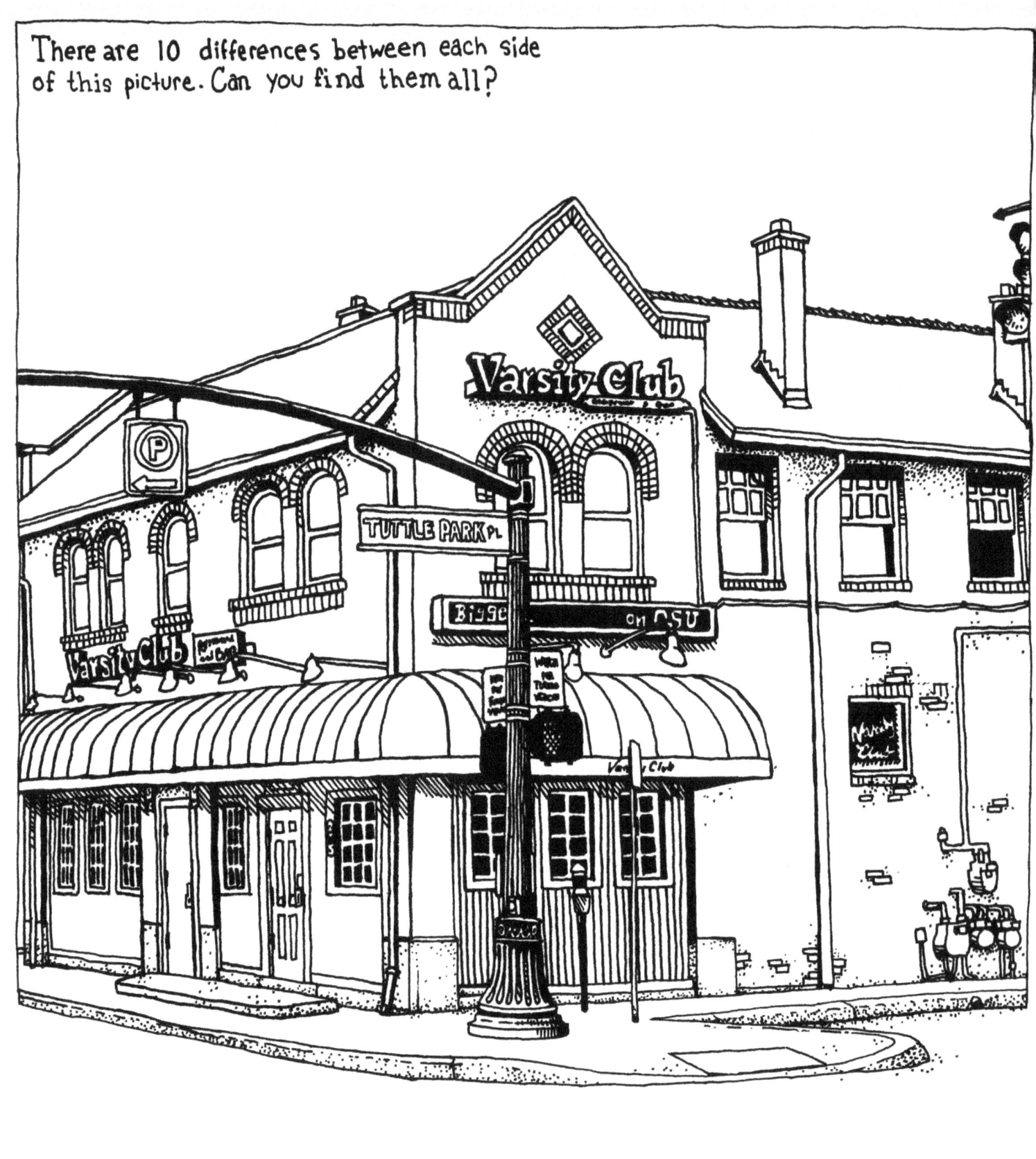

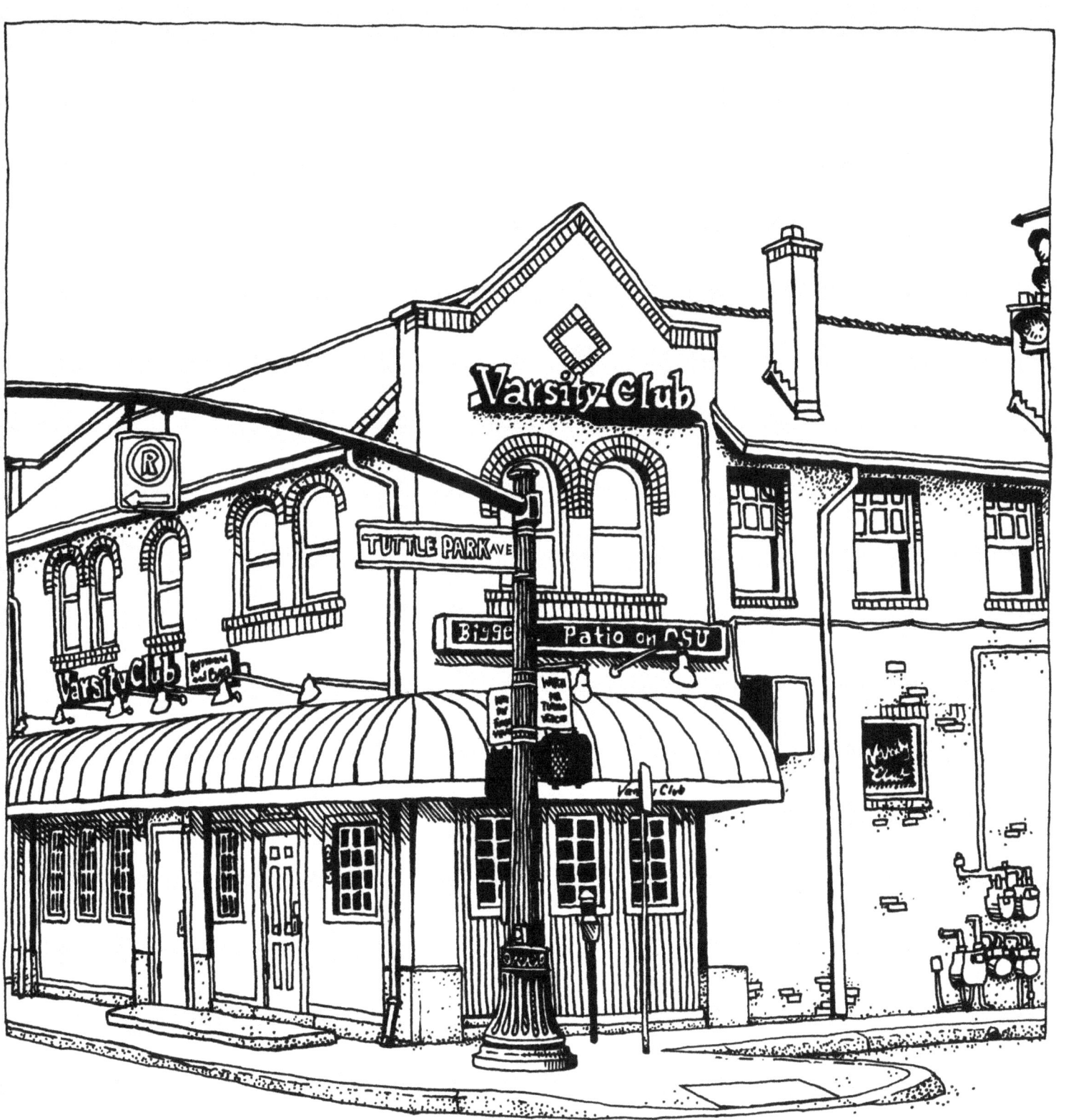

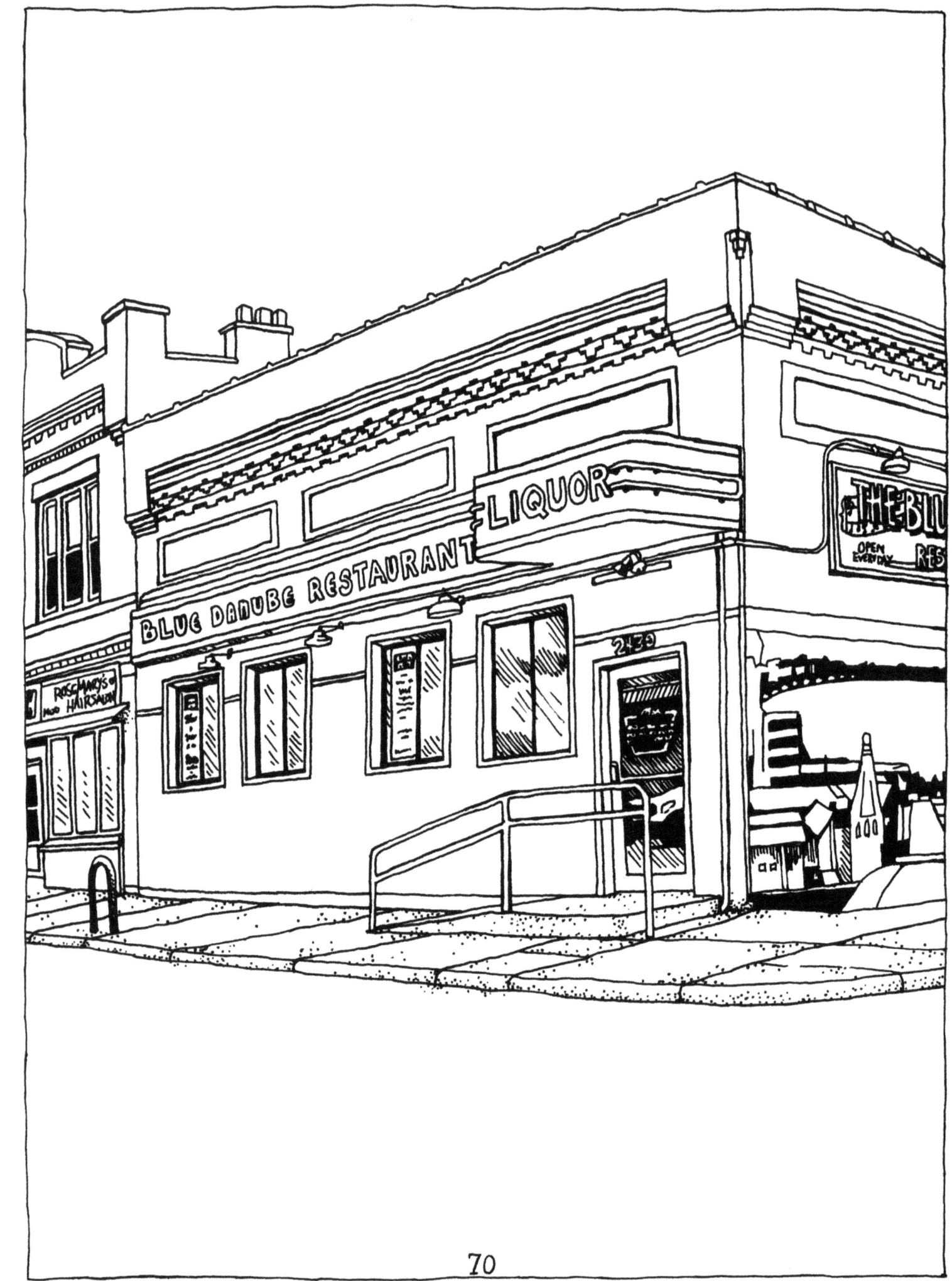

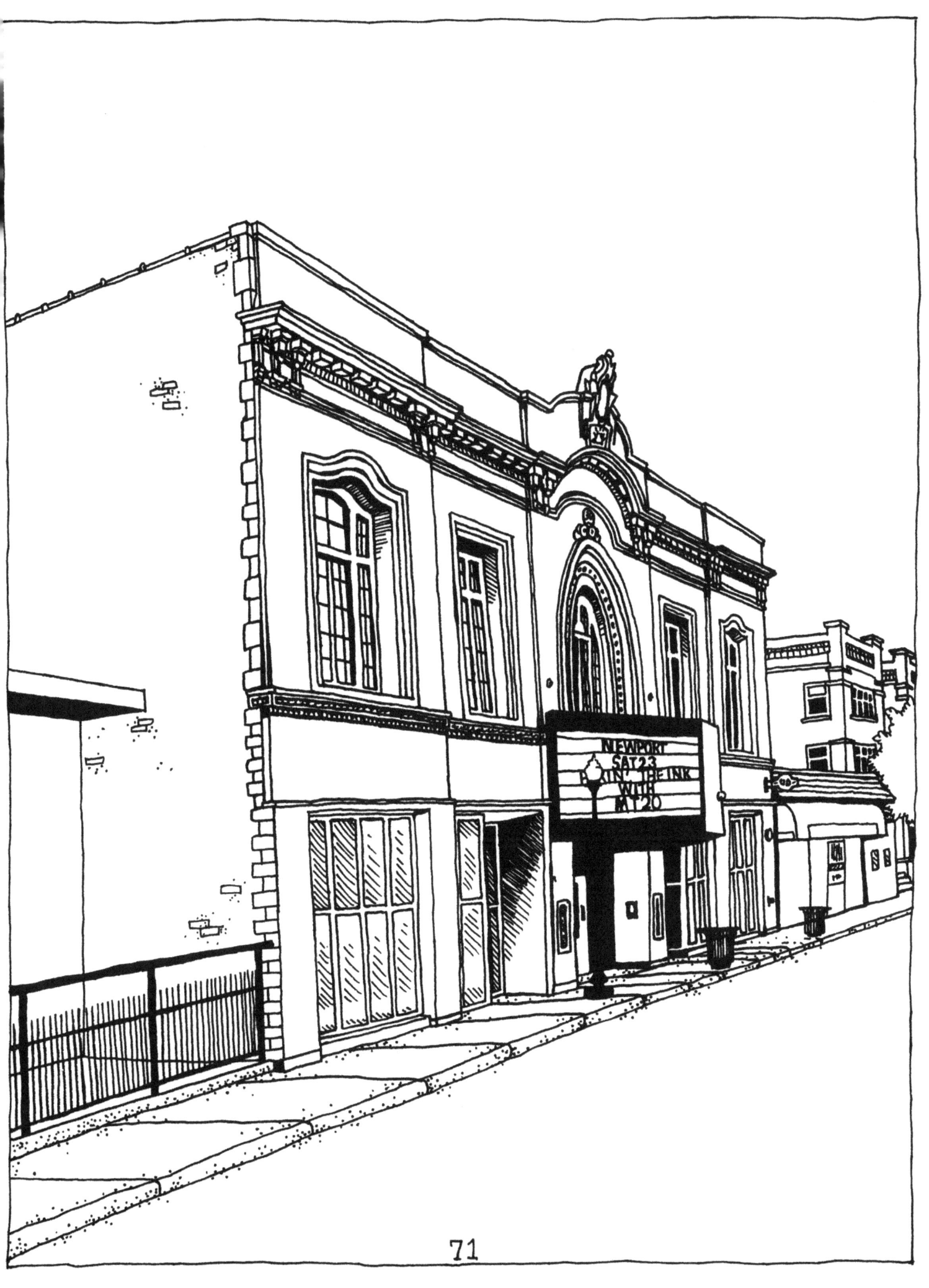

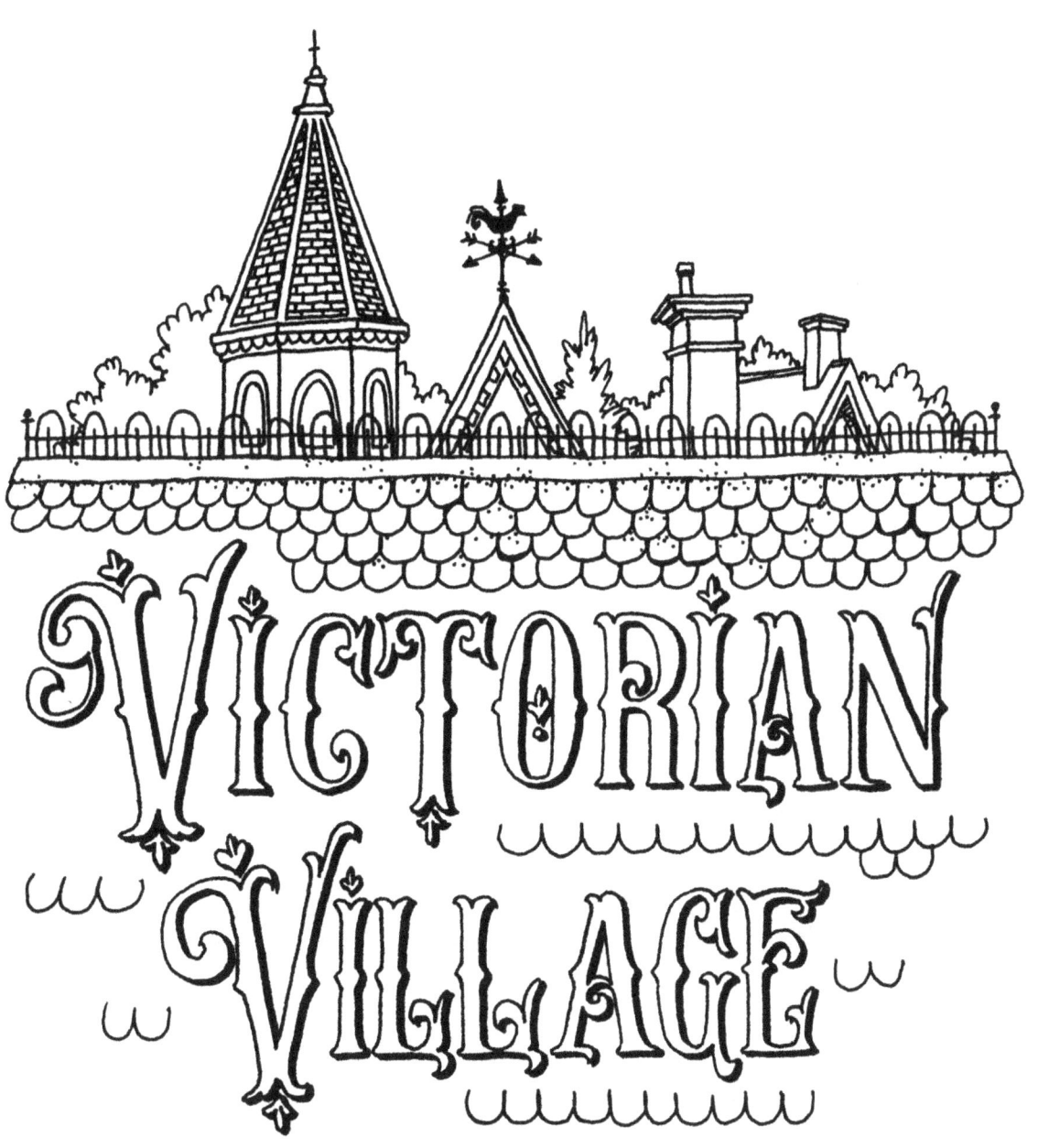

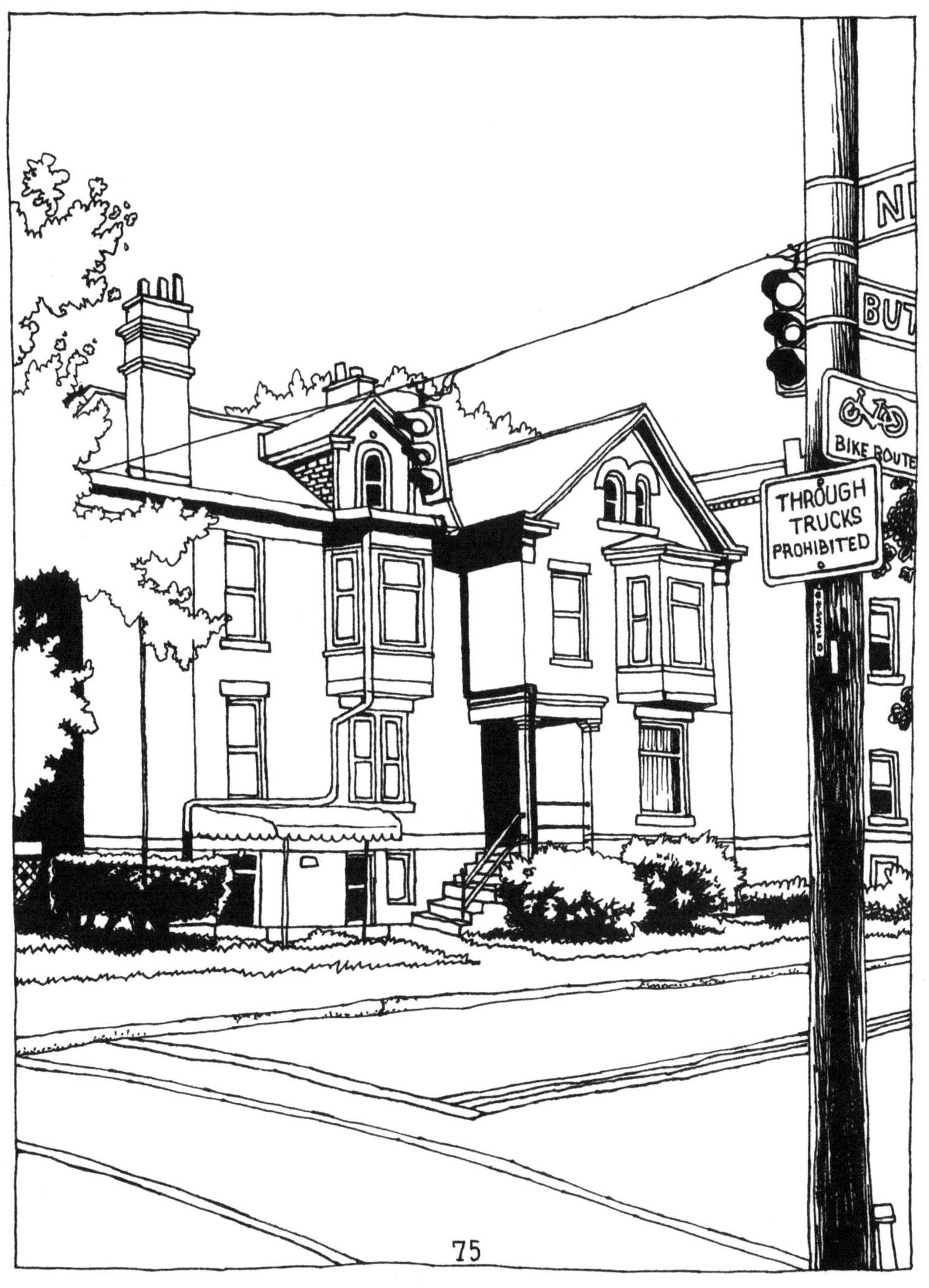

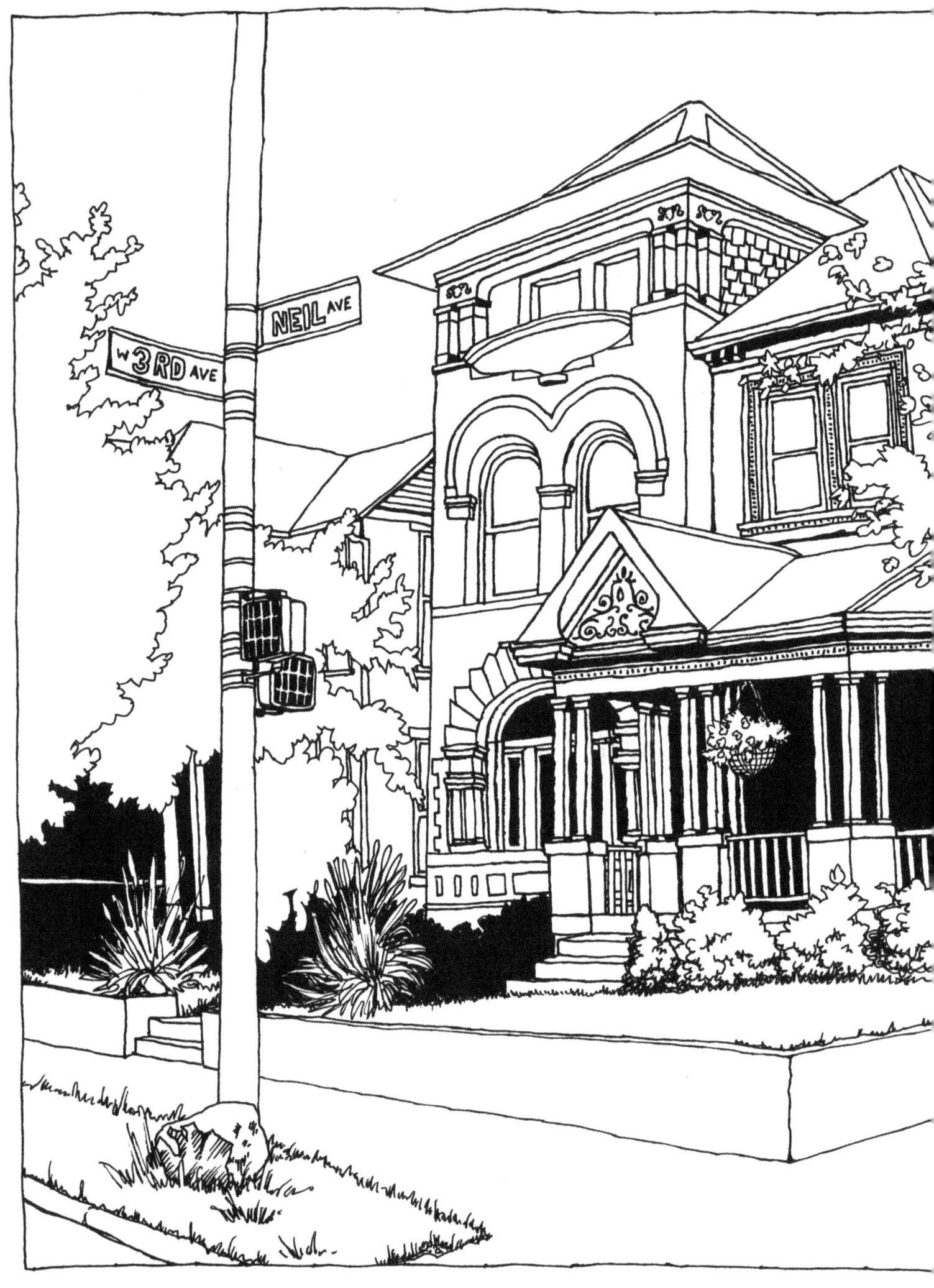

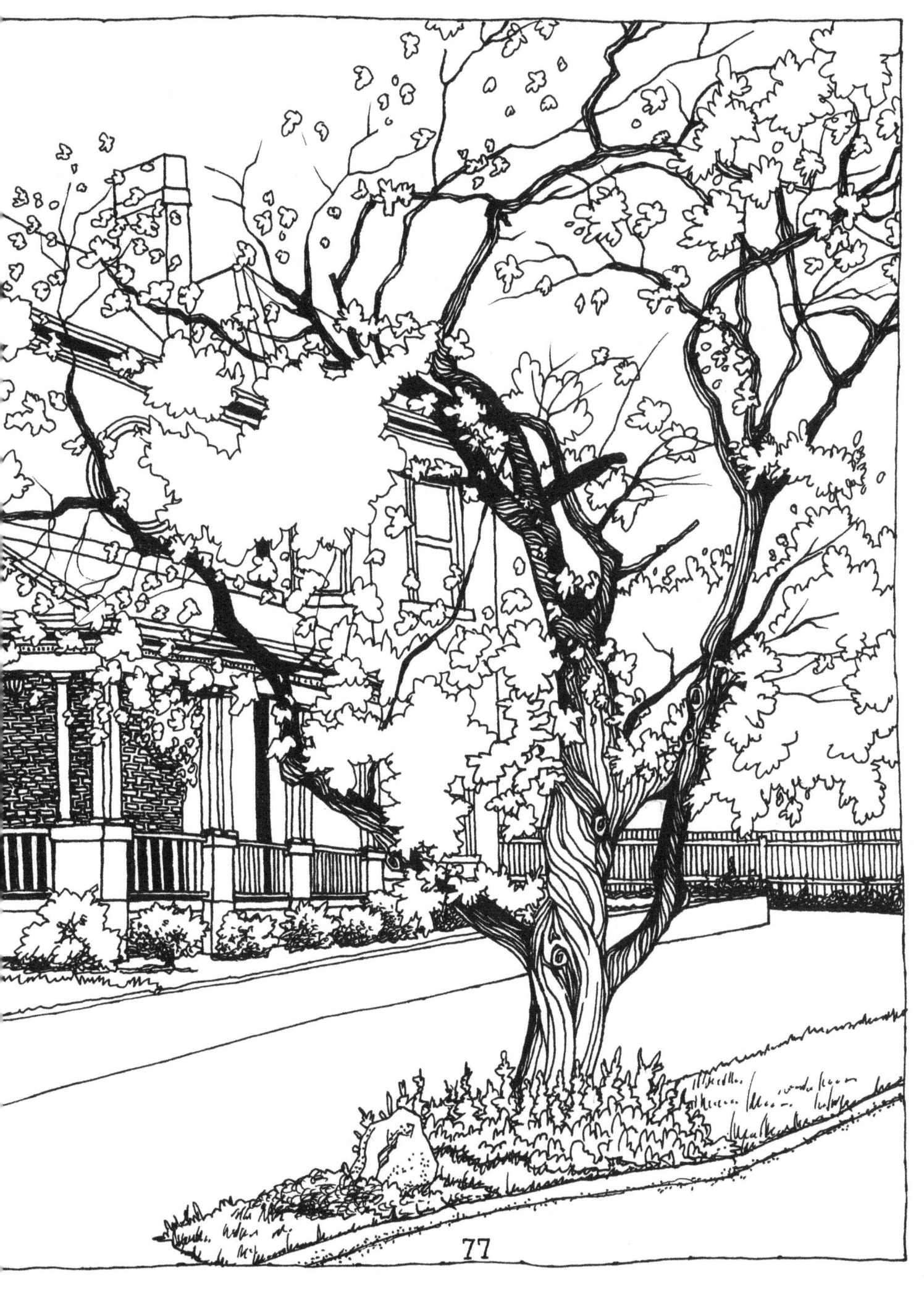

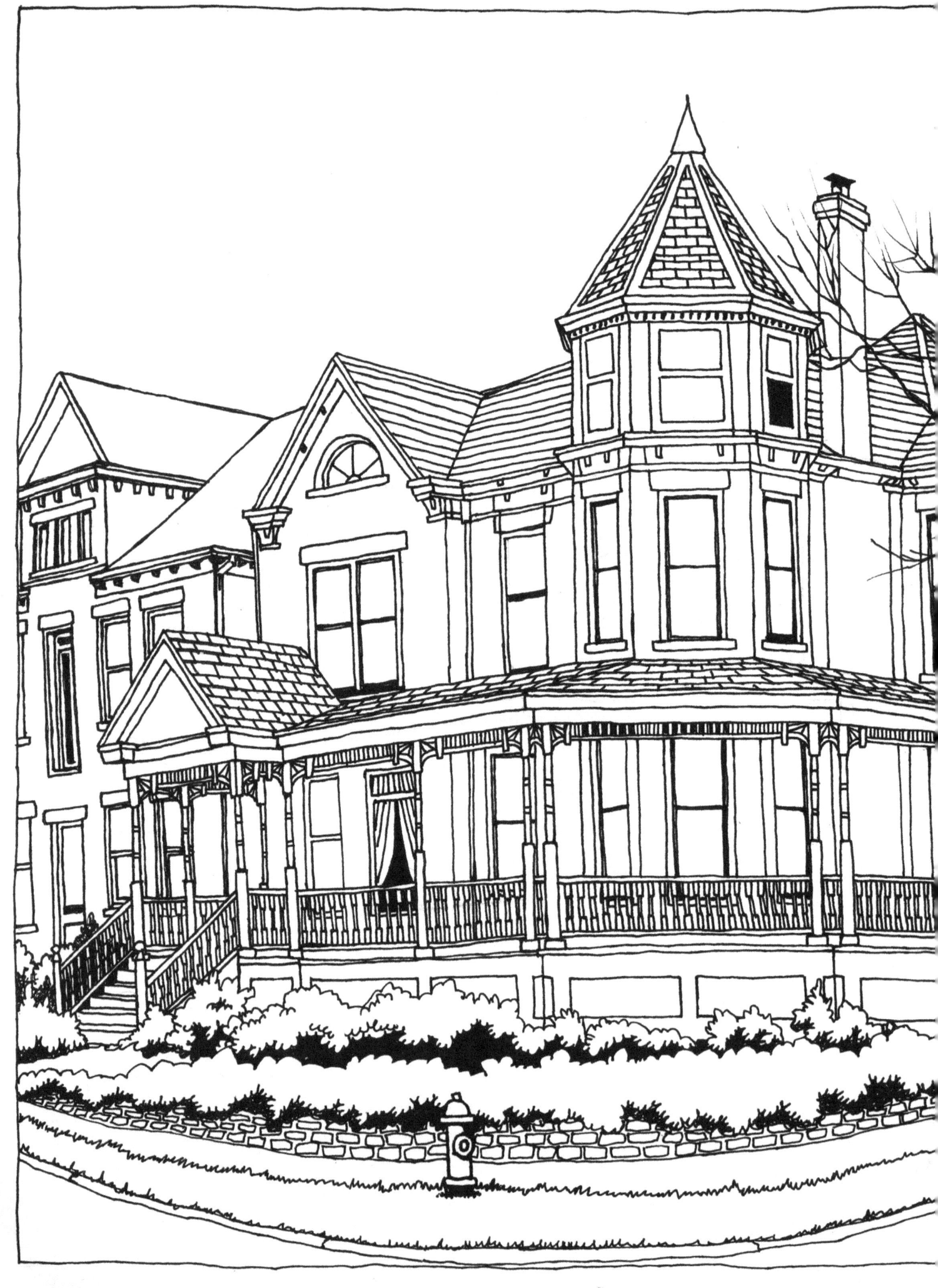

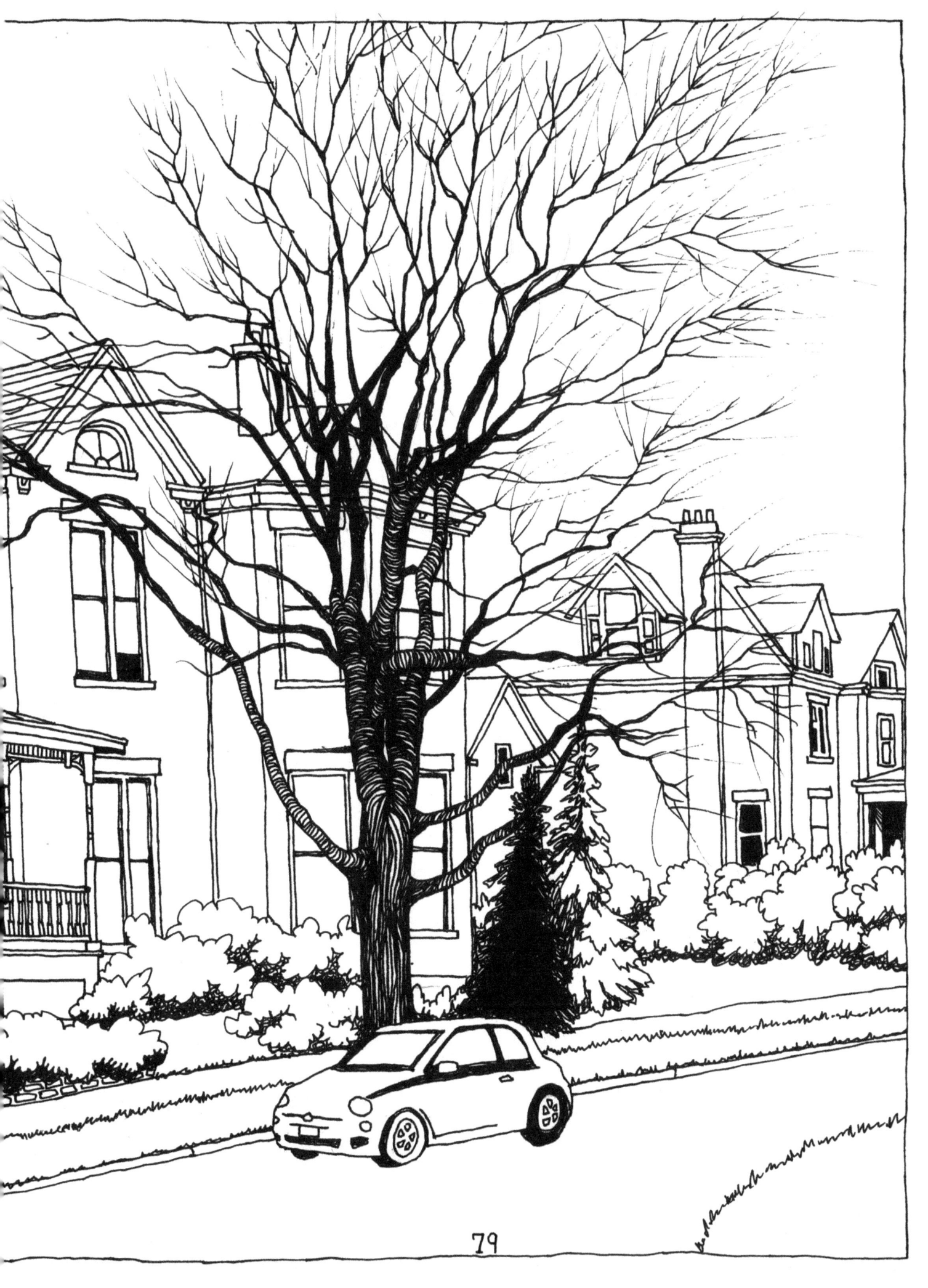

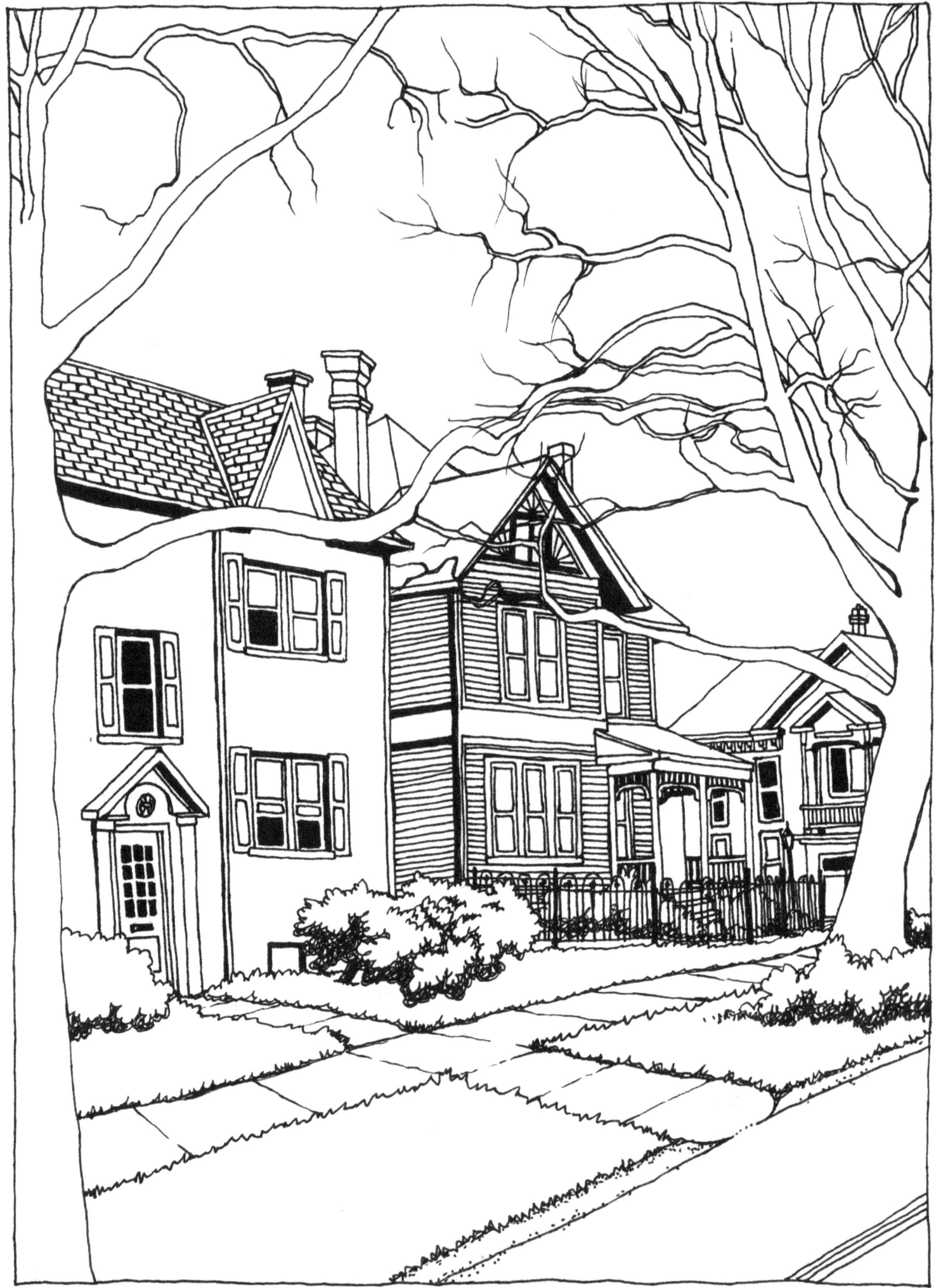

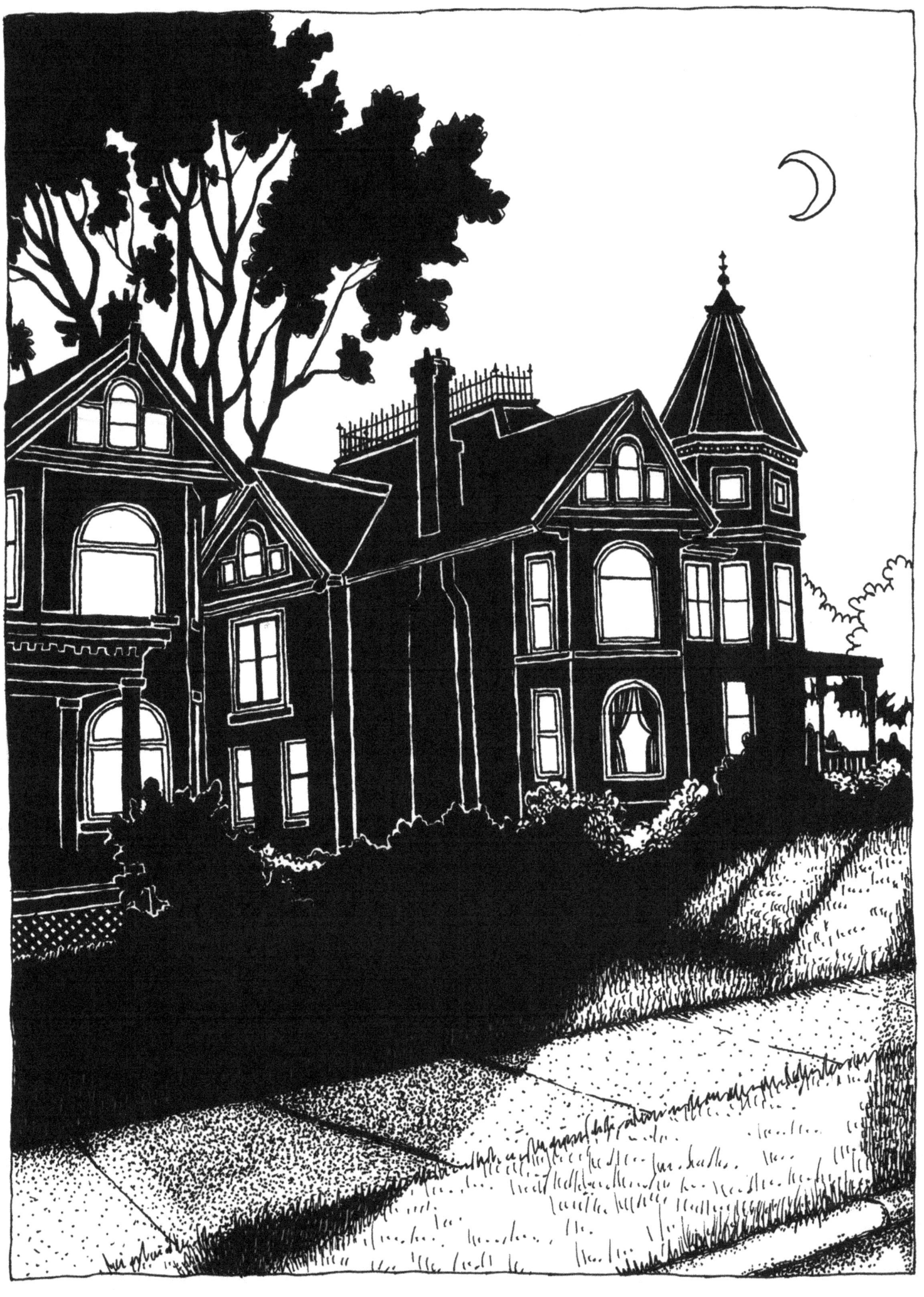

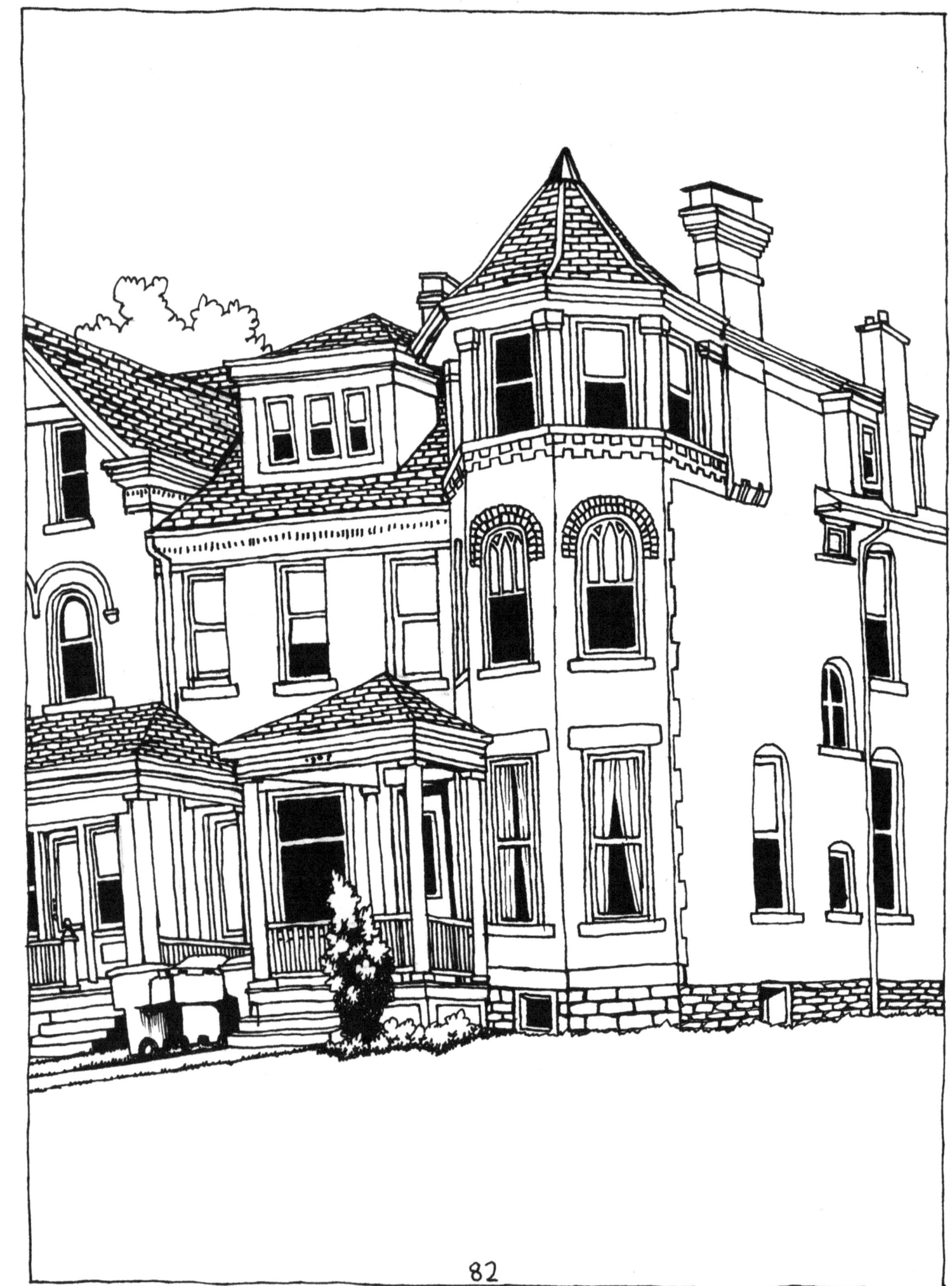

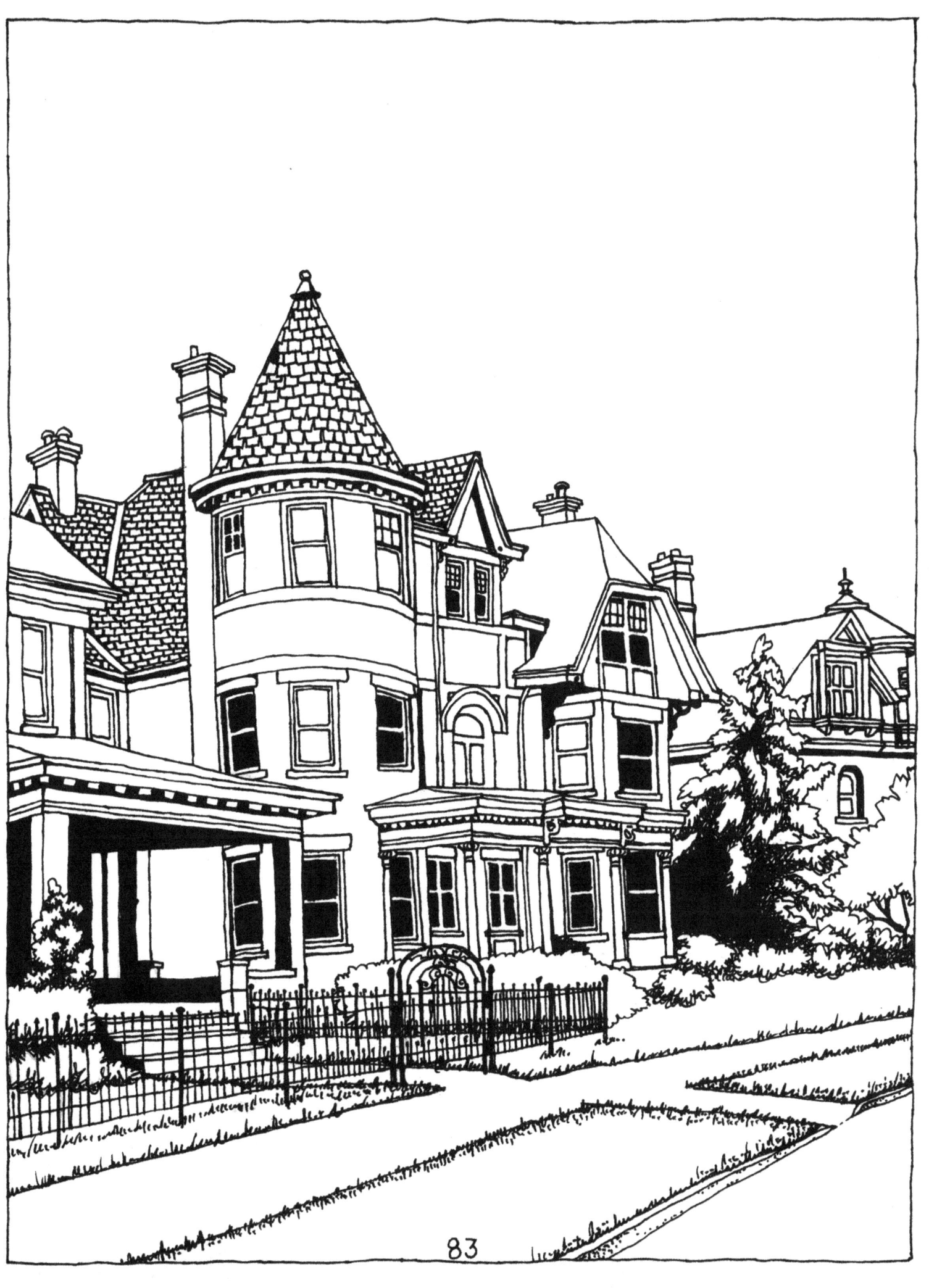

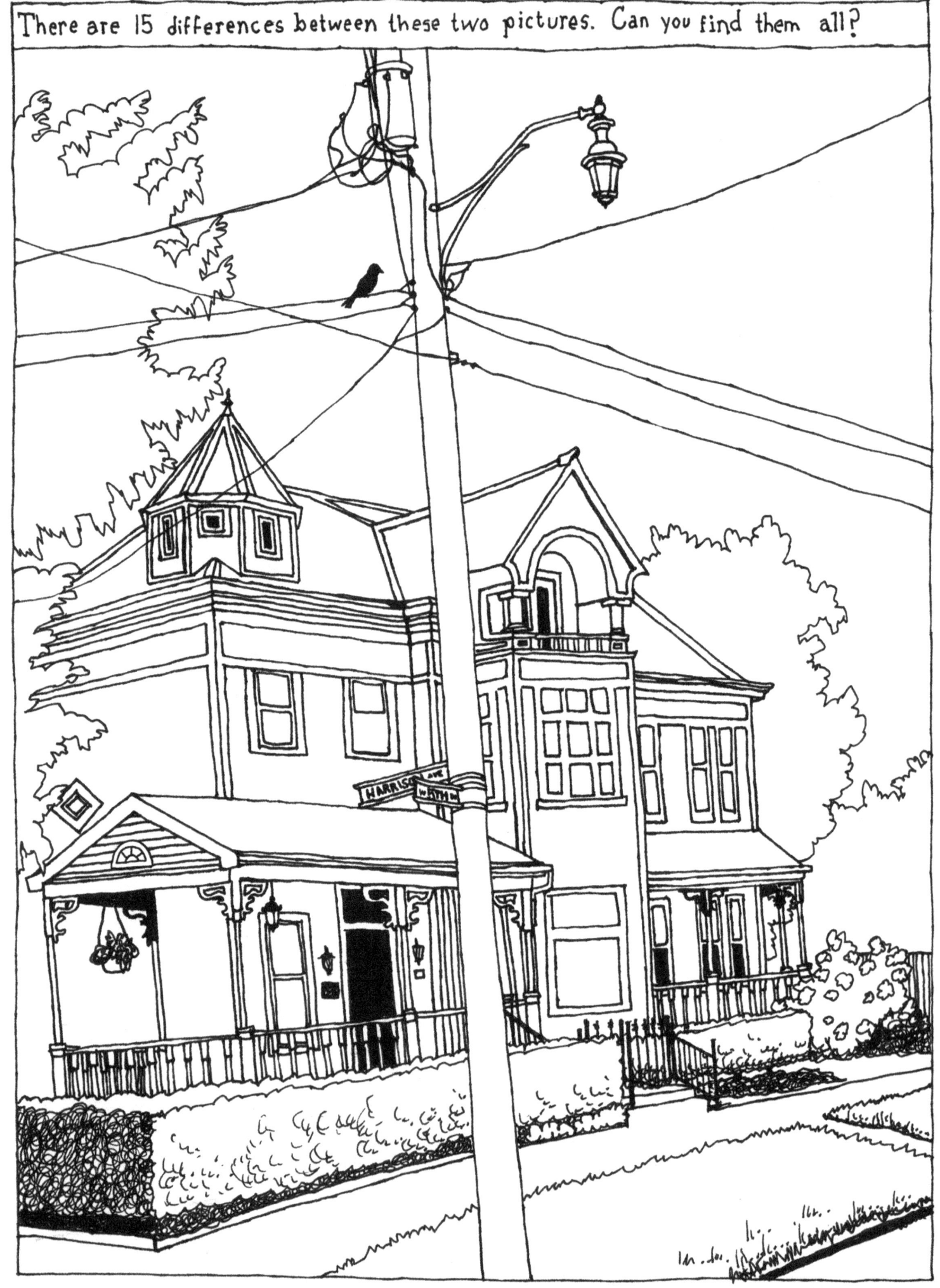
There are 15 differences between these two pictures. Can you find them all?

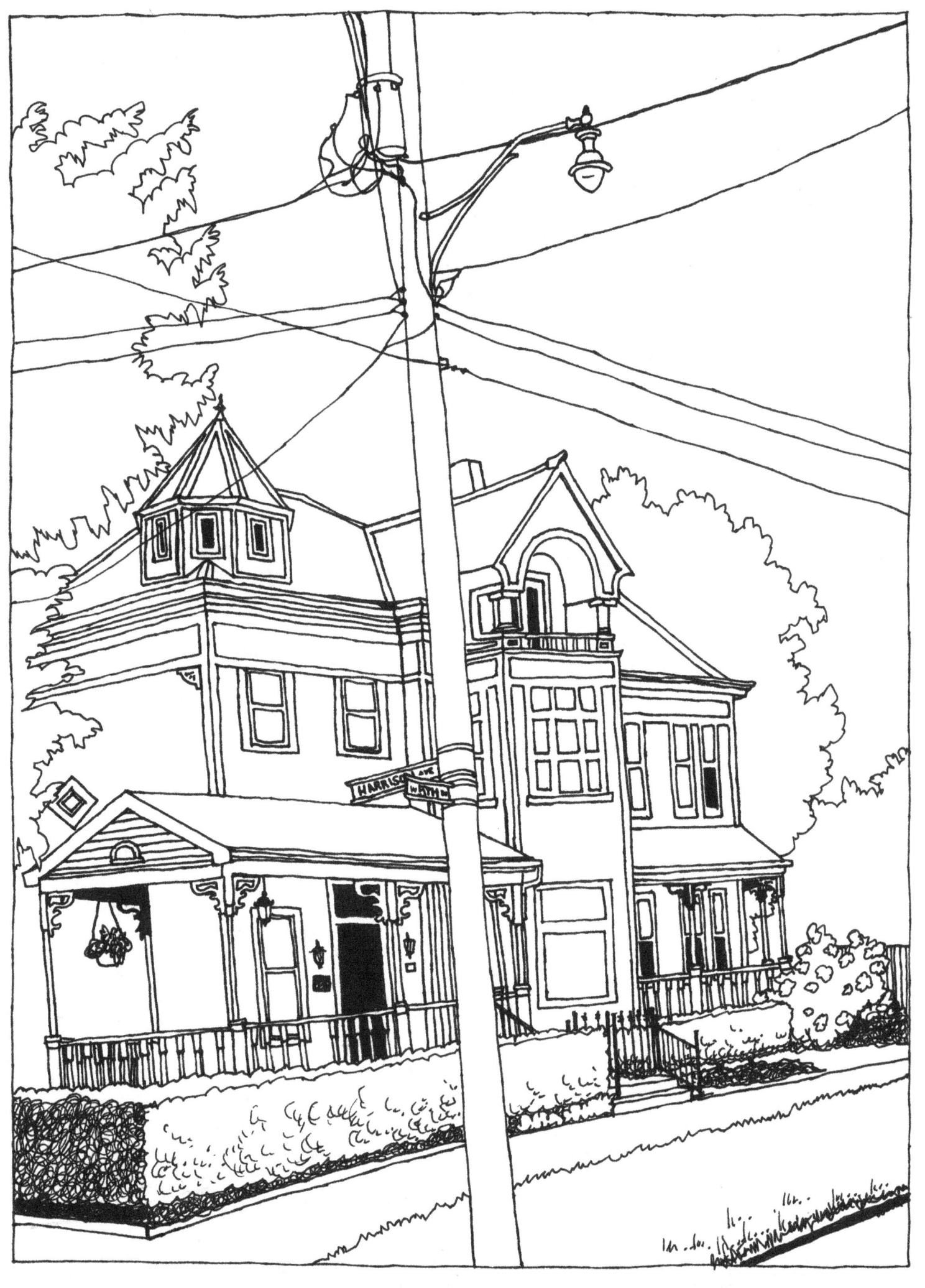

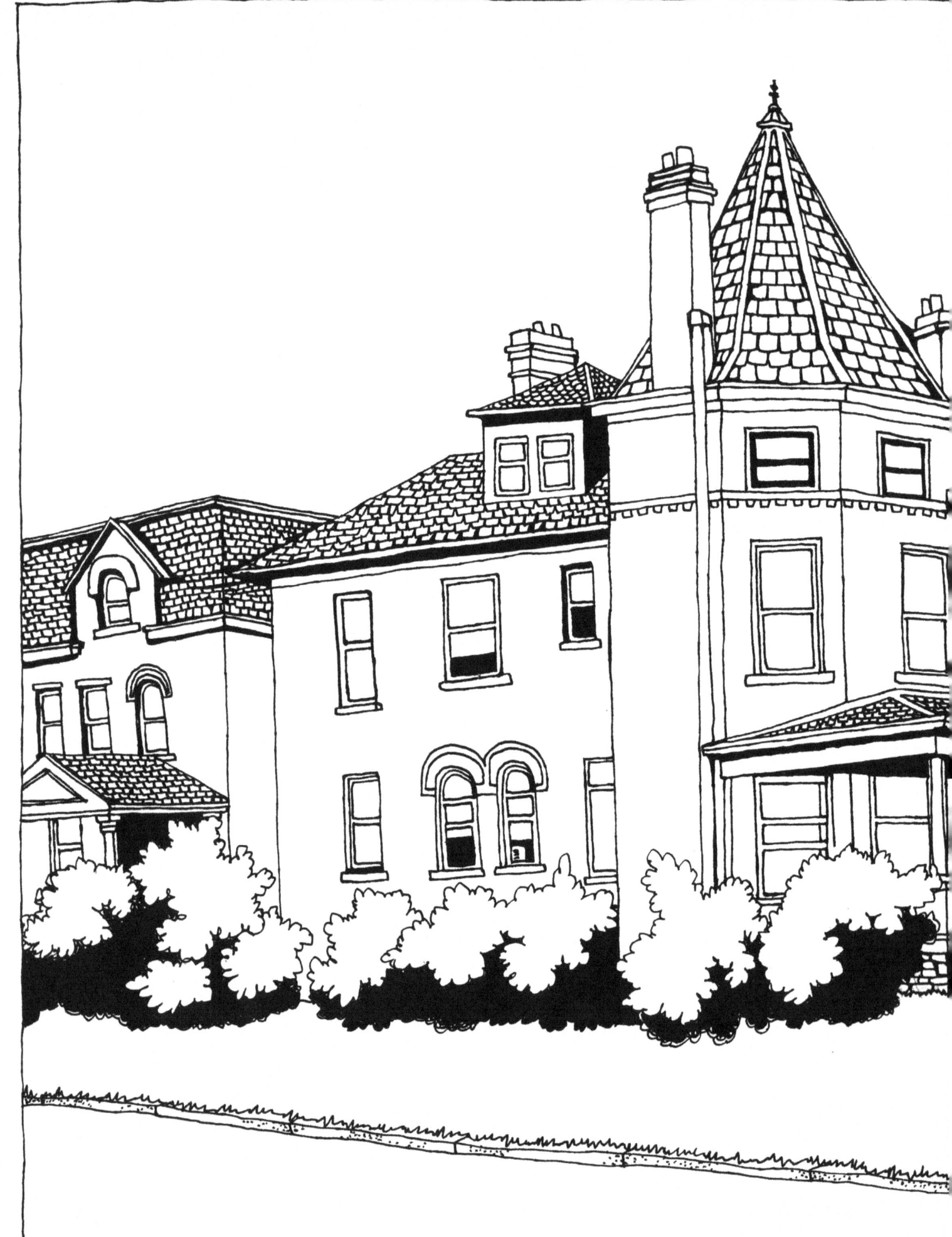

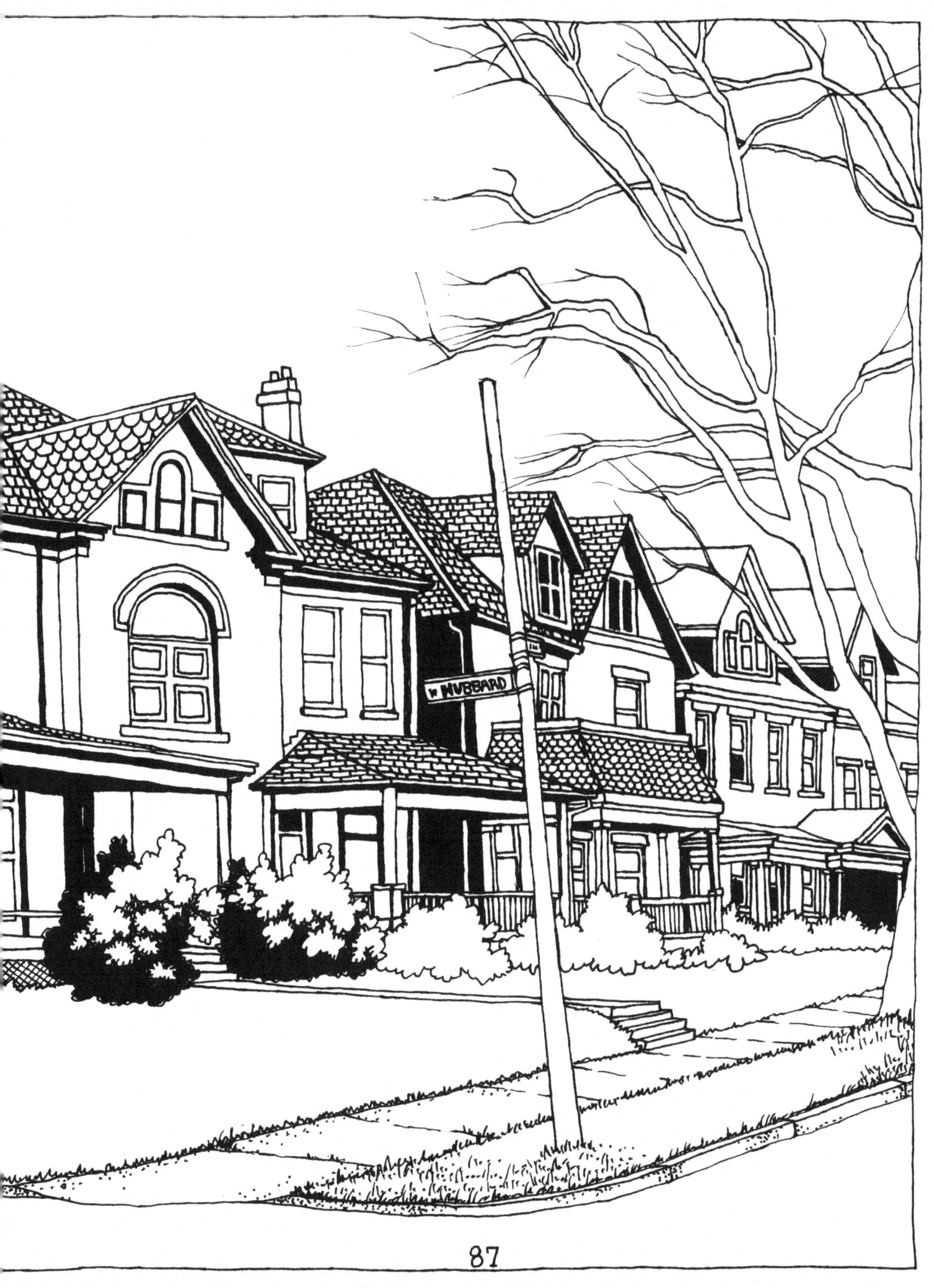

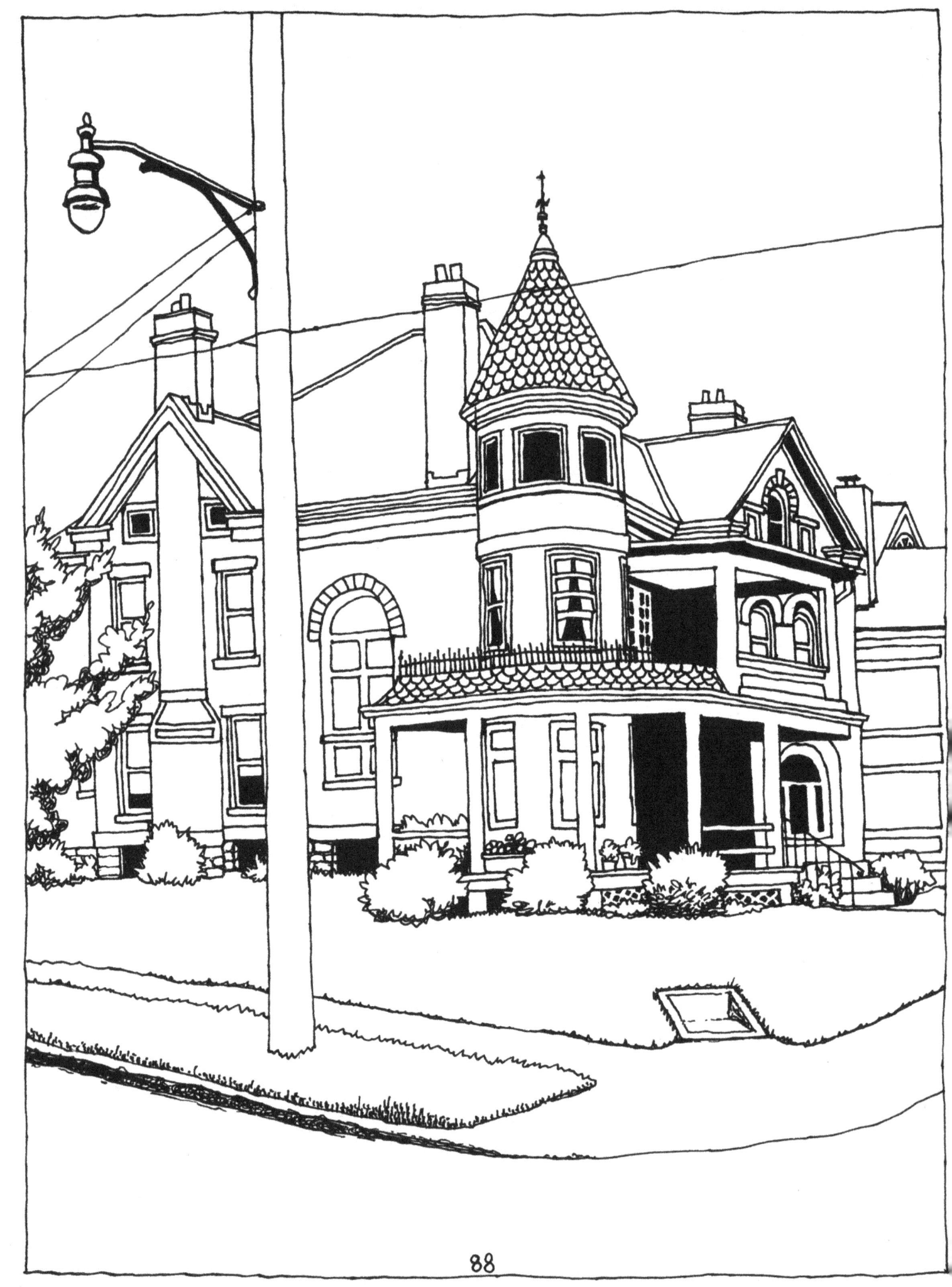

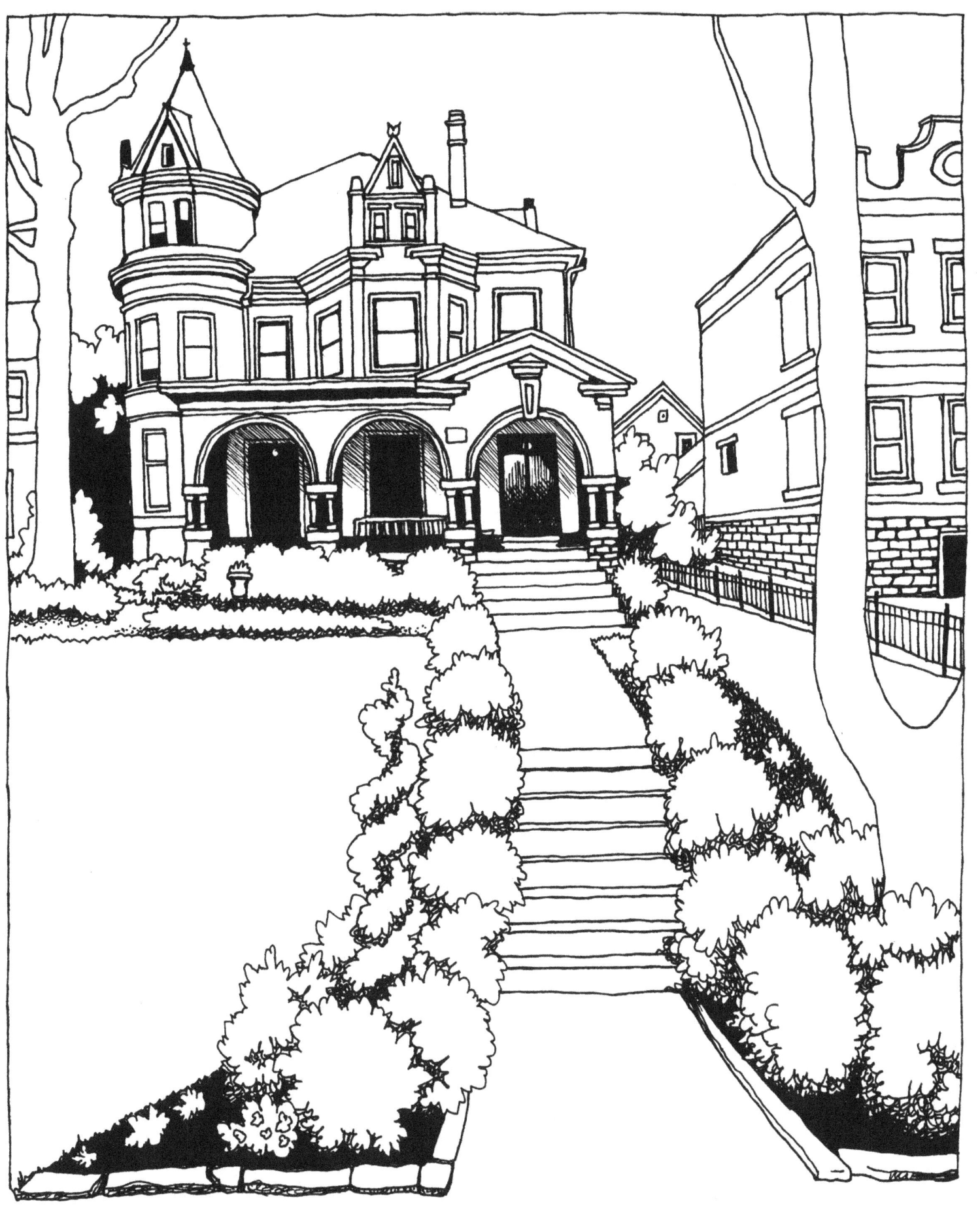

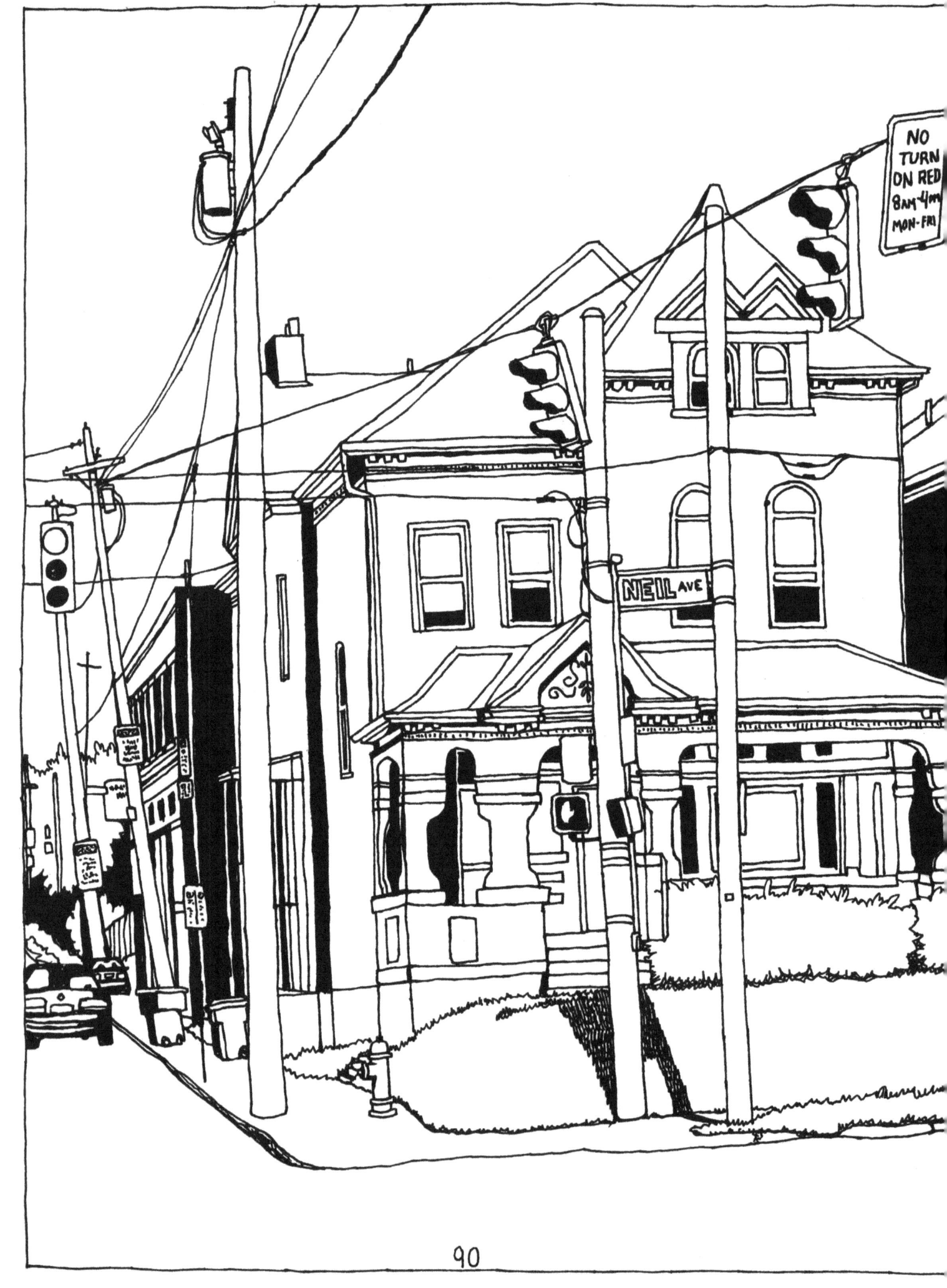

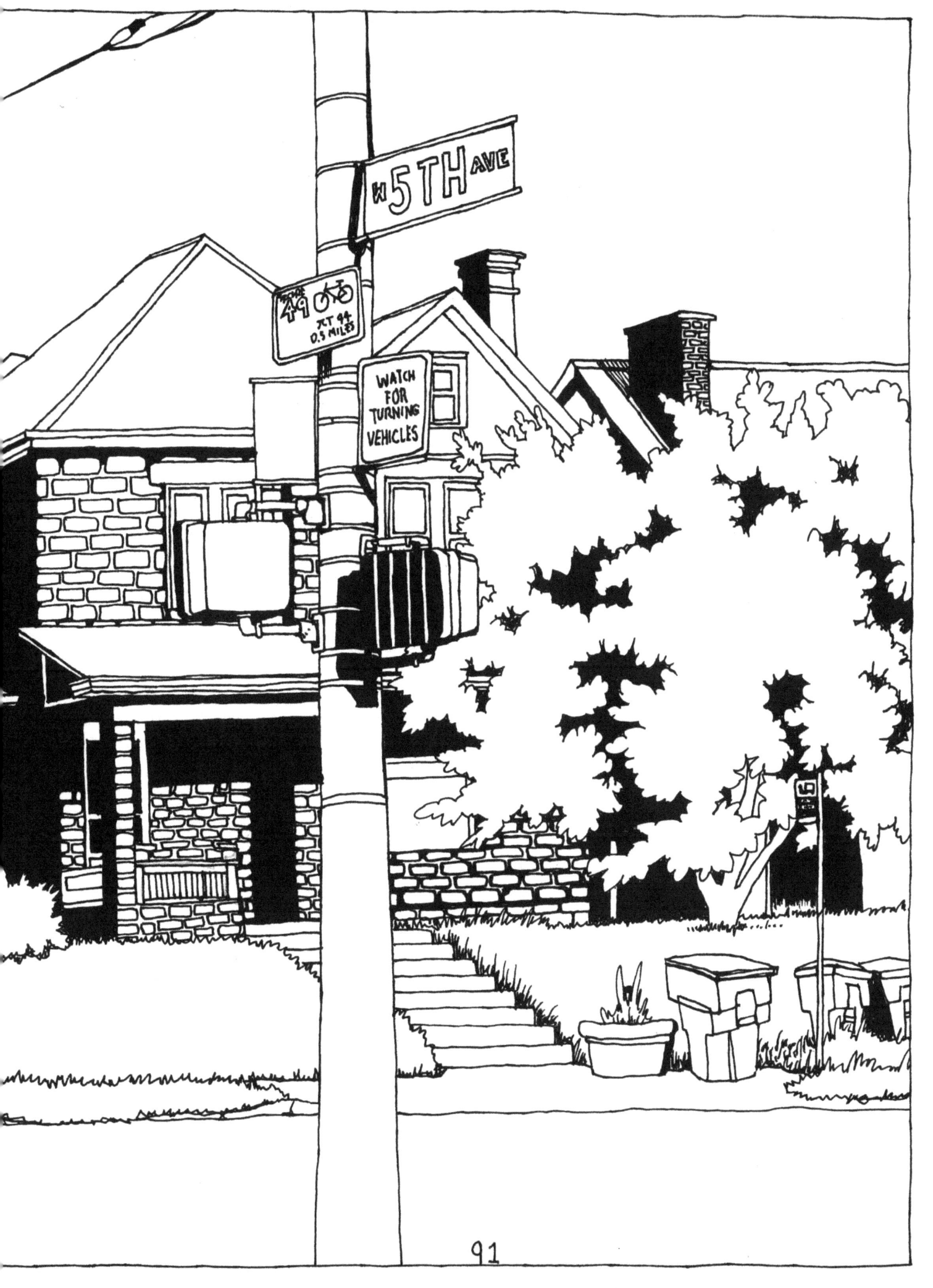

# ANSWERS

16.

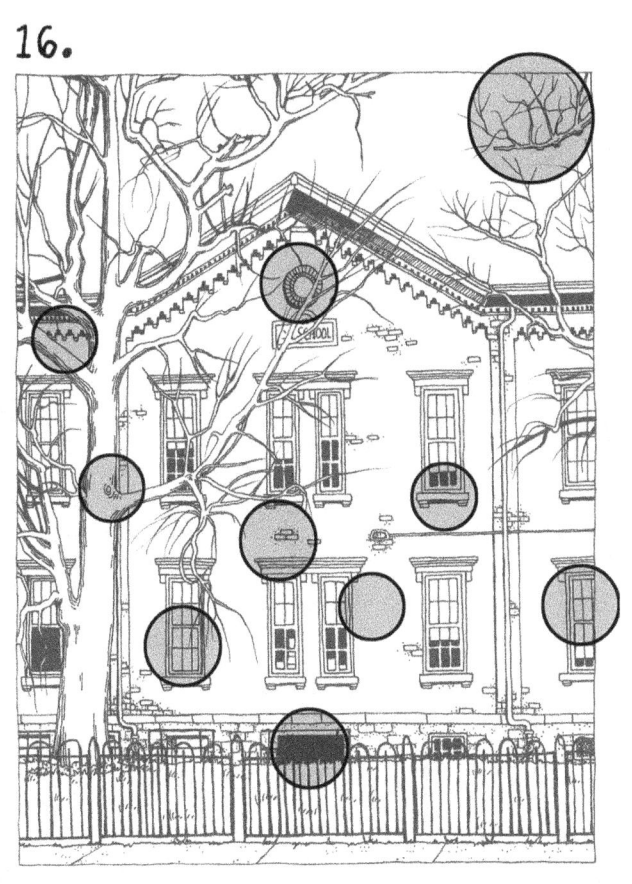

20. 8

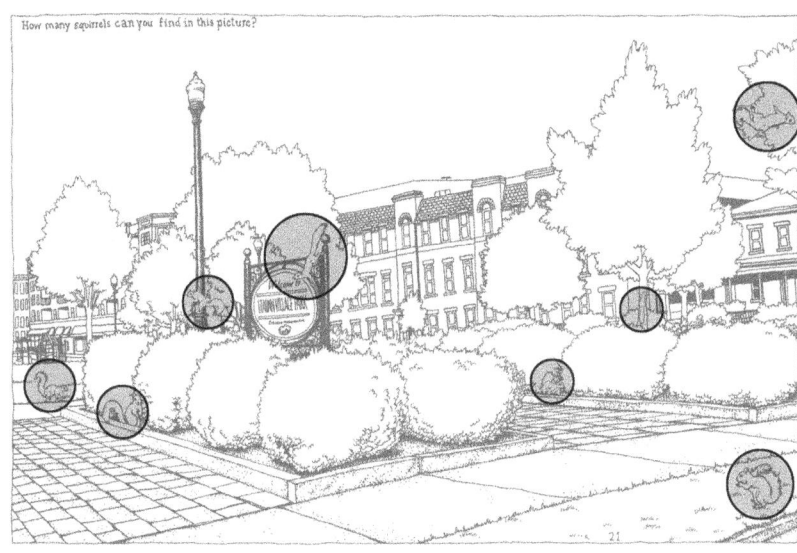

30. 13

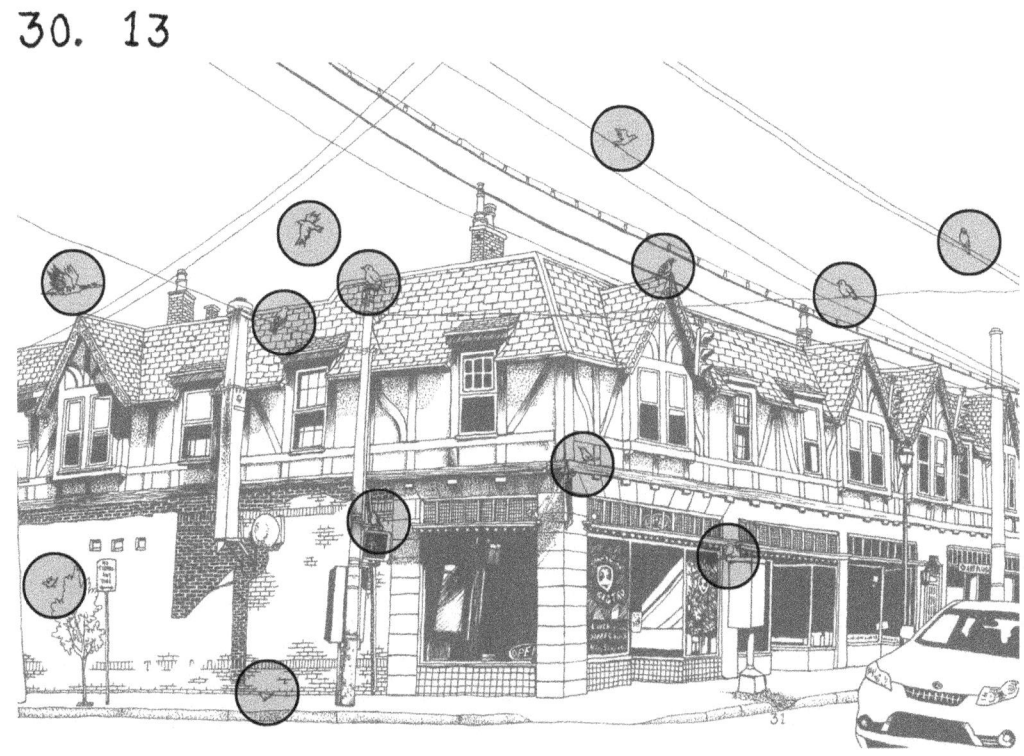

93

46.

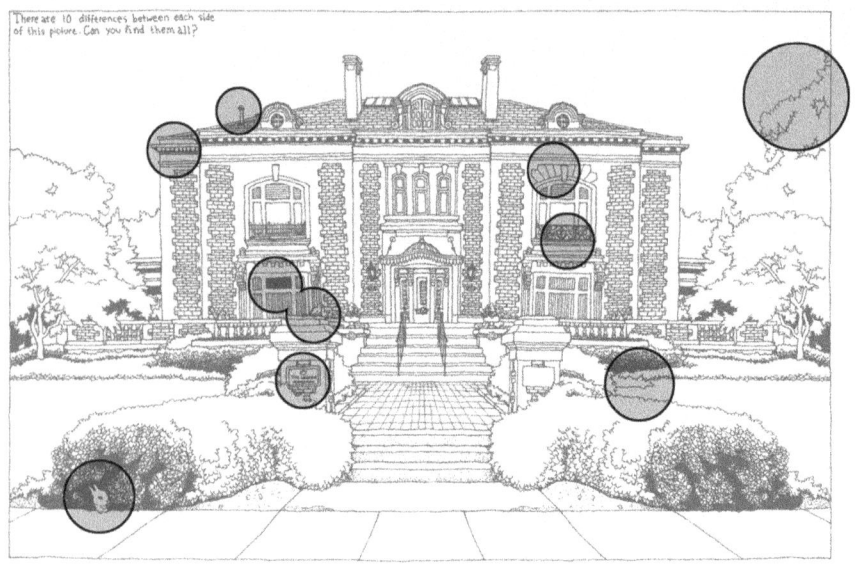

57. 12

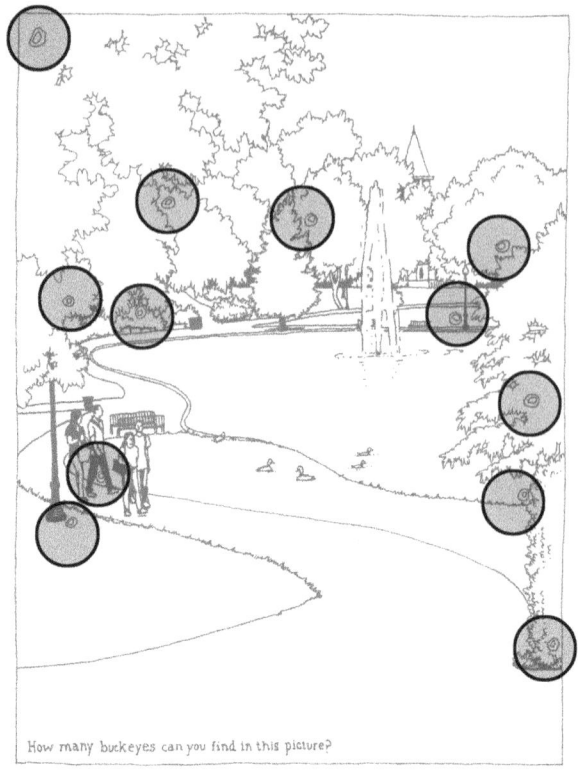

68.

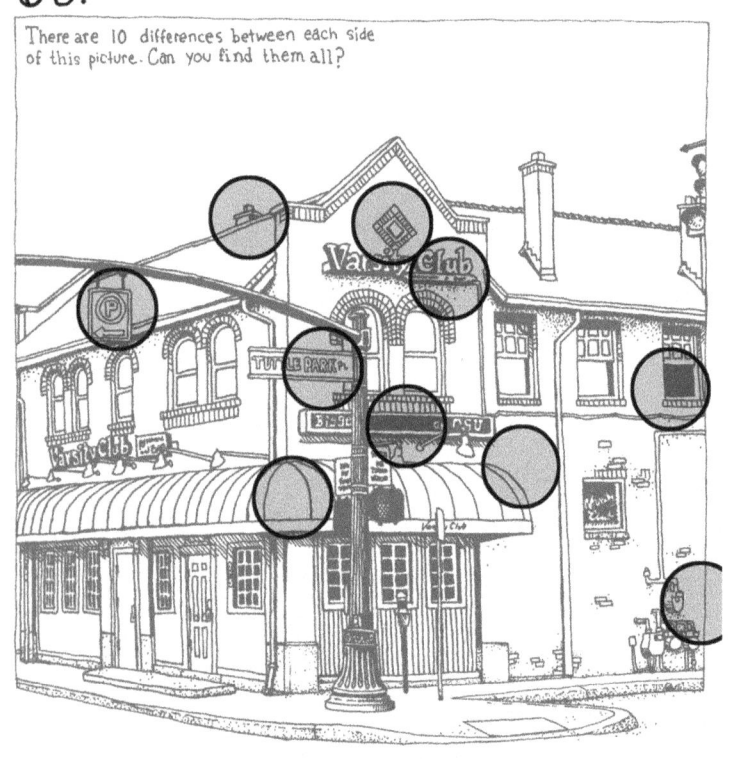

84.

www.ingramcontent.com/pod-product-compliance
Lightning Source LLC
Chambersburg PA
CBHW041920180526
45172CB00013B/1344